Birds of the
Heart of England

Birds of the Heart of England

*A 60-year study of birds in the
Banbury Area, covering North Oxfordshire,
South Northamptonshire and South Warwickshire
1952–2011*

Edited by Trevor Easterbrook

Banbury
Ornithological
Society

Liverpool University Press

First published 2013 by
Liverpool University Press
4 Cambridge Street
Liverpool L69 7ZU

British Library Cataloguing-in-Publication data
A British Library CIP record is available

ISBN 978-1-84631-885-6 cased

Edited, designed and typeset by BBR (www.bbr.uk.com)

BOS area context map and terrain/distribution map background image
©MAPS IN MINUTES™ 2012
Contains Ordnance Survey data ©Crown Copyright and database right 2010
Distribution maps by Trevor Easterbrook using DMAP software by Alan Morton

Cover photographs:
front: Great Spotted Woodpecker by Barry Boswell
rear: Grey Heron in flight by Trevor Easterbrook

Printed and bound by Gutenberg Press, Malta
Gutenberg Press prints for BirdLife Malta

Contents

This book is dedicated to three outstanding people whose foresight, enthusiasm and emphasis on recording, fieldwork and conservation inspired so much of the work of the Banbury Ornithological Society and underpinned its founding principles.

Glyn Davies
(1921–1991)

Cliff Christie
(1935–2003)

Royston Scroggs
(1926–2006)

Foreword

Amongst a long tradition of bird clubs in Britain, the Banbury Ornithological Society (BOS) is one of the smaller versions but its individual approach to bird recording has resulted in a remarkable picture of changing bird life over many decades. I became aware of this around 1980 when I met Royston Scroggs from the BOS who, like me, was interested in the Hobby. At the time, this small falcon was considered to be a rarity in England, largely confined to breeding on the southern heaths. Royston and his friends had ascertained that breeding pairs were well established on farmland in the BOS recording area in the centre of lowland England, well north of the known range. This exciting discovery, based on careful long-term observation of a local area, was perhaps the first indication that this bird was poised to expand throughout much of the country.

One of the reasons why birdwatching is so appealing is that the behaviour and numbers of birds reflect changes in our own environments. The annual rhythms of avian arrivals and departures are seasonal milestones: the appearance of Swifts in spring, Cuckoo song, the first Fieldfare flocks in autumn – these are significant annual markers for so many people. If the birds keep arriving, then the world seems in fair shape. These days, unfortunately, many of the migrant birds are not arriving in the numbers they used to and some of our resident birds are faring poorly too.

The BOS has developed its own unique long-running projects to track the changes in the birds of its area both in summer and winter. Recent national trends for many species are strongly mirrored in the findings of these surveys. The Banbury area has, for example, seen declines of Turtle Doves, Cuckoos, Whinchats, Spotted Flycatchers, Willow Warblers, Tree Pipits, Lesser Spotted Woodpeckers, Willow Tits, Lapwings, Grey Partridges and Corn Buntings. On the other hand, there has been a rise in numbers of Buzzards, Red Kites, Barn Owls, Ravens, Great Spotted and Green Woodpeckers, Long-tailed Tits and Chiffchaffs.

Detailed records amassed by the BOS also show intriguing patterns that are not so evident in national data sets, raising interesting questions about possible causes of change. Does the recent decline in the Lesser Spotted Woodpecker represent a return to the population levels that existed before Dutch elm disease? Did Moorhens decline in the late 1980s as a result of predation by Mink? Do reductions in numbers of migrating waders such as Greenshank, Ringed Plover and Common Sandpiper reflect population changes, shifts in migration routes or changing local habitat?

The BOS recording area is a sample of the typical countryside of central England. It contains no nationally famous bird sites, no large tracts of wild habitat. This book stands, therefore, as an account of how the bird populations of 'middle England' have changed over a 60-year period that has seen massive changes in land use. There could be no clearer illustration that nature is not static and that long-term records have enormous value. What the next 60 years will bring for the bird life and habitats of the Banbury area is impossible to predict, but one wishes the members of the BOS great enjoyment and continuing interest in tracking the future changes.

Rob Fuller
Director of Science – Ecological change
British Trust for Ornithology, Thetford, Norfolk
September 2012

List of abbreviations

ABSS:
: Annual Breeding Season Survey. A total of 26 species were selected in 1962 which were neither rare nor common, one species to be studied in detail each year. By 2012 all the species had been surveyed twice, 25 years apart.

BAD Kineton:
: MoD Base Ammunition Depot near the village of Kineton.

Banbury SF:
: Banbury Sewage Treatment Works at Spital Farm. This was a good area for birdwatching up until the early 1990s when the construction of a new treatment plant, using more modern disposal methods, made the area less attractive to birds.

BBONT:
: Berkshire, Buckinghamshire and Oxfordshire Naturalist Trust began in 1959 but in the 1990s was renamed the Berkshire, Buckinghamshire and Oxfordshire Wildlife Trust (BBOWT).

BBRC:
: British Birds Rarities Committee, the official adjudicator of rare bird records in Britain.

BBS:
: BTO/JNCC/RSPB Breeding Bird Survey, set up in 1994 and which replaced the Common Birds Census (see CBC) in 2001.

BoCC:
: Birds of Conservation Concern. Leading conservation organisations have worked together to produce a review of the status of birds that regularly occur in the UK. Species are assessed against a set of objective criteria to place them in **green**, **amber** or **red** categories, indicating an increasing level of concern.

BOS:
: Banbury Ornithological Society.

BOS area:
: Consists of twelve 10km squares in a rectangular block using the National Grid Reference System (see maps, pages x and 6).

breeding season:
: Varies from species to species but for most it falls between mid-April and mid-July.

BTO:
: British Trust for Ornithology.

CBC:
: BTO Common Birds Census, which ran from 1962 to 2000. It was replaced by the Breeding Bird Survey (see BBS).

CES:
: Constant Effort Site. A site where birds are regularly ringed in order for monitoring to take place over a long period.

JNCC:
: Joint Nature Conservation Committee.

larger lakes:
: Waters over 1ha, such as Chesterton Pools, Ditchley, Edgcote, Farnborough and Fawsley.

Mid-Cherwell Valley:
: The area of flood plain between Nell Bridge and Clifton (see map, page 6).

MoD:	Ministry of Defence.
RSPB:	Royal Society for the Protection of Birds.
SOC:	Scottish Ornithologists' Club.
SRSS:	Summer Random Square Survey. A 1km square is randomly selected and surveyed three times during the breeding season, from April to July. For further explanation of the methods used see page 174.
WeBS:	BTO Wetland Bird Survey.
winter period:	November to February inclusive.
WRSS:	Winter Random Square Survey. Similar to the SRSS in that a randomly selected 1km square is surveyed for 2–3 hours on the last Sunday in November and the last Sunday in February each winter. For further explanation of the methods used see page 173.
WWT:	Wildfowl and Wetlands Trust.

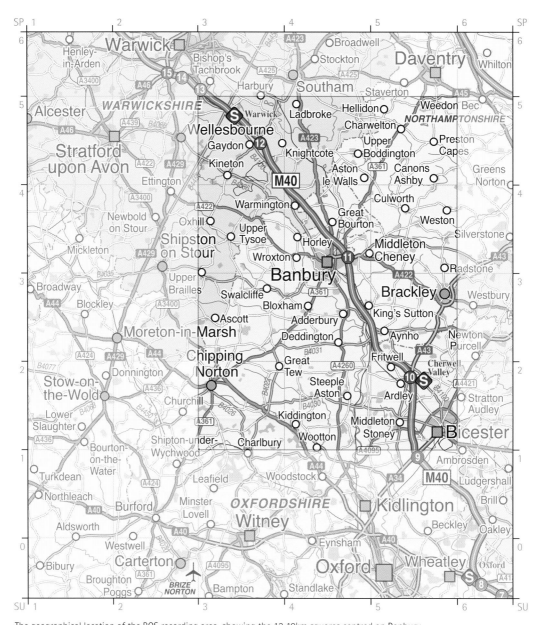

The geographical location of the BOS recording area, showing the 12 10km squares centred on Banbury

Introduction

The Banbury Ornithological Society (BOS) was formed following a series of lectures on ornithology given by Dr Bruce Campbell at Banbury in 1951. He was at that time the first full-time secretary of the British Trust for Ornithology (BTO) based then at Oxford and became the Society's first President from 1952 to 1993. From a small start of just six members, the BOS now has around 80 members, well over a third of whom regularly contribute records and/or participate in organised fieldwork.

The aims and activities of the Society are to encourage and co-ordinate the scientific study of birds in the Banbury area, to strive to ensure their welfare and be able to provide evidence for their conservation. In 1952 the BOS area was based on those parts of Warwickshire and Northamptonshire within a nine-mile radius, and that part of Oxfordshire within a 12-mile radius of Banbury Cross. In 1962 it was decided to use the National Grid Reference System and the area was changed to cover the 12 10km squares SP32–35, SP42–45 and SP52–55, centred on Banbury.

Since its inception in 1952, BOS members have submitted records of sightings. Organised local fieldwork began in 1957 with a survey to estimate the number of breeding Corn Buntings in north-west Oxfordshire and has since included an Annual Breeding Season Survey (ABSS), Winter and Summer Random Square Surveys (WRSS/SRSS), and Short and Long Day Counts. The Society has also participated in many national surveys run by bodies such as the BTO and the Wildfowl and Wetlands Trust (WWT). In this book I have also included records collected by O. V. Aplin, a great historian of Oxfordshire birds, who worked, virtually alone, in the Banbury district in the late Victorian period. One of the main founding members of BOS, Glyn Davies, started the ringing section, which was very active from 1962 to 1991. Rule changes concerning ringing sites then presented increasing problems and activities gradually ceased until a new ringing group was set up in 2006 (see page 164).

Always very conscious of the need to provide good habitat for birds, the BOS has also been able to provide evidence supporting reasons for securing particular habitats. Our data is frequently used by environmental agencies to assist with the requirements of planning applications, by those objecting to development or by landowners who wish to encourage suitable habitat for wildlife. As an example, an analysis of data for the Mid-Cherwell Valley during 1952–72 showed how valuable such water meadows were for waterbirds and waders. This enabled the Society, with the support of farmers in this stretch of the valley, to convince the Berkshire, Buckinghamshire and Oxfordshire Naturalist Trust (BBONT) to declare this area a Nature Reserve in 1972. This designation eventually persuaded planners to route the M40 motorway around the valley rather than right through it.

The BOS continues to be very active in conservation (see page 156) and has worked in conjunction with Thames Water to manage Grimsbury Woodland Reserve and Bicester Wetland Reserve. In 1991 Glyn Davies passed away and generously left the residue of his estate to the Society, much of which has been used to increase our participation in conservation work. The Society now owns four reserves: Balscote Quarry, Glyn Davies Wood, Pauline Flick Reserve and Tadmarton Heath Reserve. These represent four different types of habitat: wet disused quarry, mature deciduous woodland, disused railway line and rough grazed, arable farmland. Since 2011 the BOS has also taken on the management of a woodland area within the Neal Trust Reserve at Combrook in Warwickshire.

BOS members have taken part in all the national surveys organised by the BTO from the start of the Nest Record Card scheme and the original Common Birds Census (CBC), and are now involved in the ongoing Breeding Bird Survey (BBS). They continue to take part in our own surveys and have been active in supplying information to the forthcoming UK and Ireland 2007–11 atlas and the new Oxfordshire county atlas.

The BOS has been a registered charity since 1990 (number 1001397), governed by a written constitution. Two of its main objectives are to advance public education on aspects of ornithological life, and to promote research and publish the useful results for the benefit of the public. This takes the form of monthly newsletters and annual reports, together with publications such as this book on more specialised ornithological topics.

The BOS is always pleased to welcome new members, particularly those who are interested in birdwatching, recording their observations and taking part in fieldwork. If you would like more information, please visit our web site at: www.banburyornithologicalsociety.org.uk

About this book

The main aims of this book are to:
- collate and interpret all the data collected by the BOS since the Society's foundation in 1952 including historical records from 1800,
- produce accurate information on the status and distribution of birds in the Banbury area,
- serve as a basis for further study,
- illustrate what can be achieved by a few enthusiastic and committed amateur birdwatchers.

The information contained in this book is based on all the records submitted by members since 1952, the diaries of O. V. Aplin and his book, *The Birds of Oxfordshire* (1889) and also the data, comments and status descriptions included in the BOS ten-year reports: 1952–61 (Davies 1967), 1962–71 (Brownett 1974), 1972–81 (Easterbrook 1984) and 1982–91 (Easterbrook 1994).

Detailed descriptions of the terrain and habitat of the BOS area and comments on changes in bird populations are followed by a complete list of species seen here since 1800. Every species seen since 1952 is given a status, relevant for the present day, which describes its numerical density and occurrence. Charts, tables and maps are included to show, where appropriate, population trends, distribution and abundance.

Also included in the book are reports on our conservation history, our reserves and the ringing section, together with more detailed descriptions of the methods used in surveys.

Record keeping and fieldwork rationale

Like many bird clubs and ornithological societies we collect detailed records of sightings of birds in our area as well as taking part in national surveys organised by BTO, RSPB and WWT. Our database contains over 250,000 computerised records as well as many paper records from the last 60 years. In this book I have attempted to draw conclusions based on this data as well as provide a historical record of birds in the BOS area.

Recording system

Initially records were collected giving number, date and parish or site for each species. In 1975 members were encouraged to give sightings with a four-figure grid reference (a 1km square reference) as well as a parish/site and, from 1981, a habitat code was added to each sighting. To help members, a *Guide for Observers* was produced showing what records were needed for each species, together with an explanation of the habitat codes. Standardising the records meant they could easily be entered into a computer database, begun in 1982. To ease the work of the bird recorder, a computer program has been written to enable members to enter their records electronically. The vast majority of records are now e-mailed to the bird recorder and can be quickly entered into the database.

Annual Breeding Season Survey

The BOS area does not contain any large waters or significantly important habitats; it is a typical lowland farming area in the middle of England. Rarities or falls of migrants are not usual so much of our birdwatching is about studying the commoner farmland and woodland species. To this end, in the 1960s, it was decided to produce a list of 26 species to be surveyed in detail that were neither rare nor very common at that time. This survey became known as the ABSS.

A pilot survey, involving a small number of active fieldworkers, is carried out in the year prior to each full survey. This helps to establish the best system of sampling and to provide guidelines for carrying out the survey. The particular methods used depend on the species and include coverage of the whole area, transects across the area, sampling blocks of nine 1km squares, to just surveying a single 10km square, and focusing on particular habitats like reed-beds. When each species is resurveyed, the method and area of the first survey is repeated as far as possible for comparison purposes. Whenever the survey area has altered this is usually because the number of members participating is different. The results enable us to give a status definition for each of these species. We completed the list for the second time in 2012 and it is interesting to see how the status of some species has changed (see ABSS summary, page 170).

Winter Random Square Survey

In the 1970s it became apparent that, despite all the data we had collected, we still did not know the status of some of the most common species. We had no measure for abundance or distribution; we only had an overall impression. All we knew was that certain species were found in large flocks and, for migratory birds, their arrival and departure dates. To rectify this, a WRSS was started in 1975, where each observer surveys a randomly selected 1km square for a minimum of 2–3 hours, recording the species present, together with an estimate of the total number seen. This survey takes place on the last weekends of November and the following February with the results combined to give a winter total. Data from the initial three winters (1975/76 to 1977/78) was averaged to establish a yardstick to which

all subsequent winters could be compared. The survey has continued every winter since then and has meant that we can now produce measures of abundance and distribution for around 40 common species. It is probably the only long-term survey of farmland winter birds anywhere in the country and has shown that during the 1970s and 1980s several species declined rapidly and then, during the late 1990s and 2000s, stabilised at this lower level. For a few, the decline is continuing. Modern farming practices appear to have had a detrimental effect: winter sowing, fewer stubble fields and large-scale use of pesticides and fungicides may well be leading to a shortage of food for birds, as well as causing a lack of nesting sites for ground-nesting species. See page 173 for further details of Random Square Survey methods.

Summer Random Square Survey

After the success of the WRSS it became clear that more information about birds in the breeding season was needed. The only data we held for many of the summer visitors was arrival and departure dates together with notes of any large flocks or of abnormal behaviour. In 1991, an SRSS was started. This differs from the WRSS in that an observer is again given a random 1km square but this is visited a minimum of three times, in late April/early May, late May/early June and late June/early July. Each species observed is recorded, together with any evidence of breeding such as carrying nesting material. At the end of the survey, observers are asked to estimate how many breeding pairs of each species there are in the square and which other species just use the square for feeding or for flying over. Every year an index of abundance and distribution can be calculated which helps produce trend graphs for each species. The results for the first three breeding seasons (1991 to 1993) were averaged to establish a yardstick to which subsequent years' results could be compared.

Short and Long Day Counts

Every year, two full-day counts are held, one in the first week of January from 08.00hrs until

16.00hrs and the other in the first week of May for a total of any 12 hours. In each 10km square a team of two or three observers records as many different species as they can find. These counts, together with the SRSS and WRSS and normal monthly records, ensure the whole of our area, not just favoured places, is covered as fully as possible each year.

BOS Domesday Surveys

Awareness of land use changes and concern about possible consequences for the bird population led to a decision to carry out a field-by-field survey of the BOS area. Between 1982 and 1986, in what became known as the Domesday Survey, BOS members surveyed and mapped each of the 1,200 1km squares, recording the percentage of pasture and arable land, woodland, standing water and built-up area together with the lengths of roads, railway, streams, rivers and, most importantly, hedgerows. This survey was repeated between 1993 and 1998, and again between 2003 and 2008, thus facilitating comparisons between each of the ten-year periods.

All this fieldwork and the associated data help us to provide an informed statement about the current status of all species seen in the area, any changes that have occurred to their populations and, thereby, an indication of the health of the countryside with regard to bird life.

The findings of the BOS Domesday Surveys have also informed the discussion of habitat changes in the chapters that follow. Some of the results of the survey can be found in Appendix 2.

Avoiding bias

Our aim has been to use all the data effectively and produce accurate statements about each species. In an attempt to reduce error and bias in the conclusions made from the data, the number of 1km squares in which a species is present (rather than the number of records for the species) is used to determine the species status. This reduces the chance of the same bird being recorded many times. Occasionally, however, the number of records is a more appropriate indicator.

Despite fluctuations in BOS membership, the number of active fieldworkers who regularly submit records and/or participate in surveys has remained relatively constant, at 20 to 30, over the last 40 years. The diagram shows the 10km squares in which participating members have lived and, as would be expected, members are not evenly distributed with the majority residing in the squares nearest to Banbury. To reduce the possible imbalance this could cause to records, we actively encourage members to visit other 10km squares and use the WRSS, SRSS and Short and Long Day Counts to ensure that all the 10km squares are visited at least four times each year. An additional benefit of both the WRSS and SRSS is the random nature of the squares selected which forces observers to visit areas that might otherwise be overlooked.

SP35 6	SP45 7	SP55 7
SP34 5	SP44 14	SP54 5
SP33 10	SP43 21	SP53 5
SP32 7	SP42 6	SP52 7

The percentage of participating members resident in each 10km square, where Banbury is located in the south of SP44.

Terrain of the BOS area

Incorporating parts of north Oxfordshire, south Warwickshire and south Northamptonshire, the BOS area largely lies over a system of rocks laid down as sediments during the Jurassic period, 200–145 million years ago. This Jurassic system runs almost continuously from Lyme Regis in Dorset to the Cleveland Hills in Yorkshire and comprises bands of clays and limestones formed from deposits of mud and sand in the warm seas of that time. Subsequent earth movements have create a landscape of tilted strata with the edges of the clay layers more eroded than the limestones between.

Escarpments and dip-slopes

An escarpment is made up of two slopes: the scarp, which is the steep slope, and the dip which is the gentle slope that follows the direction of the underlying strata. The limestones in the BOS area form a series of plateaux, each with an escarpment facing north or west and a gentle slope towards the south-east. The most important of these escarpments, and the dominant feature, is a 40m-deep band of limestone, the Marlstone Rock, that forms the escarpment of Edge Hill. Its steep face is continued northwards by the Dassett Hills and beyond the Cherwell gap towards

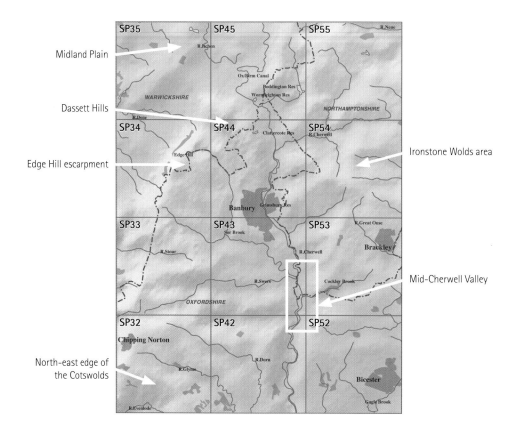

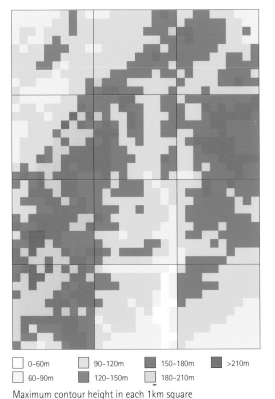

☐ 0–60m	☐ 90–120m	■ 150–180m	■ >210m
☐ 60–90m	■ 120–150m	☐ 180–210m	

Maximum contour height in each 1km square

Daventry, whilst the plateau surface dips gently to the south-east from Edge Hill towards Oxford. Below this escarpment to the west is a country of grey-clay fields, part of the Great Midland Plain. Over the top of the escarpment are the rich brown fields of the plateau, mostly used as arable land.

The south-western part of the BOS area rests on the northern edge of the Cotswolds. It is a windswept area and stone walls are used in place of hedges. The fields are larger and usually arable, although a small amount of sheep farming is still continued.

Rivers and streams

Streams that follow the dip-slope south-eastwards generally have carved out steep-sided valleys, often wooded, that form part of the parklands of Wroxton, Broughton, Astrop and Tew amongst others. These woods, of mixed hardwoods, often have Beech as the principal tree and also Oak which, although common, is never as dominant as in some other parts of England. Lines of Elm and pollarded Willow used to border the streams before the outbreak of Dutch elm disease in the

The view across the Chadlington area shows that the habitat is now dominated by winter wheat and Oil-seed Rape

TREVOR EASTERBROOK

The lake at Ditchley Park, which is one of the largest estates within the BOS area

1970s; now an Elm tree is a very rare sight. These streams flow into the Cherwell Valley, which is open-ended to the north-east, the line of which was followed by the engineers of the Oxford–Birmingham Canal during its construction in the late eighteenth century. Further down the valley are wide flood plains, the largest being between Nell Bridge and Clifton, also known as the Mid-Cherwell Valley, where several small streams and brooks flow into the River Cherwell. The only major westward-flowing stream is in the upper valley of the Stour and follows the limestone edge around Rollright. This line of steep hillsides virtually forms the Warwickshire county boundary.

In the north-eastern section of the area are found the sources of the rivers Leam and Nene that eventually feed into the Great Ouse, which flows eastwards. The Cherwell also originates here on the edge of Northamptonshire. This area down towards Banbury is known as the Ironstone Wolds, with the scenery similar to that already described for the Mid-Cherwell Valley, but on a smaller scale and with less individuality in the minor valleys.

Parkland, woodland and heathland

There are several large estates in the BOS region, with most having good areas of parkland consisting of pasture and mature hardwood trees. Major wooded areas at Badby, Ditchley, Glympton, Heythrop and Kiddington consist mainly of mixed deciduous trees with a few conifers. There is very little scrub woodland now as trees have reached maturity and some sections have been felled and replanted. No true heathland is left in the area; only a few Gorse thickets remain and frequently coincide with patches of sand. In the west these occur at Tadmarton, Heythrop, Tyne Hill near Sibford and, on the eastern side of the area, Gorse can still be found near Overthorpe and Tusmore.

UNA FENTON

Standing water

Many lakes and ponds of varying sizes can be found throughout the area. Most of the big estates and larger country houses have a lake in their grounds. The number of waters increased during the late 1980s and early 1990s when, due to economic necessity, several farmers started to diversify, for instance developing fishing lakes and golf courses with water features. Near the Cherwell Valley watershed are the reservoirs of Boddington, Clattercote and Wormleighton, built to maintain the water level of the Oxford–Birmingham Canal. In 1961 a reservoir was built at Grimsbury on the outskirts of Banbury, which attracts migrant birds.

Quarries and sand pits

There are several disused quarries in the area and a few ironstone works producing stone for local houses. A disused quarry holding a Regionally Important Geological and Geomorphological Site (RIGS) designation is located in the Burton Dassett Hills Country Park, to the south-east of the village of Northend, 10km north-west of Banbury. The site provides exposure through Lower Jurassic and Middle Jurassic rocks approximately 180–200 million years old. The Marlstone Rock exposed in the old quarry and overlain by later clays, forms the steep slope that rises up to the highest point of the Dassett Hills where it is capped by the harder Northampton Sand. At Ardley Fields Quarry, dozens of dinosaur footprints were exposed in part of the White Limestone quarry floor. The fine muddy limestone was deposited very near to the shore of a sea and probably represents the remnants of a gradually shelving mudbank. At some point, approximately 165 million years ago, dinosaurs walked across the mudbank while the sediment was still soft and wet. These tracks were removed from the quarry and are now on display

TREVOR EASTERBROOK

Banbury Cross

at the Oxfordshire Museum in Woodstock. The succession of limestones and clays which run through the BOS area can contain sands, which may occur as an impurity, but they only influence the scene to any extent in the Aston, Duns Tew and Tadmarton areas. Duns Tew is now the only fully working sand extraction pit left in the area and is a nesting site for Sand Martins.

Urban development

Population changes are affecting our area where Banbury is the largest town and is still expanding. The towns of Bicester, Brackley and Chipping Norton, together with many of the villages, have also grown significantly in the last 30 years and are continuing to do so. All the towns and villages throughout the area, however, contain large gardens and open spaces that provide useful habitats for birds. A major change occurred with the building of the M40 motorway, which virtually bisects the area diagonally from the south-east to the north-west. Following successful lobbying, the final route of the motorway avoided the main flood plains of the Cherwell Valley and runs largely through arable farmland which, in most cases, fails to provide a very beneficial habitat for birds. However, the verges of the motorway incorporate strips of rough grassland that are good habitat for small mammals and insects and, consequently, good for Kestrels and other species. In general, the whole of the Banbury area contains no extremes but does include as great a variety of habitats as can be expected in the heart of England.

The M40 skirting the Mid-Cherwell Valley

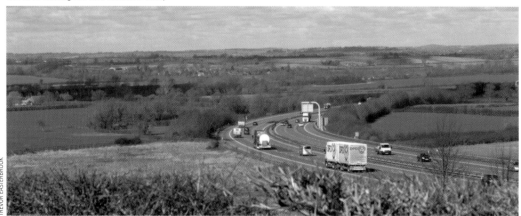

TREVOR EASTERBROOK

The 12 10km squares of the BOS area

The BOS area covers 12 10km squares of the National Grid Reference System which lie within the 100km square prefixed by the letters SP. Each of the 12 squares has different features as described below.

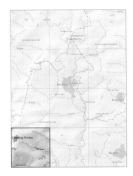

SP32

This square has high windswept uplands edging onto the Cotswolds, with the highest point at 227m lying in the north-west corner at Over Norton. Many fields are large and bounded by stone walls, frequently arable with a predominance of winter wheat and Oil-seed Rape, but also a small amount of sheep farming still exists. Successions of tiny streams, bordered mostly by narrow steep strips of permanent pasture, cut through the higher ground. There are few areas of significant open water but the main ones are located at Broadstone Hill, Ditchley Park, Heythrop Park and Old Chalford. Several smaller fishing ponds or lakes have been formed in the last 20 years and there is a small section of the Evenlode which flows along the bottom edge of the square. There are good areas of woodland and parkland, mainly at Over Norton, Heythrop, parts of the estates of Great Tew and Ditchley. For many years the Great Tew estate had woodland with a very good shrub

The River Evenlode
at Chadlington

layer and many areas of scrub. However, more recently and under new management, the estate has been tidied up so much it now has the look of a manicured park. In the 1960s and 1970s, the Ditchley estate was dominated by conifer plantations but in the last few years a lot of these areas have been felled and planted with deciduous species or thinned out with only the Beech trees remaining. The square still has areas for breeding Corn Bunting but Grey Partridge is very rare; the high windswept areas are good for Skylark and Merlin in the winter but very poor for duck species. It has a broad range of woodland species including Hawfinch and Crossbill.

SP33

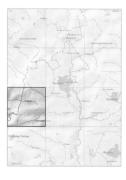

About two-thirds of this intensively farmed square is over 150m above sea level, including Oatley Hill, the highest point at 235m. It has three main valley systems, two of which, the Sor Brook and the River Swere, run eastwards into the River Cherwell, while the River Stour meanders as a small stream to the west. Standing water is scarce, with only three small lakes of note, Lamb's Pool being the largest at 1.5ha. Woodland is similarly sparsely distributed and, apart from 60ha of Whichford Wood on the western limits of the square, is confined to small copses and shelter belts. Parkland survives at Swerford and Swalcliffe but much of the old heathlands at Tadmarton and Wigginton have been lost. In 2008 the BOS acquired a field near Tadmarton Heath and has begun developing it by reintroducing Gorse as well as planting a section with a wildbird cover crop.

The Edge Hill escarpment

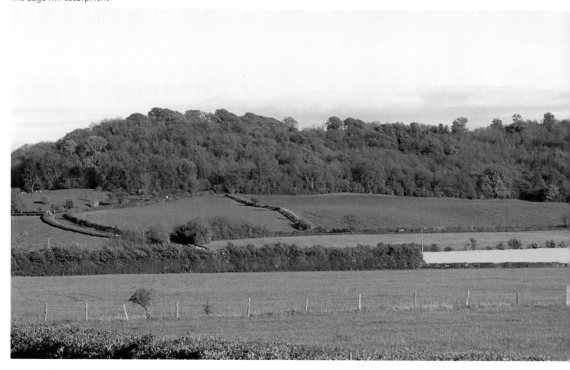

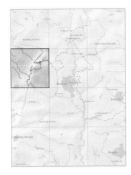

SP34

The square is divided by the Edge Hill escarpment into roughly equal but totally dissimilar areas. To the south-east, most of the land lies around the 180m contour, rising in one place to 223m, and a series of steep-sided valleys provide the only relief. North-west from the foot of the escarpment, the Midland Plain allows little variation to the landscape and the four streams that flow northward make no significant contribution. Much of the area is intensively farmed, although valuable pockets of woodland occur at Edgehill, Upton House and Compton Wynyates with attractive lakes and parkland at the latter two. In the extreme north, BAD Kineton provides an area with restricted access of rough, permanent grassland as well as several small woods. This is the last remaining regular breeding site for Nightingale in the BOS area.

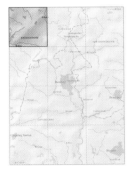

SP35

There is a rich variety of habitat to be found here which includes Oxhouse Farm, part of which is being managed as a nature reserve by the BOS. Two small rivers, the Dene and the Itchen, flow westwards but it is the lakes at Compton Verney, Chesterton, Chadshunt, Lighthorne and Moreton Morrell, as well as the gravel pits at Bishop Itchington, which ensure that water birds are well represented. The major woods are at Chesterton, Oakley and Itchington Halt with additional smaller areas in parklands at Compton Verney, Moreton Morrell, Little Kineton and Ashorne. Extensive scrub and mixed plantations occur within BAD Kineton and the Vehicle Proving Ground at Gaydon, but access is totally restricted.

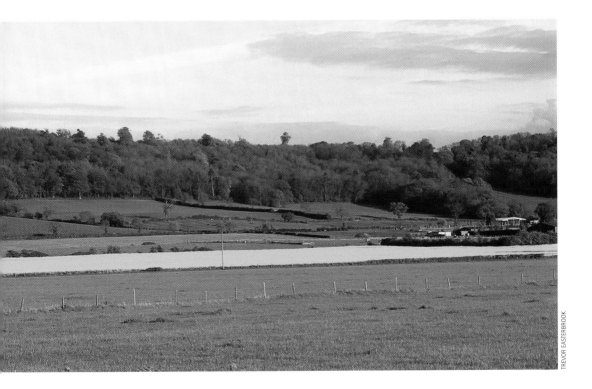

The River Glyme at Glympton

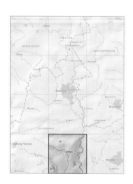

SP42

Starting on the high ground to the north-west, peaking at 183m, the landscape then undulates through the minor valley systems of the Dorn and Glyme to the broad flood plain of the River Cherwell, which dominates the entire eastern side of the square. The parklands of Barton, Kiddington, Rousham and Glympton provide substantial areas of woodland together with four small lakes. Another important area is the Somerton region of the Mid-Cherwell Valley which is good for ducks and Golden Plover, particularly during winter when the Cherwell Valley floods. Rich deciduous woodland can be found at Worton Woods and at Tackley where there is also a sizeable area of heathland. There is no town in the square but it does include several large villages such as Deddington and Steeple Aston.

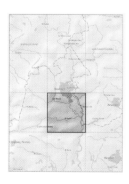

SP43

In the east the flat arable fields, adjoining the south of Banbury, become the River Cherwell flood plain into which the minor valleys of the Sor Brook and River Swere steer their catchment water. Seasonal flooding attracts flocks of ducks, Golden Plover and a variety of passage waders, with numbers depending on conditions. The central part of the square contains Barford Airfield together with a mixture of arable and pasture land: an area favoured by Skylarks, Yellowhammers, migrating Wheatears and wintering Golden Plover. The high ground lies to the west and south-west where part of the Great Tew estate currently provides good habitat for woodland birds. Other parkland includes Adderbury, Broughton and Wykham.

SP44

Banbury itself dominates the south of this square as does the broad valley of the River Cherwell, followed closely by the Oxford–Birmingham Canal, the railway to the east and the M40 motorway, which bisects the square diagonally. On the western side there are closely folded valleys where extensive iron-ore extraction has terraced some of the hills. The old canal reservoir of Clattercote and the domestic supply reservoir at Grimsbury, together with mature lakes at Wroxton, Farnborough and Chacombe, provide a wide variety of water habitats. Large stretches of low-lying land around Nethercote, in the River Cherwell valley north of Banbury, and in the Warmington valley, can become very wet during the winter months and can flood. Woodland, however, is more scarce, although valuable areas are to be found around Wroxton and Farnborough.

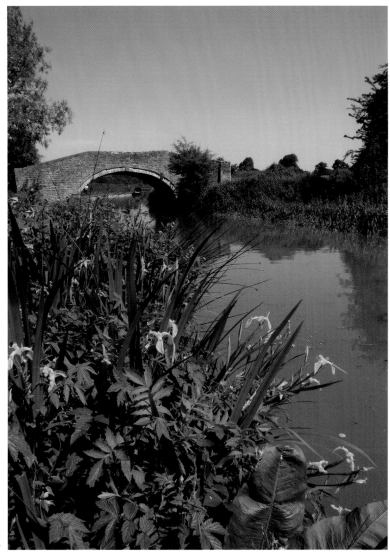

The Oxford–Birmingham Canal
in the Mid-Cherwell Valley

SP45

Straddling the Warwickshire/Northamptonshire border, this square is devoid of woodland except for small areas at Priors Hardwick, Avon Dassett and Wormleighton, though 76ha of woodland were planted in the early 1990s at Barnrooden, Priors Marston, on former arable farmland. The Oxford–Birmingham Canal and its feeder reservoirs at Boddington and Wormleighton, together with Newfield Pool and the lakes at Lower Radbourn, Chapel Ascote and Stoneton Manor, provide ample suitable habitat for water-associated birds throughout the year. The flood meadows bordering the headwaters of the River Itchen attract wintering Lapwing, Golden Plover, Snipe and ducks. Parkland is restricted to Bitham House, Avon Dassett and Ladbroke Manor, and the disused railway line between Byfield and Fenny Compton offers attractive habitats of scrub and rough grass. The steep-sided Burton Dassett Hills peak at 205m and are a mixture of arable, rough grassland and Gorse, providing breeding habitat for Linnets and occasionally Meadow Pipits. Regular passage birds include Wheatear, Whinchat and Ring Ouzel.

Wormleighton
Manor House

TREVOR EASTERBROOK

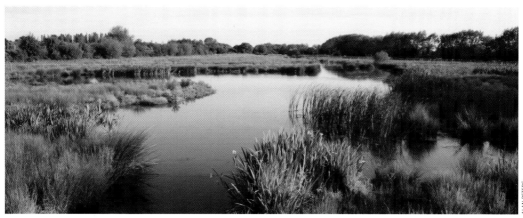

ALAN PETERS

The main water at Bicester Wetland Reserve

SP52

This flat, gently shelving area reaches towards neighbouring Otmoor from which much of its original character stems. In 1970 it was typified ornithologically by the abundance of Corn Buntings, which accept the monotony of large-scale cereal production. Much has changed since then. First, a large amount of development has taken place: the route of the M40 now crosses the square diagonally and the town of Bicester has expanded rapidly in recent years with a population currently estimated at 30,000. In addition there are plans for a large eco-town to be built on the north-west edge of Bicester in the near future. Secondly, Corn Buntings are now largely confined to the areas around Northbrook, Calcott and Lower Heyford. In conjunction with Thames Water, the BOS has developed the Bicester Wetland Reserve beside the Bicester Treatment Works, which now attracts a variety of ducks, waders and the occasional Little Egret, Great White Egret and Bittern. A waste disposal plant has been set up at Ardley Fields Quarry, which now sees large numbers of gulls congregating. In the south of the square there is the large MoD ordnance depot at Ambrosden. In contrast, the parklands of Bignell, Kirtlington and Middleton Stoney provide good habitat for woodland birds, Sparrowhawk, Red Kite and Buzzard. The only significant waters are the lake at Middleton Stoney Park and a smaller one at Kirtlington.

SP53

The old market town of Brackley and the scatter of nine villages throughout the square do little to spoil an area rich in woods, parks and small waters. St James Lake, Brackley (with its island refuge), together with the lakes at Astrop, Tusmore, Aynho and Cottisford, cater for a wide variety of breeding birds including Red Kite. Parkland includes Astrop, Aynho, Evenley, Steane, Shelswell and Tusmore, all of which contrast starkly with the windswept disused wartime airfield at Hinton-in-the-Hedges favoured by Skylark and migrating Wheatear. The disused stone quarry at Croughton also provides a small water and a good area for migrating birds. This square contains no exceptionally high or low ground but is made up of an interesting mosaic typical of the heart of England.

SP54

Although no major features occur in this square, a wide variety of habitats can be found. Woodland, of many different types, is scattered throughout with two woods of predominately Oak at Halse, the mixed deciduous Allithorne Wood and Warden Hill, large pure stands of Alder at Thorpe Mandeville and many fine yews at Thenford. Large areas of water are absent but the River Cherwell in the north-west and Edgcote Lake, together with lakes at Marston-St-Lawrence, Thorpe Mandeville and Thenford, afford a suitable habitat for many breeding water birds. The high ground between Sulgrave and Weston attracts regular flocks of wintering Golden Plover.

SP55

The Rivers Leam and Nene originate in this square, eventually feeding into the Great Ouse, as well as the River Cherwell which rises here on the edge of the Northamptonshire uplands. Their valleys provide large areas of permanent grassland, in contrast to the featureless cultivation on the higher ground. The woods at Badby, Canons Ashby, Church Charwelton, Fawsley, Mantles Heath, Warden Grange and Redhill, together with the parkland at Canons Ashby, Catesby, Fawsley and Little Everdon, provide an important diversity of habitat.

TREVOR EASTERBROOK

Bluebells in Badby Wood

Habitat changes over the 60 years

Farmland

Farmland practices have changed a great deal over the last 400 years. Our evidence shows that the status of many farmland birds has waxed and waned in response to agricultural development.

The enclosures begun in the seventeenth century resulted in a loss of lowland heath and rough grassland but did produce an abundance of hedgerows. By the nineteenth century there was widespread adoption of the four-course rotation of crops, arguably marking the beginning of modern farming. Drainage of large areas of land in both the eighteenth and nineteenth centuries particularly affected wetland birds. Gamekeeping on large estates, especially in the nineteenth century and up to World War II, helped to preserve good habitats but led to the widespread killing of birds of prey and corvids, together with those birds that looked like hawks such as Cuckoos and Nightjars. In the nineteenth century there was a huge cage-bird trade (Linnets and Goldfinches in particular), milliners used feathers for hats and costumes, and the taxidermist supplied the fashion for stuffed animals. These trades caused widespread concern, which eventually led to the passing of the Wild Birds Acts from the 1880s onwards and the formation of the RSPB. Since World War II, profound alterations in farming practice have come about as a result of scientific developments, government subsidies and greater demands for food.

The BOS area is principally one of lowland farming where, in the 1950s, farms were a mixture of livestock and arable. During the 1960s and 1970s many farmers changed their farming

Oil-seed Rape is now a common sight in the countryside

methods, led largely by government grants and subsidies for particular crops or practices. More autumn/winter cereals were sown which meant fewer fields of winter stubble and so less food for birds. The move to more arable crops resulted in bigger fields to accommodate larger farm machinery and, as a consequence, rough areas and some permanent pasture were ploughed up and many hedgerows grubbed out. That which remains, normally around villages, is now used mainly as pony paddocks. The Dassett hills are the only place in the BOS area with open hill pasture without hedgerows. Since the 1980s, grassland has further decreased by 7% and arable land by 4%. This may well be accounted for by land lost to the building of the M40 and the large increase in building around towns and villages in the area.

Survey period	Farmland	Built–up	Water	Wood	Other
1980s	90.5	5.2	0.2	3.9	0.2
1990s	86.3	5.9	0.2	5.9	3.4
2000s	83.4	6.5	0.3	7.7	4.5

Percentage of land for various habitat types in the BOS area as recorded in the BOS Domesday Surveys

On the plus side, owing to economic necessity, many farmers diversified their activities in the 1990s, took advantage of government grants and planted trees, and also dug many lakes and ponds, mainly for fishing. Five new golf courses have also been constructed and these benefit birds and insects by providing small areas of scrub, copse and grassland of various heights, as well as small lakes in some cases.

A move away from cattle and sheep farming has been more pronounced since the early 1980s, with sheep farming now mainly confined to the hilly areas to the south-west and many farms now totally arable. Alternative crops have also been introduced: Oil-seed Rape, Linseed, peas, beans and potatoes have become a common sight in the countryside. Fields, when crops are in flower, now show swathes of yellow, blue and white turning brown in late summer.

The striking blue of Linseed in bloom

Although the use of organochlorines was stopped by the early 1970s, with a resulting increase in numbers of birds of prey in particular, other pesticides and insecticides have continued to adversely affect farmland bird numbers. Advances in technology have meant improved and more efficient agrochemical control hence far fewer invertebrates, insects and weed seeds are available. Many seed-eating birds feed their chicks on invertebrates collected from arable fields, and outside the breeding season crop

stubbles and field margins containing weeds are by far their most important habitat. Very few species make use of the centre of the field for nesting, particularly with winter-sown crops, and those that do, such as Skylarks and Lapwings, find autumn/winter crops too tall for their nests. Although subsidies, when available, encouraged farmers to leave field margins and take other measures to protect wildlife, economic necessity has naturally dominated farming decisions and bird numbers continue to be affected.

Following increasing concern about the loss of semi-natural habitats and the growth of intensive agriculture the government passed the 1986 Agriculture Act. This paved the way for Environmental Sensitive Areas (ESA), the Countryside Stewardship Scheme (CSS) and the Higher Level Scheme (HLS). Such schemes basically compensate farmers for carrying out a series of environmental changes to their farms and farming practices to benefit wildlife while still allowing sufficient quantities of food to be produced. For these schemes to be successful, careful monitoring is required in order to ensure that each farm is carrying out what has been agreed and whether the approaches taken are indeed benefiting wildlife.

The data from our records and from our Random Square Surveys has shown that numbers of farmland birds have been falling for a long

Fields of wild flowers are rare in farmland today

time, with the steepest decline between the mid-1970s and the mid-1980s. Whilst the rate of decline has slowed in some species, in others it has continued to be very worrying, for example Grey Partridge and Corn Bunting.

Woodland

It is interesting to note that some species adapt readily to change while others fail to cope effectively. Dutch elm disease decimated many woods, denuding the hedgerows of this majestic and valuable tree and, in many areas, completely changing the visual landscape. When the Elm trees began to die *en masse*, spotted woodpecker numbers actually rose as they were able to exploit the dead-wood insects. This was most noticeable in the Lesser Spotted Woodpecker numbers that increased dramatically between 1976 and 1980, but after 1986 regressed back to 1970s levels. It was thought that this pattern would be repeated with the Great Spotted Woodpecker but in fact it has increased in number. Other species such as Rook, Carrion Crow and Hobby that use crows' nests for breeding, together with the cavity-nesting

species such as Owl, Jackdaw, and Kestrel, have had to seek alternative sites but appear to have adapted successfully. During the 1960s and 1970s a large number of conifer plantations were created throughout the area and as these developed they became good habitat for Grasshopper Warbler, Willow Warbler and Tree Pipit. However, when the trees reached over 3m in height they ceased to be suitable habitats for such species. As the trees matured over a period of 20–30 years, these plantations were cut down and replaced instead with a variety of deciduous trees.

Wet meadows

During the late 1970s and early 1980s there were government grants for draining wet fields and meadows. A proportion of our wet and marshy areas was drained for crop production resulting in a loss of habitat for breeding waders. The reduction in availability of wet meadows and the increase in winter-sown cereals has had a significant effect on several species, so that breeding Lapwings have decreased markedly while Snipe and Redshank have ceased to breed in the BOS area altogether.

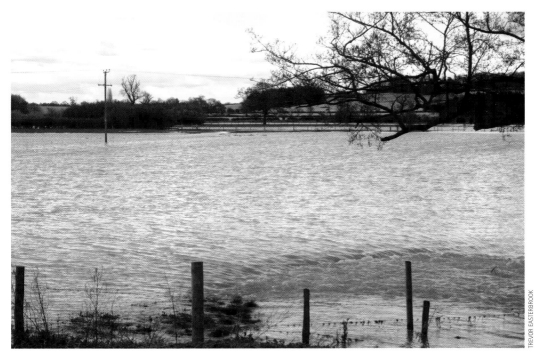

The River Cherwell in flood at Cropredy

TREVOR EASTERBROOK

Hedgerows are an important feature of farmland

Hedgerows

It is necessary to return to the issue of hedgerow loss. Good thick tall hedgerows that contain a variety of shrubs are an important habitat for birds, particularly Lesser Whitethroat. Hedgerows provide a good source of food for a large part of the year as well as nesting sites, roost sites and song posts, and for those birds feeding on the field margins they act as a sanctuary from birds of prey. Ditches, which often run beside hedgerows, are also important for several species like Reed Bunting and Sedge Warbler. Farming practice is again an important factor as hedges need to be cut at the right time to maximise fruit and seed yields. The neat small hedges often seen around fields, which are easily maintained by flailing with a tractor, are only beneficial for a few species; Whitethroats can be often seen dancing along the tops of these hedges. The BOS Domesday Surveys have shown that, although

the greatest destruction occurred between 1985 and 1995, hedgerow loss continued between 1995 and 2005. Overall, since the 1980s, 27% of hedgerows have vanished from the BOS area (see Appendix 2).

Town and village development

Over the last 50 years population levels have increased in nearly all our towns and villages and during the last 20 years the number of houses being built has increased significantly (see table). A large section of our area is arable and is mostly a clinical monoculture of winter wheat or Oil-seed Rape. The large amount of spraying for the suppression of weeds and insects has reduced the food left for birds in the countryside, particularly from February to early April and, as a consequence, gardens in villages and towns have now become a very important habitat for birds.

Ride a cock horse ...

Town	Population		Number of households	
	1961	2011	1961	2011
Banbury	21,000	43,000	6,594	21,890
Bicester	5,521	30,000	1,671	12,750
Brackley	3,208	14,500	995	6,000
Chipping Norton	4,245	6,600	1,330	2,920

Census data showing the increase in population and households for the major towns in the BOS area

Great Tew Post Office and pub

The number of houses that provide food for birds has also increased as has the variety of seeds and nuts that is available compared to 30 years ago. It is not surprising that many species have been quick to exploit this food source and, in the last ten years for instance, there has been an increase in records of Reed Bunting and Yellowhammer visiting gardens during the late winter.

The building of the M40, which cuts diagonally through our area, does not appear to have had a serious effect on birds; in fact the motorway verges produce good rough hunting areas for species like Kestrel and Barn Owl. A challenge that will affect our area in the future is the proposed High Speed Rail link between London and Birmingham: at the time of writing, plans show this crossing the north-eastern section of our area. For the BOS in particular, this means that part of the Glyn Davies Wood Reserve will probably be badly affected or could even be lost completely.

Game bird management

Pheasants may well be contributing to the decrease in the numbers of birds in the countryside. In the last 20 years there has been a marked increase in the number of Pheasant-rearing farms and the number of Pheasants being released for shooting. It is estimated that in Britain there are 38 million birds released each year for the four-month shooting season. As only 90% are shot, a certain proportion therefore joins the wild population each year. Many estates plant a game crop as food and cover for Pheasants, with these plots sometimes containing a variety of different food plants. These usually last until January and help to sustain other farmland birds but, from February until April, Pheasants search the woods and hedgerows for invertebrates, seeds and seedlings, thereby reducing the food that is needed by the rest of the wild bird population.

Bird population changes over the 60 years

Bird records have been collected since the formation of the Society and some of the fieldwork has been repeated annually since 1975. Using all records of sightings, together with information from our various types of fieldwork, it has been possible to produce a measure of distribution and abundance for each species. Since O. V. Aplin published his work in the late nineteenth century there have been many changes in the populations of certain birds, very often related to adoption of new agricultural methods over the period. Loss of habitat, changes in weather patterns and, for migrants, problems in wintering areas or during migration can all affect numbers.

Some of the species whose populations are currently on the increase are Buzzard, Raven, Red Kite and Goldfinch while Grey Partridge, Willow Tit, Corn Bunting, Turtle Dove, Cuckoo and Nightingale are decreasing. Snipe, Redshank, Whinchat, Redstart and Tree Pipit no longer breed in our area but now occur as passage migrants or during the winter. Species like Little Egret and Cormorant, not seen 20 years ago, are now regularly seen at more sites. The list below gives a brief indication of the changes within the main family groups of birds.

Swans, Ducks and Geese

Whooper and Bewick's Swans have become less frequent. Canada and Greylag Goose are continuing to expand. Pochard flocks have declined noticeably over recent years whereas Teal and Wigeon flocks have increased, particularly when there is flood water in the Cherwell Valley. Goosander numbers have increased in the last ten years and Mandarin Duck and Gadwall are now breeding in the area.

Partridges and Pheasants

Grey Partridge numbers have declined from their peak in 1979/80 and are currently at a very low level. Pheasant numbers appear to be on the increase now that larger numbers are being released on the shooting estates.

Birds of Prey

In general, birds of prey are doing well. Sparrowhawk, Kestrel and Hobby numbers remain at good levels and Buzzards are now seen soaring over every area of woodland. Red Kites are now being seen more frequently right across the area. Over the past decade there have been many more sightings of Peregrine and, during the winter period, of Merlin. Sightings of passage birds of prey, Osprey and Marsh Harrier, have also gradually increased over the last ten years.

Waders

Snipe and Redshank no longer breed in the area but Curlew, Woodcock and Little Ringed Plover still breed at a few sites. Breeding Lapwings, once common, have also decreased significantly, particularly over the last ten years. Passage wader numbers vary from year to year depending on how much mud is exposed at our larger lakes and reservoirs. Our records show that Redshank and Ringed Plover numbers have decreased in the last ten years, whereas Golden Plover and Green Sandpiper sightings have increased.

Doves

Collared Doves, since their arrival in 1962, increased dramatically to a peak in the early 1990s. Numbers then decreased and have remained stable at their 1995 level. Sightings of Turtle Dove began to decline significantly from 2006 and are currently at a very low level. The habitat that once held Turtle Doves does not

appear to have changed and, as there is national concern about this migratory species, the problem may well lie in its wintering grounds or in persecution during migration.

Cuckoo

The SRSS results indicate that numbers of Cuckoo have been decreasing since 1991 and have plummeted since 2006. Again one can speculate on why this is so: are there problems on migration, are their host species also declining or are these host species nesting earlier, before the Cuckoos arrive, thereby disrupting breeding success?

Owls

Barn Owls have made a good comeback in our area since the late 1990s though numbers can be affected by very cold winters, particularly when there are long periods of frost or snow. Little Owl numbers have a cyclic fluctuation and currently seem to be at the low point. Tawny Owl numbers appear to be constant.

Kingfisher

Numbers of Kingfishers can vary a lot depending on the severity of the previous winter and currently they are relatively low due to the hard winters of 2010 and 2011. Both drought conditions and flooding can also cause difficulties during the breeding season.

Woodpeckers

In 1889 Aplin wrote that the Lesser Spotted Woodpecker was the most abundant of the three woodpecker species, but this is certainly not true today. Numbers had decreased significantly by the 1950s when it was considered to be scarce. It then thrived in the 1970s, with more wood-boring insects available due to Dutch elm disease, but since then numbers have dropped back to those found in the 1950s and 1960s. The Green and Great Spotted Woodpeckers have continued to increase and are at their highest levels, with the latter now commonly seen visiting bird feeders in gardens.

Crows

Corvids appear to be thriving. Jackdaw numbers have increased over the last ten years. It was not until 1998 that Ravens began to be seen regularly but numbers have increased steadily and breeding is now recorded in all of the 10km squares.

Tits

The tit species' numbers do fluctuate but populations are generally stable for all but the Willow Tit. Long-tailed Tits were the last of the tits to use the bird-feeder resource in residential areas and are now regular winter visitors to gardens. Their numbers are currently at a high level, whereas the Willow Tit has decreased significantly since the 1990s and there are now only a few sites where it still breeds.

Larks

Skylark numbers decreased in our surveys between 1975 and 1990 but since then numbers have stabilised around that 1990 level.

Swifts, Swallows and Martins

Numbers of breeding pairs have decreased during the last ten years. One factor could be the lack of suitable traditional nesting sites, as many barns, old farm buildings and other structures throughout the area have been updated or converted into houses.

Warblers

Chiffchaffs are doing well and birds have regularly over-wintered in the area since 1980. Good numbers of Willow Warblers arrive in late March/April but numbers staying to breed have declined since 1990. Blackcap breeding numbers are doing well and the numbers of over-wintering birds from Central Europe increase each winter. Grasshopper Warbler has decreased significantly since the 1980s, which may be due to a lack of suitable habitat as small conifer plantations have matured and few new ones have been planted.

Starlings

The numbers of both breeding and over-wintering birds have declined since the 1970s.

Thrushes, Chats and Flycatchers

Song Thrush and Mistle Thrush numbers have declined significantly over the past 60 years. Numbers continued to fall until the late 1990s but since then appear to have stabilised. Nightingale numbers have always been low in the BOS area as this is at the extreme edge of their range and a breeding pair has been recorded regularly at only one site since 2008. Whinchats and Redstarts ceased to breed in the area by the mid-1990s and are now only recorded on passage. Spotted Flycatcher, once commonly seen on the edge of woodlands, in churchyards and in gardens, has declined since the mid-1990s and more dramatically since 2000.

Sparrows

House Sparrow numbers fell between the late 1970s and the early 1990s but have now stabilised and currently many villages have thriving populations. Tree Sparrow numbers have declined since the 1970s but there are still several sites holding good numbers of birds.

Pipits and Wagtails

Tree Pipits no longer breed in the area but do pass through on migration. Yellow Wagtail numbers declined severely between the late 1990s and 2005 but since then there have been more sightings and reports of breeding, particularly in pea, bean and potato fields. Pied and Grey Wagtail numbers have remained fairly constant.

Finches

The outbreak of the disease *trichomonosis* may well account for the decline in Greenfinch numbers since 2005. Goldfinch numbers have increased significantly, particularly since the late 1990s, and appear to have benefited from the increase in the use of Nyjer and Sunflower seed in garden feeders. Large flocks are also not uncommon in game/wildbird cover crops. Linnet numbers have fluctuated over the period with numbers decreasing in the breeding season since the late 1990s.

Buntings

The Reed Bunting population increased significantly in the early 1970s but by the early 1980s numbers had fallen back to the 1970 level. In the late 1980s it was noticed that birds were diversifying into farmland habitats. Currently they use, and now breed in, Oil-seed Rape as this crop maintains a damp microclimate. Corn Bunting has declined significantly over the last 20 years and there are currently only a few places, mainly in the south of the area, where a small number of pairs breed. Yellowhammer numbers decreased from the late 1980s but have stabilised over the last ten years.

Systematic Species List

Introduction

Nomenclature and sequence

The list embraces 269 species recorded since 1800. There are earlier records (Mason 1964, Morton 1712) but these are very few indeed. Species recorded before but not since 1962 follow the reports of Davies (1967), Brownett (1974), and Easterbrook (1984, 1994). The systematic list follows the sequence and nomenclature of the British List of the British Ornithologists Union (as at 15 December 2011) using the British (English) vernacular name of species.

Acceptance of records

To maintain a uniformly high standard of acceptance the following principles are applied:
- Submission of a written description is required for certain species
- There is corroboration by a third party or sufficient circumstantial evidence
- Known ability and experience of the observer is taken into account

 A record is rejected if there are good grounds for believing the evidence to be deficient. To assist in submitting records a *Guide for Observers* is given to all members.

Status categories

A status is only given for species which have occurred since 1952 (note that this refers to a species' status in the BOS area and not to its national status). Each status category consists of at least two parts, the first being a term describing the species' numerical density and the second based on its occurrence and sometimes, where appropriate, a term about its distribution.

Numerical density

Non-breeding species

This classification applies to species which only occur as visitors during the winter period, as passage migrants or as vagrants to the BOS area.

 The occurrence of a number of birds together in one locality on one day is termed a **unit record**. However, when the same individuals are reported on many occasions the number of localities is used as the unit record.

 A locality is usually defined as a 1km square or water, or exceptionally, a site such as the Mid-Cherwell Valley. The number of different localities/records in which a species was recorded during a ten-year period is then given a status term according to its place on the scale opposite.

Status term	Records/Localities
Rare	1–2
Very occasional	3–9
Occasional	10–29
Fairly frequent	30–99
Frequent	100–299
Very frequent	300+

Breeding species

The breeding status of residents and summer migrants is determined by one or more of three methods:
* Breeding density established by a survey
* Counting the number of records occurring during the breeding season
* Counting the number of occupied 1km squares during the breeding season

Status term	Numerical scale		
	Method 1 Pairs per 100 sq. km	Method 2 Number of sightings	Method 3 Number of occupied 1km squares
Rare	0–0.1	0–5	1–5
Scarce	0.1–0.3	5–25	6–25
Not scarce	0.3–3.0	25–125	25–125
Fairly numerous	3.0–30	125–625	125–500
Numerous	30–300	625–3,125	500–1,000
Abundant	300+	3,125+	1,000–1,200

Occurrence

Occurrence term	Definition
Resident	Present as a breeding species and recorded throughout the year but not necessarily as the same individuals.
Summer visitor	Species which arrive in the spring, breed in the area and depart before winter.
Over-wintering	Once regarded as summer visitors, some species can now be seen all year round, with wintering birds thought to be mostly visitors from central Europe rather than British breeders that have stayed on.
Winter visitor	Species which visit the area during the winter period but breed elsewhere.
Passage migrant	Species which visit the area only when moving to some other area, normally on passage from winter quarters to breeding grounds or vice versa.
Casual visitor	Species which have occurred in less than 50% of the years of the report and which can occur in most months of the year.
Regular visitor	Species which have occurred in more than 50% of the years of the report and can occur in most months of the year but do not breed in the area.
Vagrant	Passage migrants off their normal route, wanderers or species which are present for some unknown reason.
Escape	Birds which are thought to have escaped from private collections.

Distribution

Distribution term	Area/density ratio
Extensive	10+ records per 100 sq. km
Very widespread	5–9 records per 100 sq. km
Widespread	1–4 records per 100 sq. km
Local	Recorded in 5+ 10km squares
Restricted	Recorded in 1–5 10km squares

Flock size

Flock term	Flock size
Small	1–9
Medium	10–99
Large	100–999
Very large	1,000–9,999
Innumerable	10,000+

Charts, graphs and maps

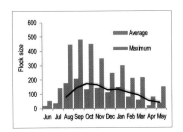

Charts

Bar and pie charts are used to illustrate a wide range of indices depending on the species in question. When a trend line can be produced, the method used is a three-year moving average in order to eliminate individual variations per year. A three-year moving average is the average of results over each successive period of three consecutive years.

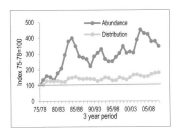

WRSS graphs

The WRSS graphs indicate abundance and distribution during the winter period. For species that are generally numerous in any 1km square, the index for distribution will be fairly constant so in these cases the index for abundance gives a better indicator of the status of the species.

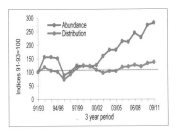

SRSS graphs

The SRSS graphs indicate abundance and distribution during the breeding season. As the SRSS was not begun until 1991, care is needed when comparing the graphs of species in the WRSS with the SRSS.

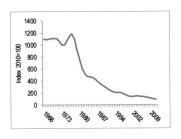

CBC/BBS graphs

CBC/BBS graphs show UK trend graphs of species. Unless indicated to the contrary, these cover the period from 1966 to 2011.

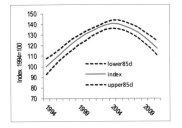

BBS graphs

These are trend graphs from 1994 to 2011 for breeding species, produced from Breeding Bird Survey data by the BTO for the administrative regions of England. As the BOS area unfortunately impinges on three of these regions, the South East England region has been chosen for comparison purposes.

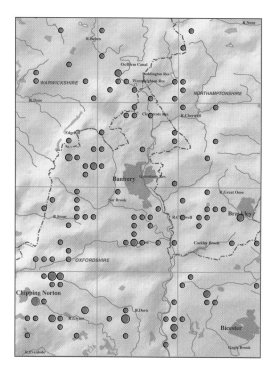

Maps

Most breeding-bird atlas maps use a 2km × 2km grid (known as a tetrad) as their basic mapping measure. However, the BOS records are based on the four-figure grid reference of a 1km square so the maps in this book use this finer grid.

Maps are only included for species that are rare, have a changing status and/or have specialised habitats (for instance Merlin, Raven, Kingfisher), and for which members are asked to report all sightings.

The dots used in the maps represent:

- 0–25% of the data
- 26–75% of the data
- 75–100% of the data

where the data may be, for instance, the number of sightings per 1km square, the number of occurrences per 1km square during a given number of years or the percentage of habitat per 1km square.

Waterfowl *Anseriformes*

Swans

All three species of swan have been recorded in the area. The Mute Swan is the only resident and can be found on almost all waters of the BOS. Winter herds do occur, usually in the Mid-Cherwell Valley and at Boddington Reservoir. The other two species are winter visitors to the area. The Bewick's Swan was regularly observed in the 1970s and a Whooper Swan family was seen most winters in the Cherwell Valley from the late 1970s into the 1980s. More recently both species occur irregularly, probably making a stopover when moving to and from their winter quarters at the WWT Slimbridge Wetland Centre.

Mute Swan *Cygnus olor*
Not scarce resident with widespread distribution

From the mid-1970s evidence across the country suggested that Mute Swan populations were declining, with many swans found dead of lead poisoning. Lead weights lost or discarded by fishermen were being ingested by swans, together with the grit needed to aid their digestive process. This caused lead to be absorbed into their blood and neuromuscular systems with death resulting from starvation. Our records reflected the national picture over this period with Mute Swan numbers declining. By 1987, however, the sale and use of lead weights was prohibited and since that time their numbers have returned to previous levels. Breeding occurs on many of the reservoirs, lakes, pools and rivers of the BOS area. The largest winter herds that have been recorded were of 42 birds at Edgcote Park on 13 October 1968, 44 in the Cherwell Valley on 12 January 1991, 62 at Belcher's Lake, Nell Bridge on 4 February 1996, 62 at Boddington Reservoir on 11 November 1997 and 44 at Belcher's Lake on 8 January 2003.

Bewick's Swan *Cygnus columbianus*
Very occasional winter visitor with restricted distribution

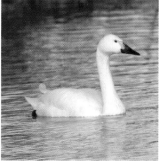

The only record before 1937 was of two birds seen near Wykham Mill in 1918. During the 1960s birds were seen in the Cherwell Valley each winter, with a flock of 42 there in 1964 and 43 birds at Grimsbury Reservoir in March 1966. During the 1970s birds were recorded regularly until 1977; since then the number of records has declined. There was, however, at least one sighting each year throughout the 1980s, except for 1984, with records from the Cherwell Valley and Grimsbury and Boddington Reservoirs. A group of 18 birds was seen flying SW at Bicester on 12 November 1985 and another of 11 at Bloxham on 7 December 1986. The number of sightings decreased even further in the 1990s. The largest flocks were 36 birds seen flying SW at Ledwell on 26 December 1993, 22 birds at Boddington Reservoir on 6 November 1994, 11 there on 17 November 1996, 13 birds in the Cherwell Valley on 2 March 1996

and ten at Fenny Compton on 31 December 1996. The only records since 2000 were of two birds in the Cherwell Valley 7–14 February 2001, six at Radway on 5 December 2003 and four at Barford on 9 November 2005.

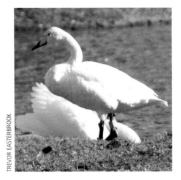

Whooper Swan *Cygnus cygnus*
Very occasional winter visitor with restricted distribution
Early records were of a few birds in the Cherwell Valley in 1891 and 1893. Ten birds were sighted at Boddington Reservoir in February 1956 and 20 adults with ten juveniles were there in November 1959. During the 1960s birds were recorded in small numbers from five waters. From 1970 to 1988 at least one family party of adults and juveniles regularly visited the Cherwell Valley and stayed for several weeks and on 19 December 1981 the herd of mixed adults and juveniles built up to 17. The other large herd recorded was of 15 birds in the Mid-Cherwell Valley on 27 January 1992. Small numbers of birds were recorded at five other waters. Throughout the 2000s the only records were of six birds flying south at Wormleighton on 25 December 2000, a single bird at BAD Kineton on 15 January 2001, two birds at Wormleighton Reservoir from 23 November until 16 December 2005, two in the Cherwell Valley on 23 and 24 November 2007, a single bird at Nell Bridge on 7 December 2008 and three at Caversfield on 2 December 2009. With the number of sightings declining, the status of the species has changed from *frequent* to *very occasional winter visitor.*

Geese

The only resident species are the Canada Goose and, more recently, the Greylag Goose. Other species of goose normally pass overhead, sometimes stopping to feed in fields or on flood water in the Cherwell Valley or at the larger reservoirs. There are also several records of birds flying over the area at night.

Bean Goose *Anser fabalis*
Three birds were shot near Adderbury in December 1890 and a single bird was observed near Somerton in February 1937.

Pink-footed Goose *Anser brachyrhynchus*
Rare winter visitor
Aplin (1889) states that 'on 19 February 1881 in the Sorbrook meadows near Adderbury, I unsuccessfully pursued a flock of sixteen birds, for some hours, without getting a shot, the whole "gaggle" rising in the first instance from a partly flooded meadow at not more than 150 paces.' A single bird was recorded at Somerton in October 1958. In January 1973 a bird belonging to this species was shot from a flock of 100+ unidentified geese flying over the Cherwell Valley. Single birds were observed at Banbury SF on 1 March 1979,

the Mid-Cherwell Valley on 28 December 1985 and 3 February 1986 and at Clattercote Reservoir on 7 March 1993. A flock of 200+ birds was observed flying northwards at Fenny Compton on 7 February 1996. Four birds were observed in the Mid-Cherwell Valley on 7–9 February 2001. Single birds were recorded at Boddington Reservoir on 1 and 5 October 1998, 29 December 2003 and 2 January 2011.

White-fronted Goose *Anser albifrons*
Very occasional winter visitor

The only definite records before 1937 were from North Aston in 1890 and Bloxham in April 1926. In the 1950s and 1960s it was an irregular but not rare visitor in small numbers to the Mid-Cherwell Valley in the winter months. In the 1970s, however, there were only four records, mainly of flying birds. Since 1982 there have been only 41 sightings. Thirty records were of one or two birds, from 11 sites. The other records were of ten flying birds at Radway on 7 February 1996, nine at Somerton on 10 January 1986 and six adults with two juveniles flying and calling at Lighthorne on 7 November 2003. Skeins of 20 were observed at Banbury on 24 December 1990, 25 flying NE at Fenny Compton on 18 January 1996 and 19 there flying SSE on 23 October 2003. The three largest flocks were of 42 birds in the Mid-Cherwell Valley on 29 December 1985, 70 birds flying at Byfield on 19 January 1986 and 95 flying NE at Fenny Compton on 1 February 1999.

Greylag Goose *Anser anser*
Rare resident

Deciding whether the birds were of feral or wild stock has become increasingly difficult over the years. It was not until 1981 that the BOS started recording the species and since then birds have been recorded at 30 sites and in every month of the year. In 2005, at Compton Verney Lake, a pair bred and produced four goslings which was the first confirmed breeding record. Birds now breed there regularly and have also started breeding at Chesterton Pools. On 23 July 2011 the Compton Verney flock had risen to 70 birds consisting of both adults and juveniles. Other recorded large gaggles were of 18 birds at Aynho on 26 January 1991, 19 at Banbury SF on 24 February 1991, 22 at Bicester Quarry on 29 December 1995 and 30 at Kiddington Hall on 19 October 2008.

Snow Goose *Anser caerulescens*
Rare vagrant/escape

Single birds were first recorded in 1989. Since then it has been reported in 11 of the last 21 years from eight sites, 90% of all records from Boddington Reservoir. The 2007/08 WeBS reported that in November 2007 12 birds were present at Blenheim Park Lake, which is just outside our area.

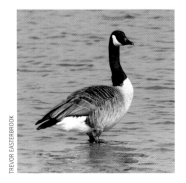

TREVOR EASTERBROOK

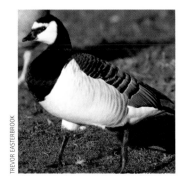

Maximum and average flock size per month 1982–2011 for Canada Goose

Canada Goose *Branta canadensis*
Fairly numerous resident, very widespread
Davies (1967) listed the Canada Goose as an *uncommon visitor* reporting that a bird was shot near Banbury in the 1880s. One was seen near Somerton in March 1917, two there in February 1958 and two others near Kings Sutton in October 1959. By 1970 numbers and sightings were beginning to rise and since the 1980s their numbers have increased dramatically. They have been recorded at waters of many sizes, from quite small pools to large reservoirs, and in over 20% of the 1km squares of the BOS area. Breeding was not confirmed until 1973. During the last 20 years birds have bred on almost every suitable water, particularly those with islands. The large flocks that occur during August to early October consist of post-breeding birds (see chart). The largest recorded flocks have been of 400 birds at Chesterton on 6 September 1987, 450 at Caversfield on 21 October 2006 and 480 at Boddington Reservoir on 14 September 1997. According to farmers, these large flocks are causing problems due to their crop-grazing activities.

Barnacle Goose *Branta leucopsis*
Very occasional winter visitor
Our first record was six birds present in the Cherwell Valley from 28 January to 28 February 1978, but since 1982 birds have been recorded in almost every year. Most records have been of one or two birds, and frequently seen associating with Canada Geese. They have been recorded at 28 different sites with the majority of records coming from Boddington Reservoir. Largest numbers recorded were: five at Fawsley on 23 September 1998, five at Boddington Reservoir on 30 September, 1 October, 1 and 2 December 1998, five at Bicester Quarry on 29 December 1995, six at Edgcote on 19 February and 11 March 1989 and 18 at Boddington Reservoir on 17–19 September 2006. These birds could be either escapees from wildfowl collections or part of the national naturalised population which has been increasing over the years.

Brent Goose *Branta bernicla*
Rare winter visitor
Birds were first recorded at Warkworth in 1871 and at Banbury in 1891. The next recorded sightings were of eight birds at Grimsbury Reservoir on 22 January 1987 and a single bird there on 3 December 1988. Two birds were seen in the Mid-Cherwell Valley on 14 and 22 February 1988 and one there on 1 January 1995. A single bird at BAD Kineton on 24 February 1995 and two at Bicester Quarry on 8 February 1997 were the last sightings.

Egyptian Goose *Alopochen aegyptiaca*
Rare casual visitor/escape

A bird was shot at Shelswell Park in 1822 and another at Rollright in 1914, both of which had probably escaped from captivity. The next sightings were of single birds at Boddington Reservoir on 16 March 1993 and Radbourn Lakes on 15 May 1993. Two birds were seen at Hodnell Pool on 24 January 2009 and five at Boddington Reservoir on 18 October the same year.

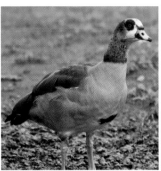

Ducks

Mallard and Tufted Duck are our only regular breeding species and are often supplemented by extra birds in the winter. Teal and Pochard have bred only once or twice since 1953 and mainly now occur as winter visitors. Gadwall and Mandarin Duck on the other hand have begun to breed here in recent years. All other ducks are winter visitors, passage migrants or vagrants. Diving ducks are usually seen on the canal reservoirs and larger lakes of the area. They will, together with the surface-feeding ducks, visit the flood waters of the Cherwell Valley, particularly when floods are extensive. The BOS area now contains many more waters than in 1961 due to the building of ponds and small lakes on many farms and estates throughout the area. In consequence, many species are being recorded on more waters than in the past but the large flocks still mainly occur at Boddington Reservoir, Bicester Wetland Reserve and Fawsley, or on flood water in the Cherwell Valley. The table shows the maximum recorded flocks for a number of duck species during the ten-year periods since 1961.

Species	1962–1971	1972–1981	1982–1991		1992–2001		2002–2011	
	Max	Max	Max	Median	Max	Median	Max	Median
Wigeon	500	300	580	20	600	64	1,000	63
Gadwall	2	16	20	3	56	6	32	10
Teal	400	325	346	20	400	26	450	37
Mallard	460	400	342	71	400	64	500	63
Pintail	37	13	48	3	53	6	74	4
Shoveler	20	14	11	3	81	6	24	5
Pochard	200	130	180	22	290	20	70	5
Tufted	60	84	101	18	165	23	135	14
Goldeneye	2	4	15	2	15	2	3	1
Goosander	3	6	6	2	8	6	63	8

Maximum flocks of certain duck species recorded in the BOS area since 1961

Ruddy Shelduck *Tadorna ferruginea*
Rare casual visitor

The species was first recorded at Somerton from 16 to 30 August 1968. The only records are in 1982 a pair reported at Boddington Reservoir on 27 March, two at Chapel Ascote on 6 April and three birds at Fawsley on 10 April. One bird was seen at Boddington

Reservoir on 8 September 1989, three birds at Hodnell Pool on 24 January and two there on 22 February 2009.

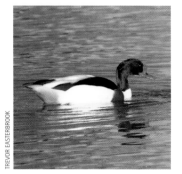

Shelduck *Tadorna tadorna*
Fairly frequent regular visitor with restricted distribution
The species has occurred every year, usually between January and April, and again from mid-August. The majority of sightings come from Boddington Reservoir with several records from Grimsbury Reservoir, Balscote Quarry and on flood water in the Cherwell Valley. Single occurrences have been reported on 17 of the larger waters throughout the period 1982–2011. The largest numbers seen together were 30 birds at Chesterton Pools on 28 February 1991, ten birds at BAD Kineton on 18 May 1993 and ten birds at Boddington Reservoir on 19–21 September 1994.

Mandarin Duck *Aix galericulata*
Rare resident with restricted areas
Mandarin is a shy and secretive species favouring secluded and undisturbed waters in mature open, deciduous woodland. They are hole-nesters favouring Oak and Ash trees. The species was first recorded in 1982 at Astrop Park and was thought to be the offspring of a pair of captive birds which successfully bred in 1980. Birds continued to be recorded there and in the Cherwell Valley, Brackley, Helmdon, Thenford and Kiddington during 1982–85, 1987, 1989, 1993 and 1994 with all records in this period occurring between January and May. From 2002 until 2010, birds were regularly recorded from Ditchley and occasionally from Compton Verney Lakes, Edgcote Park, Fawsley Park, Kiddington, Radbourn Lakes, Spelsbury (Dean Common), Swerford Park, Grimsbury Reservoir and Wormleighton Reservoir. Sightings in this period were between January and May and from September to December. On 9 May 2010 a pair with six very young ducklings was recorded at Kiddington Lake. This is the first recorded evidence of Mandarin Duck breeding in the BOS area.

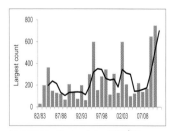

Largest count per winter 1982/83–2010/11 for Wigeon

Wigeon *Anas penelope*
Very frequent winter visitor with local distribution
The species usually arrives in late September/early October and remains in the area until late March/early April. The biggest numbers usually occur on flood water in the Cherwell Valley with the largest flock of 800 birds recorded there on 16 January 2011. From the chart it can be seen that very large flocks are sometimes recorded. Flocks of 100+ birds have occurred in past decades at Boddington and Grimsbury Reservoirs but have not done so for many years, although in recent times flocks of a comparable size have regularly been seen at Hodnell Pool. Wigeon have also occurred in small numbers on 78 of the BOS waters over the last 30 years.

Gadwall *Anas strepera*
Frequent winter visitor and rare resident with local distribution

The Gadwall was first recorded in the BOS area in 1963 and is now a regular sight. The chart shows that the overlying trend is increasing with it being recorded on more waters each decade. Breeding was suspected at two sites in the early 1990s and was finally confirmed in 1994, though it is still a rare breeder in the area. Middleton Stoney Park and Boddington Reservoir, together with flood water in the Cherwell Valley, were the commonest waters on which to find Gadwall in the 1980s and 1990s. Since then both Kiddington and Bicester Wetland Reserve have regular flocks. The four largest recorded flocks were of 56 birds at Middleton Park on 5 February 2000, 49 at Boddington Reservoir on 13 October 1998, 32 on flood water in the Mid-Cherwell Valley on 16 January 2008 and 28 at Bicester Wetland Reserve on 23 February 2008.

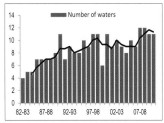

Waters per winter 1982–2011 for Gadwall

Teal *Anas crecca*
Very frequent winter visitor with widespread distribution

Aplin (1889) states that 'Teal is best known as a winter visitor but of late it has remained to breed in 3 or 4 instances ... in 1884 and in 1885 young broods of Teal were seen in August at Clattercote Reservoir.' Davies (1967) reported that a family party was seen at Boddington Reservoir in July 1959 but, since that time, no evidence of breeding has been obtained and the species remains solely a winter visitor. Brownett (1974) reported that the species was recorded on 22 waters and large flocks were observed fairly frequently in the Cherwell Valley from November to March, with a maximum of 400+ at Somerton on 1 March 1970. During the period 1972–81 birds were recorded in every month of the year with the winter influx starting in mid-August and most birds leaving by the end of April. From 1982 onwards Boddington Reservoir, Mid-Cherwell Valley, Bicester Wetland Reserve and Wormleighton

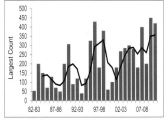

Largest count per winter 1982–2011 for Teal

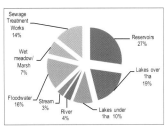

Habitats used by Teal

Reservoir have been the main waters where large flocks regularly occur. The highest recorded counts were of 450 birds on flood water in the Mid-Cherwell Valley on 21 February 2010, 400 at Boddington Reservoir on 29 November 1996 and 400 at Bicester Wetland Reserve on 31 December 2009. The chart gives the maximum count per winter period from 1982 to 2011 and shows that the species exhibits fluctuations. These variations may arise as a result of cold weather movements, combined with the species' susceptibility to variations in water levels, which may alter the attractiveness of sites.

Green-winged Teal *Anas carolinensis*
Rare vagrant
A single male was seen displaying at Boddington Reservoir on 25 January 2002.

Mallard *Anas platyrhynchos*
Numerous resident with extensive distribution
Large flocks build up from early August through until March and are supplemented by birds from other areas, particularly in midwinter. Breeding occurs wherever there is suitable habitat. Random Square Surveys show that the species has been recorded in 40% of the 1km squares in the BOS area. Over the period 1975–2010 the distribution index shows that the species has remained fairly constant but the abundance index fluctuates widely. This may be due to weather conditions on the day of survey or to sampling variation.

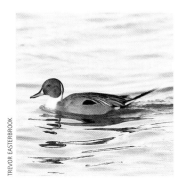

Pintail *Anas acuta*
Fairly frequent winter visitor with restricted distribution
The first recorded sighting of the species in the Banbury area was in January 1939 when three drakes were observed at Somerton. It can be seen from the chart that the majority of sightings occur during

Decade	1962–1971	1972–1981	1982–1991	1992–2001	2002–2011
Waters	3	9	6	11	16
Max flock	20	37	13	48	74

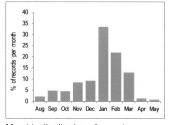

Monthly distribution of records 1982–2011 for Pintail

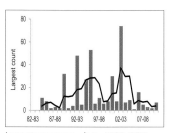

Largest count per winter 1982–2011 for Pintail

January and February. Most of the records occur on flood water in the Cherwell Valley. Boddington Reservoir and, more recently, Bicester Wetland Reserve are also now regularly visited. The largest recorded flock was of 70+ birds in the Mid-Cherwell Valley at Souldern Wharf on 25 and 26 January 2003.

Garganey *Anas querquedula*
Very occasional passage migrant

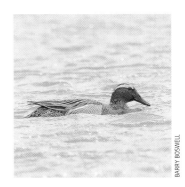

This small duck is a passage migrant wintering in Africa. The first recorded sightings occurred in 1877 near Banbury and at Boddington Reservoir in 1882. The table shows the number of records per decade. The species occurs mainly in the spring, from late March to end of May. There have only been two sightings during the autumn migration, two birds at Boddington Reservoir from 27 July until 9 August 1980 and one at Upper Heyford on 15 July 1989. The most recent records were of a pair in amongst a flock of Teal at Knightcote on 20 March 2003, one bird at Wormleighton Reservoir on 7 April 2009 and two males and a female at Balscote Quarry on 29 April 2010. Half of all sightings have been recorded at the three main reservoirs, Boddington, Clattercote and Wormleighton, with the rest occurring on seven other waters.

Decade	Pre–1952	1952–1961	1962–1971	1972–1981	1982–1991	1992–2001	2002–2011
Records	3	4	6	6	5	4	3

Shoveler *Anas clypeata*
Frequent winter visitor with local distribution

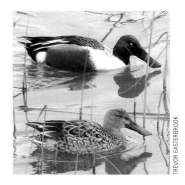

The earliest records for the area were of a drake near Aynho in 1865, a female there in 1881, an immature at Clattercote Reservoir in October 1885 and a drake at Wroxton in December 1900. The species was a regular visitor in small numbers in the 1960s and in the period 1962–71 was recorded on 12 waters, the largest flock being of 20 birds. During the next ten years the species was recorded on 20 waters and on 23 waters between 1982 and 1994. Since 1994 it has been recorded on 35 waters and has continued to flourish as a winter visitor. All the largest counts occurred at Boddington Reservoir during 1998: 53 birds on 13 October, 81 on 28 October and 44 on 1 November. Most sightings in recent years have occurred at Boddington Reservoir, Bicester Wetland Reserve and on flood water in the Mid-Cherwell Valley.

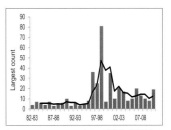

Largest count per winter 1982–2011 for Shoveler

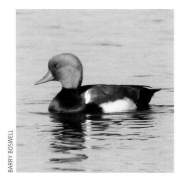

BARRY BOSWELL

Red-crested Pochard *Netta rufina*
Very occasional winter visitor

A male bird was recorded for the first time in the Banbury area at Boddington Reservoir on 24 August 1969. A female was recorded at Fawsley on 13 October 1973 and an immature was present at Wormleighton Reservoir on 28 October. In September 1975 a pair with a juvenile was recorded at Grimsbury Reservoir. The next sightings were at Poolfields on 27 and 28 August 1990 and Boddington Reservoir on 5 and 6 January 1993. A male was seen at Boddington Reservoir on 4 and 5 December 2002. Single birds were present at Farnborough Pool from 26 October until 2 November 2007 and at Byfield Pool on 5 January 2008. The latest sightings were of a single bird at Farnborough on 28 March 2011 and a pair in eclipse plumage was present at Fawsley Park on 4 August 2011.

Pochard *Aythya ferina*
Frequent winter visitor with widespread distribution

The species has been recorded in every month of the year. Breeding occurred during the period 1961–72 at Chesterton (Warks) where up to five pairs produced broods. The only other breeding record was in 1994 at Wormleighton Reservoir where a pair produced two young. Wintering bird numbers usually build up from late September/early October and birds leave in late March. They can be found on any reservoir or larger lake and on flood water. During the period 1971–98 flock sizes fluctuated but large flocks of 100+ birds were not uncommon. Since 1998, however, as illustrated on the chart, the size of the flocks has dropped substantially and now only small and, occasionally, medium flocks are seen.

Largest count per winter 1982–2011 for Pochard

Ferruginous Duck *Aythya nyroca*
Very occasional casual visitor

The first record was of a male bird at Wormleighton Reservoir in December 1978. Between 1980 and 1989 single birds were recorded at Clattercote Reservoir, Farnborough Park, Grimsbury Reservoir, Horley, Temple Pool and Upton House. The last sighting was at Balscote Quarry on 5 July 1992.

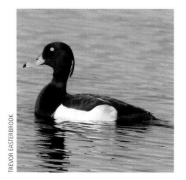

TREVOR EASTERBROOK

Tufted Duck *Aythya fuligula*
Not scarce resident and frequent winter visitor with widespread distribution

There was evidence of breeding at Middleton Stoney between 1922 and 1937 and then no breeding records until 1964. In 1966 breeding was recorded at Astrop Park. In the 1974 ABSS a total of 11 pairs were located at eight waters and in the repeat survey of 1999, 20 pairs were found at 14 waters. The species is a late breeder and broods are not always seen until after mid-July; summering birds at some sites may well be non-breeders. In the period 1983–92 birds were recorded on 143 waters and in 1993–2009 on 182 waters.

Residents are supplemented by large influxes of wintering birds that begin to arrive from late August. In the past all the reservoirs and larger lakes have held substantial flocks but during the last ten years only Boddington Reservoir and Hodnell Pool have attracted the biggest numbers. The three largest flocks were of 165 birds at Boddington Reservoir on 28 January 1998, 150 there on 15 February 1998 and 135 birds at Hodnell Pool on 24 December 2007. Chesterton Pools, Radbourn Lakes and Wormleighton Reservoir have occasionally held flocks of 100+ birds. The chart shows the fluctuation in maximum flock recorded but that the overall trend remained upward until 2008.

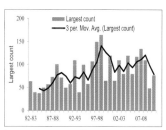

Largest count per winter 1982–2011 for Tufted Duck

Scaup *Aythya marila*
Very occasional winter visitor
A female was recorded at Grimsbury Reservoir in 1966, which was the first record since 1935. All subsequent sightings were of one or two birds seen between late October and mid-April. They were observed at Boddington Reservoir in 1998 and 2006, on floodwater in the Cherwell Valley in 1994 and 1995, at Croughton Quarry in 1996 and 1997, at Middleton Stoney in 1996 and 1997, and at Hodnell Pool in 2007.

Lesser Scaup *Aythya affinis*
Rare vagrant
A single bird was present at Farnborough Lake from 27 February until 1 March 2005. This was the first and only sighting in the BOS of this vagrant North American species, which is now being seen more regularly in Britain.

Eider *Somateria mollissima*
Rare vagrant
The first record was of a single male at Boddington Reservoir on 1 and 2 November 1993. An immature bird appeared at Croughton Quarry on 13 November 1998 and remained there for the winter, leaving on 14 March 1999.

Long-tailed Duck *Clangula hyemalis*
The only records were of a female bird at Clattercote Reservoir from 12 to 19 November 1967 and a female at Wormleighton Reservoir on 25 March 1968.

Sightings per year 1966–2011 for
Common Scoter

Common Scoter *Melanitta nigra*
Very occasional casual visitor
Four males and a female were recorded at Grimsbury Reservoir on
13 September 1966, which was the first record since one was shot
at Broughton Castle in October 1890. The species was then recorded
once in each of the next four years. In the 1970s birds were recorded
on six occasions from 1975 to 1981 at the reservoirs of Boddington,
Clattercote and Grimsbury. The chart shows the irregularity of
occurrences. Only 25% of the records have occurred in the spring,
usually from late March to mid-April and the rest were recorded
between late July and mid-November. The maximum flock recorded
was of 17 birds at Boddington Reservoir on 10 March 2000.

Goldeneye *Bucephala clangula*
Frequent winter visitor with local distribution
The earliest records were of birds at the canal reservoirs and at
Cropredy in 1897. Since 1970 birds have been recorded in the area
at least once during each winter and usually from late September
until mid-March. The majority of sightings have come from the
four canal reservoirs but it has also been recorded on 20 other
waters. The average number per sighting is 1–2 birds though the
two largest flocks recorded are of 22 birds at Boddington Reservoir
on 7 December 1991 and 15 there on 28 February 1993.

Waters per winter 1981/82–2010/11 for
Goldeneye

Smew *Mergellus albellus*
Rare winter visitor
Since 1958 the only records were a male at Boddington Reservoir
on 7 and 8 February 1976, a female at Wormleighton Reservoir on
21 February in the same year, a female bird recorded at Bicester
on 25 January 1987, three birds at Grimsbury Reservoir on 24
November 1988, a single female at Boddington Reservoir on 19 and
20 December 1997 and another on 6 December 1998. Since that
time there have been no further sightings recorded.

TREVOR EASTERBROOK

Red-breasted Merganser *Mergus serrator*
Very occasional winter visitor with restricted distribution
The first sighting since 1882 was recorded on the Oxford–Birmingham
Canal at Tackley on 26 December 1972. Other records were of two
males and two females at Boddington Reservoir on 16 February
1979, a male observed at Grimsbury Reservoir on 3 and 4 March
1979 and a single bird recorded at Edgcote Park on 11 September
1989. Individual birds were recorded at Boddington Reservoir on
15 September and 15 November 1989 and 10 November 1990
with an immature bird on 4–6 December 1991. Three males were
present at Fawsley Park on 10 December 1994. There were no more

records then until 2007 when one bird was recorded at Chesterton Pools on 7 January and two birds at Boddington Reservoir on 27 December. The WeBS survey report of 2007/08 notes that there has been a decline in this species over the last 12 years, probably associated with climatic change. Our lack of records may therefore be explained by the greater proportion of the population now being able to winter in sites further north in Europe.

Goosander *Mergus merganser*
Fairly frequent winter visitor with local distribution
Since the winter of 1980/81, the species has been recorded in each winter period, with 56% of all sightings occurring at Boddington Reservoir, though it has also been recorded at 30 other waters. Most sightings occur between December and March with January being the most common month. The maximum recorded flocks at Boddington Reservoir were of 63 birds on 6 January 2011, 35 on 14 December 2010 and 29 on 1 February 2007, and 28 birds were regularly observed there during late December 2008 and again in mid-February 2009. Twenty-nine birds were seen at Radbourn Lakes on 5 November 2005. The charts show the overall trend in both flock size and in number of waters visited to be increasing.

TREVOR EASTERBROOK

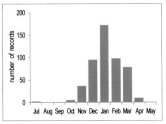

Largest counts and numbers of waters per winter 1982–2011 for Goosander

Monthly distribution of records 1982–2011 for Goosander

Ruddy Duck *Oxyura jamaicensis*
Rare casual visitor
The species was first recorded at Fawsley Park in April 1980 and successful breeding occurred. Later that year birds were seen at Boddington Reservoir. From then on the species increased dramatically until 1991 but since then it has gradually declined. Throughout the period 1980–2008 it was recorded on 28 waters with breeding confirmed at Brackley, Fawsley, Radbourn Lakes and Stoneton Pool. In 2003, the Government decided to proceed with an eradication programme as part of a package of measures to help safeguard the White-headed Duck. A five-year eradication project began in 2005, managed by the Food and Environmental Research Agency, which by March 2008 had reduced the UK's population of Ruddy Duck to 400–500 birds. The chart shows how the number of waters visited per year has declined rapidly since 2003 and that there have been no records since 2007.

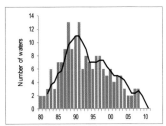

Waters per year 1980–2011 for Ruddy Duck

Gamebirds *Galliformes*

Black Grouse *Tetrao tetrix*
There have been no records since 1880 when one was shot near Tackley.

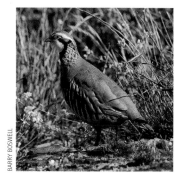

Red-legged Partridge *Alectoris rufa*
Not scarce resident
As many of the shooting estates and syndicates release birds each year, it is very difficult to ascertain how many are truly wild. The chart shows the indices of distribution and abundance in both the WRSS and SRSS. The distribution has not declined over the period whereas the abundance fluctuates dramatically. There are counts of 80 or 100 but these are probably released birds.

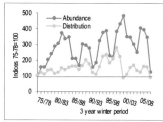

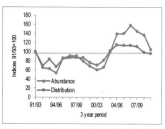

Indices for Red-legged Partridge in WRSS

Indices for Red-legged Partridge in SRSS

Grey Partridge *Perdix perdix*
Scarce resident
Davies (1967) reported that Partridge was a common resident on open arable and grass lands and seemed to be able to maintain its numbers without protection. By the late 1980s the species was becoming a cause for concern as can be seen from the charts, which show that population levels have decreased by 90% compared with the 1975–78 figures. Harsh winters and wet summers knocked the species back. Success in developing chicks into adults has been a problem as there has been a lack of the insect food which is essential for their development. This may well be due to the intensification of agriculture and to increased use of pesticides together with the fact that predators are not being as well controlled as in

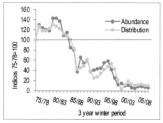

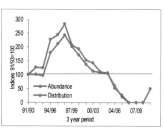

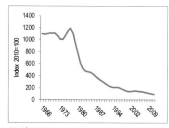

Indices for Grey Partridge in WRSS

Indices for Grey Partridge in SRSS

CBC/BBS index for Grey Partridge

years gone by. The largest covey recorded in the last five years was
25 birds at Oxhill on 6 January 2008.

Quail *Coturnix coturnix*
Scarce summer visitor

The Quail is the only British migratory gamebird. Rarely seen but
usually recognised by its distinctive call, a main feature of Quail
ecology is a large influx of birds every few years. Aplin (1889)
noted that its appearance was irregular and that in certain years a
considerable immigration of Quail takes place. In Britain, 1870 and
1885 were considered to be very good Quail years and the next
large influx years were not until 1947 and 1953. The table shows
our good Quail years (15 or more calling males) since the formation
of the BOS which, not surprisingly, correspond to good Quail years
nationally. Birds are usually found in cereal crops, hay fields or
areas with long grass. They generally arrive mid-May (earliest
record was 27 April 1998) and leave by the end of September (latest
date 1 October 1992). Birds can be found almost anywhere in the
BOS area where there is suitable habitat, particularly in fields of
barley. They have been recorded in 103 1km squares which represent
8% of the BOS area. The chart illustrates the variability of the
number of calling males per year.

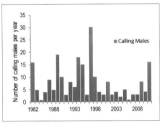

Calling males per year for Quail

Year	1964	1982	1989	1994	1995	1997	2011
Calling males	42	16	19	18	15	30	16

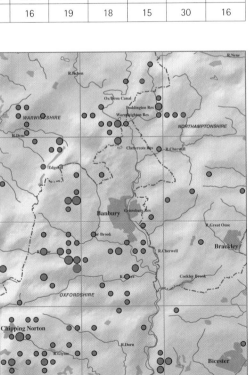

Sites in 1982–2011
for Quail

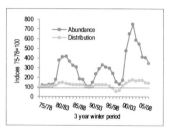

Indices for Pheasant in WRSS

Pheasant *Phasianus colchicus*
Abundant resident

Large numbers of birds are released annually and consequently their numbers can fluctuate widely in areas which are close to shooting estates or farms on which Pheasants are bred. Birds were recorded in 51% of all the squares covered in the WRSS and 38% in the SRSS. The chart clearly illustrates that Pheasant numbers grew dramatically from 2000 to 2005 and have now fallen although the current abundance index is still four times that of the 1975/77 index. High Pheasant densities potentially have negative consequences for native UK bird populations, which include their effect on the structure of the field layer, the spread of disease and parasites, and competition for food (Fuller *et al.* 2005). Infection with caecal nematodes from farm-reared Pheasants may be contributing to the decline of the Grey Partridge in Britain (Tompkins *et al.* 2000). On Pheasant farms, birds are continually fed until February, which means that, in addition to the Pheasants themselves, food is provided not only for other birds but also predators like rats. When feeding stops all these birds and predators have to find food in the 'hungry gap' period from February to April until more natural food becomes available.

Divers *Gaviiformes*

Red-throated Diver *Gavia stellata*
Rare winter visitor

Shot specimens were obtained from near Banbury in 1890, North Aston in 1891 and in Chipping Norton in 1904. In recent times single birds were present at Grimsbury Reservoir on 22 and 23 February 1976 and at Boddington Reservoir on 30 December 1988 and 25 January to 2 February 1991.

Black-throated Diver *Gavia arctica*
Rare winter visitor

Single birds were killed at Clattercote Reservoir in 1849, at Fenny Compton in 1877 and near Banbury in the same year. One was picked up alive at Bloxham in January 1905. Single birds were recorded at Grimsbury Reservoir from 27 November to 3 December 1991 and again on 9 December 2009.

Great Northern Diver *Gavia immer*
Rare winter visitor

A bird was shot at North Aston Mill in 1864 and another at Wroxton Abbey pond sometime before 1882. The only other record was of a bird observed at Fawsley Park on 21 January 1964.

Petrels and Shearwaters *Procellariiformes*

Fulmar *Fulmarus glacialis*
Rare vagrant

After being blown off course by storms a bird was found exhausted at Avon Dassett on 4 January 1981. The only other record was in 1922.

Manx Shearwater *Puffinus puffinus*
Rare vagrant

Birds are usually storm-driven vagrants, often found dead, dying or exhausted, and were recorded eight times between 1839 and 1924. Single birds were found stranded between Brackley and Helmdon after gales on 11 September 1970, at Radway on 9 September 1980, at Priors Marston on 7 September 1985 and Moreton Morrell on 4 September 1992. All but one of the 12 records has occurred in September following autumnal gales.

Storm Petrel *Hydrobates pelagicus*

The only definite records are from Chipping Norton in November 1846, Wormleighton Reservoir in August 1885 and Banbury in 1889 and 1926.

Leach's Petrel *Oceanodroma leucorhoa*
Rare vagrant

All records have occurred between October and December. Birds were recorded at Chipping Norton in 1831, Lower Heyford in 1881, Bodicote in 1901, North Newington in 1938 and Banbury in 1891 and 1952. Most of these early records were of birds found dead or exhausted. The last sightings were of single birds seen flying at Boddington Reservoir on 1 October 1978 and 23 December 1989.

Pelicans and relatives *Pelecaniformes*

Gannet *Morus bassanus*
Rare vagrant

Birds usually occur after winter storms and are found injured, exhausted or dead. The earlier records were from Banbury in 1845, 1877 and 1904, Tadmarton in November 1889 and Great Rollright in 1917. In May 1957 an adult bird was found exhausted at Alkerton, was cared for by RSPCA and eventually released on the south coast. The last record was of an immature bird found exhausted at Croughton on 14 September 1983.

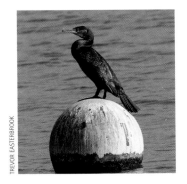

TREVOR EASTERBROOK

Cormorant *Phalacrocorax carbo*
Frequent regular visitor

Aplin (1889) commented that the species was a rare occasional wanderer from the coast. The first record was a bird shot at Clattercote Reservoir on 7 November 1879. One or two birds were recorded during most winters in the 1950s and 1960s; in the 1970s and 1980s there were more sightings per year. From 1990 onwards records increased annually with birds not only being seen at the reservoirs but also recorded on most lakes and rivers of our area. The chart shows the extent to which numbers have increased and the maps indicate how they have spread across the area. The largest numbers seen together were 36 birds at Croughton Quarry on 6 January 2007, 31 at Grimsbury Reservoir on 12 December 2009, 26 at Boddington Reservoir on 31 August 1996 and 23 at Balscote Quarry on 27 September 1999.

1km squares per year 1982–2011 for Cormorant

Shag *Phalacrocorax aristotelis*
Rare casual visitor

The first record was of a bird which was shot at Souldern in December 1890. There were 11 records up to 1963. A bird was at Somerton Deep Lock from 29 December 1974 until 2 January 1975. Dead birds were found at Chesterton (Warks) on 18 September 1980 and at Worton on 8 May 1980; one bird was found alive in a garden at Great Tew on 28 January 1984. The most recent sightings were of single birds at Boddington Reservoir on 4 February 1990, 9 November 1991 and 13 October 1998.

Herons, Storks and relatives *Ciconiiformes*

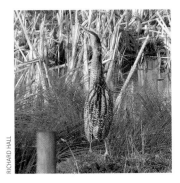

RICHARD HALL

Bittern *Botaurus stellaris*
Rare casual visitor

With one exception, all records have occurred during the winter months of January to March. Individual birds were recorded on ten occasions from 1847 to 1933. A pair was seen and heard at Bloxham during April and May 1907 and is the only record in the breeding season. Single birds were recorded at Chesterton (Warks) in 1966, Heyford and North Aston in 1968, Trafford Bridge in 1974 and Evenley in 1987. The latest sighting was of a bird which was seen clearly at Bicester Wetland Reserve on 26 February 2010 (as shown photographed on the day by Richard Hall).

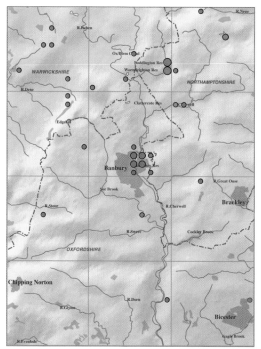

Sightings in 1980s for Cormorant

Sightings in 1990s for Cormorant

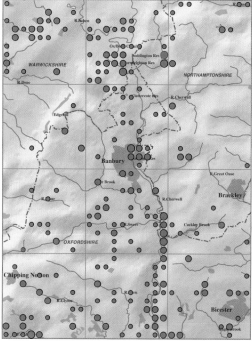

Sightings in 2000s for Cormorant

Little Bittern *Ixobrychus minutus*

A bird was recorded at Somerton in June 1909 which was the last and only record.

Night Heron *Nycticorax nycticorax*

The only definite record was of one shot at Deddington in September 1934.

Little Egret *Egretta garzetta*

Occasional regular visitor

Birds first appeared in Britain in 1989 following their steady movement northwards from the south of Europe. They first bred in Dorset in 1996 and are now breeding in large numbers throughout England. The first record in the BOS area was at Boddington Reservoir on 3 September 1994, but it was not until eight years later that there was another sighting. Birds have now been recorded in every month of the year and from 27 different sites, such that the Little Egret is designated a *regular visitor*. The normal sighting is of single birds but four were recorded at Nell Bridge on 8 May 2007.

Year	2002	2003	2004	2005	2006	2007	2008	2009	2010	2011
Records	8	3	6	6	7	9	11	16	14	17
1km squares	4	3	5	5	5	6	5	8	4	7

Great White Egret *Ardea alba*

Rare vagrant

This became a new species for the BOS when a single bird was seen roosting at Wormleighton Reservoir on 8 October 2009. On the following days it was seen around the reservoir and feeding in the surrounding fields. It later appeared at Boddington Reservoir on 20 and 21 October and returned to Wormleighton Reservoir on 1 November, remaining until 19 December. The next sightings were again at Wormleighton on 19 January 2010 and then at Lighthorne Quarry on 25 February. At this particular period, five or six birds were being reported across the country.

Grey Heron *Ardea cinerea*

Not scarce resident

The only resident of this group, the number of recorded 1km squares as shown in the chart suggests that the species has remained fairly constant since 1995. By 1997 the heronry at Great Tew had ceased to exist but many smaller heronries of up to nine nests started to appear across the area. Some of these lasted for just two or three breeding seasons and others for longer. Heronries were recorded at Astrop, Broughton, Chesterton (Warks), Edgcote Park, Grimsbury, Kiddington, Lighthorne, Middle Aston, North Aston, Swerford,

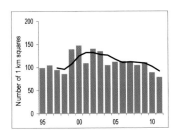

1km squares per year 1996–2011 for Grey Heron

Steeple Barton, Tusmore and Wigginton. The largest counts of birds in the same area were of 35 birds at Astrop on 27 April 2000, 26 at Nell Bridge on 6 August 2001 and 17 birds at Bicester Wetland Reserve on 30 December 2006.

Purple Heron *Ardea purpurea*
Rare vagrant
One was shot near Aynho in May 1928. Adult birds were recorded at Wormleighton Reservoir on 18 April 1970 and at Wroxton on 24 May 1971. An immature bird was seen in the Mid-Cherwell Valley on 9 August 1976 and an adult recorded at Bicester on 5 July 1979. The last sightings were of adult birds at Boddington Reservoir on 12 April 1984 and Banbury SF on 16 April 1992.

White Stork *Ciconia ciconia*
Rare vagrant
A single bird seen in the Mid-Cherwell Valley on 9 June 2002 is the only record.

Spoonbill *Platalea leucorodia*
Rare vagrant
The first record was of eight birds at Boddington Reservoir on 14 November 1984 and the only other sighting was of a single bird, again at Boddington Reservoir, on 14 October 2003.

Grebes *Podicipediformes*

Little Grebe and Great Crested Grebe are the only residents in the BOS area whereas all other Grebe species are winter visitors.

Little Grebe *Tachybaptus ruficollis*
Fairly numerous resident with widespread distribution
The ABSS surveys of 1967 and 1993 showed a slight increase in the density of pairs per 100 sq. km over the 26 years from 3.0 to 3.9. Since the early 1990s many new ponds and small lakes have been dug out and become established, and the species has exploited them. It is therefore not possible to easily compare its distribution with previous years. Little Grebe has also been recorded along many stretches of the rivers of the BOS area so, for comparison year on year, the number of 1km squares has been used as the unit of measure instead of the number of waters. Since 1982 the species has been recorded in 198 1km squares. The chart showing the number of recorded squares per year since 1982 suggests a slight downward trend, both over the whole year and in the breeding season. The very low figure in 2001 during the breeding season can

TREVOR EASTERBROOK

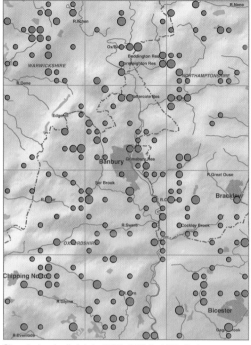

Sites during April–July in 1982–2011 for Little Grebe

Sites during November–February in 1982–2011 for Little Grebe

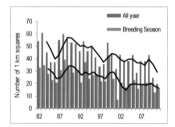

1km squares per year 1982–2011 for Little Grebe

be largely be accounted for by the foot-and-mouth outbreak when access to the majority of sites was prohibited. Little Grebe needs waters with a range of depths and fringing vegetation to conceal a nest. As long as new waters provide these requirements, and are not stocked with carp, their status should remain constant. Hard winter weather is likely to be the major factor influencing numbers and distribution. The largest numbers recorded on any water were of post-breeding groups during August and early September and wintering birds during December to February namely: 20 adults and juveniles recorded at Ardley Fields Quarry on 7 September 2008, 20 at Stoneton Manor on 8 August 1998 and 22 at Middleton Stoney Park on 13 August 1995. The largest group was of 26 birds on a small reservoir at Bodicote on 26 December 2009.

Great Crested Grebe *Podiceps cristatus*
Not scarce resident with local distribution
Birds are generally present all the year round at our four main reservoirs (Boddington, Clattercote, Grimsbury and Wormleighton) and at several of our larger lakes, only moving out in very hard winters when waters are frozen. It is not unusual to see birds on flood water, particularly in the Cherwell Valley. Breeding is predominately confined to the canal feeder reservoirs of Boddington, Clattercote and Wormleighton and a few of the larger lakes. One or two pairs have, however, occasionally been recorded breeding on 50 smaller lakes. From the chart it can be seen that the trend since

2005, for both the breeding season and throughout the year, is slightly decreasing. The largest numbers of birds seen together were all at Boddington Reservoir: 40 on 10 October 1983, 38 on 24 December 2004 and 37 on 5 November 2005. The dip in numbers during the 1990s may be attributed to the maintenance and restructuring work which was being carried out on the reservoir as well as to several years of low rainfall.

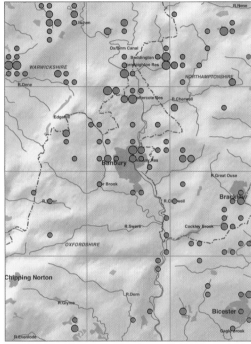

1km squares per year 1982–2011 for Great Crested Grebe

Sites in 1982–2011 for Great Crested Grebe

Red-necked Grebe *Podiceps grisegena*
Rare winter visitor/passage migrant
The first record in the area occurred in 1968 at Grimsbury Reservoir. Subsequent sightings were of up to three birds there during February and March 1979 and a single bird from 8 to 11 February 2001. Single birds were also recorded at Boddington Reservoir on 23 April 1994 and 14 September 1999 and on the river in the Cherwell Valley on 12 September 2000.

Slavonian Grebe *Podiceps auritus*
Rare winter visitor
Single birds were shot at Hook Norton in 1890, Broughton in 1895 and Wroxton in 1912. A single bird was at Boddington Reservoir on 2 to 3 February 1970 and at Wormleighton Reservoir on 1 December 1985. These remain the only sightings in recent times.

TREVOR EASTERBROOK

Black-necked Grebe *Podiceps nigricollis*
Rare winter visitor/passage migrant
One was recorded before 1882 and a pair, which might have bred in the area, was shot near Banbury in September 1899. The first sightings recorded by BOS members were at Chesterton in 1966 and at Boddington Reservoir on 13 November 1977. Two birds in breeding plumage were observed at Fawsley on 17 May 1983. A single bird was seen at Boddington Reservoir on 18 September 1992, two birds were there on 6 August 1994 and from 7 to 16 April 1999. Single birds were also recorded at Ashorne on 29 July 1999 and Boddington Reservoir on 24 July 2000. The most recent sighting was at Grimsbury Reservoir on 16 February 2002.

Vultures, Hawks and Falcons *Accipitriformes*

Honey-buzzard *Pernis apivorus*
Rare passage migrant
The species was recorded in the nineteenth century but the first records for the BOS were in 2000 when flying birds were sighted at Upper Kingston on 29 May, Woodford Halse on 29 September and Moreton Morrell on 1 October. The autumn records corresponded to the large movement of the species across Southern England in that year. Since then single birds have been recorded flying over Boddington on 17 August and Fenny Compton on 25 August 2001, at Newnham on 25 July 2002, Wormleighton on 15 May 2003, and Moreton Morrell on 7 May and 28 June 2004, 9 July 2007 and 31 May 2011. An early sighting was that of a bird being mobbed by Crows as it flew NE at Tysoe on 1 May 2011.

TREVOR EASTERBROOK

Red Kite *Milvus milvus*
Not scarce resident
Before 1830 the Red Kite was not uncommon, breeding in the larger woods. There was no definite record since Beesley (1841) until a single bird was sighted at Greatworth on 26 March 1972. The next sightings were in 1991 which corresponded with the introduction of birds in the Chilterns in 1990 as part of a programme by the RSPB and English Nature to re-establish the species. Its status was then *rare casual visitor*. It took several years before sightings became more regular and breeding in the area was finally confirmed in 2007. This changed its status to *not scarce resident*. By 2011 there were at least seven breeding sites with birds being seen in every month of the year across the whole of the BOS area. Up to 15 birds were often recorded flying around Ardley Fields Quarry in 2009, 2010 and 2011. Twelve birds were seen circling together at Glympton in October 2010 and in 2011 and up to 24

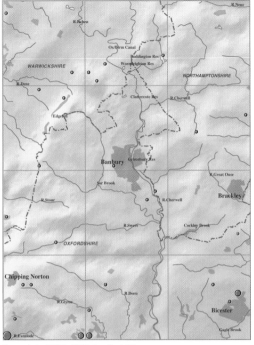

Records in 1992–2001 for Red Kite

Records in 2002–11 for Red Kite

birds gathered at Glympton after a Pheasant shoot on 29 January 2011. The chart shows how the species has increased since 1991. The increase in our records and the change of status reflects the national increase of the species and the maps show the spread from the Chilterns in the SE.

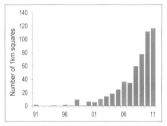

1km squares per year 1991–2011 for Red Kite

Marsh Harrier *Circus aeruginosus*
Very occasional passage migrant
A single adult female was observed at Banbury on 30 April 1993, the first sighting in the BOS area. Since then birds have been recorded in 1996, 1998 and every year from 2000 to 2011, except 2009, and from 15 separate areas, mainly from the NE part of the BOS area. Spring movement has been from March until mid-May with immature birds being recorded hunting in late May, mid-June and early July. The autumn passage is usually from late August to early October.

Month	Mar	Apr	May	Jun	Jul	Aug	Sep	Oct
Sightings	1	3	7	2	1	4	7	1

Hen Harrier *Circus cyaneus*
Very occasional casual visitor

Early in the nineteenth century the species was a winter visitor and not considered to be rare, particularly in the Chipping Norton district. The first definite record since 1895 was at Over Norton on 30 March 1974. Since then there have been 49 sightings from 26 locations, all of single birds, except when a female was joined by an immature bird at Priors Hardwick on 31 October 2004 and both were seen hunting before going to roost. The juvenile remained until 5 November. From the tables it can be seen that Hen Harrier has been recorded in all months of the year. It mainly occurs as a winter visitor from late October until late March/early April or as a passage migrant during late April to early June and again from late July/early August to October.

Month	Jul	Aug	Sep	Oct	Nov	Dec	Jan	Feb	Mar	Apr	May	Jun
Sightings	1	4	4	4	8	8	8	1	2	7	1	1

Year	1974	1975	1979	1980	1984	1986	1993	1996	1997	1998	2000	2002	2003	2004	2005	2008	2010	2011
Sightings	1	1	9	1	4	1	2	1	2	3	1	2	2	7	2	2	2	6

TREVOR EASTERBROOK

Montagu's Harrier *Circus pygargus*
Rare casual visitor

A single male was sighted at Evenley on 17 June 1979 which was the first record for the BOS. The only other records were of a male at Wormleighton on 4 June 2005 and a male bird observed in the Cottisford/Juniper Hill area during the Long Day Count on 5 May 2008. It remained there until 18 May and was seen by many observers.

Goshawk *Accipiter gentilis*
Scarce resident

The first records were in 1990 and of single flying birds at Middleton Cheney on 28 July and Grimsbury on 25 August. Since then birds have been recorded in 1992, 1994 and 1997, and in every year from 2000 to 2009. Two adults and a juvenile were observed at Whichford Wood on 27 August 1994. All other records were of single birds from 12 locations.

Month	Jan	Feb	Mar	Apr	May	Jun	Jul	Aug	Sep	Oct	Nov	Dec
Sightings	3	–	4	4	1	–	2	2	1	–	2	1

Sparrowhawk *Accipiter nisus*
Fairly numerous resident

In 1889 Aplin wrote, 'The Sparrow Hawk is a resident, although not scarce has become very much less common of late years.' In 1967 Davies states, 'it is rather scarce even in those districts where it is not persecuted by gamekeepers.' The use of organo-chlorine pesticides, which were widely used in agriculture during the 1950s and 1960s, caused the near extinction of the species. These pesticides persist in the environment for a long time and accumulate up the food chain. This caused eggshell thinning and chick mortality, problems which particularly affected Sparrowhawk and Peregrine. The Sparrowhawk has made a remarkable recovery since these chemicals were banned, and numbers have been steadily increasing since the 1970s such that by 2007 it was more numerous than at any time since the BOS was formed in 1952. Aplin also comments that in the summer the Sparrowhawk retires to the woods and quiet spinneys to breed, but in winter is more widely diffused, visiting places where small birds abound, such as stockyards and barns. This is basically still true today except that instead of stockyards they now are reported much more regularly from residential gardens, particularly those that have bird feeding stations. The WRSS chart shows the indices for distribution and abundance of Sparrowhawk from 1975 to 2011. As the 1km squares to be surveyed are chosen randomly, fluctuations are to be expected but the overall trend is still upward. The indices have increased considerably since 1975, reinforcing how successful the comeback of the species has been with it being recorded in 17% of all squares surveyed. The ABSS survey of 1981 and the repeat survey of 2007 found that breeding density was 4.3 and 4.0 pairs per 100 sq. km respectively. These figures are probably an underestimate due to the secretive nature of the birds during much of the breeding season but still places the species in the *fairly numerous* category (3–30 pairs per 100 sq. km). The bar chart shows the number of recorded 1km squares per year both in the breeding season and throughout the year. During the breeding season the number of squares has remained fairly constant but there appears to be a slight decline since 2007, which is also shown in the SRSS chart.

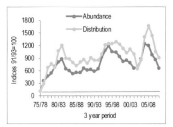

Indices for Sparrowhawk in WRSS

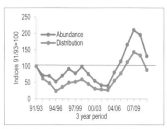

Indices for Sparrowhawk in SRSS

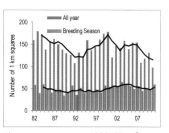

1km squares per year 1982–2011 for Sparrowhawk

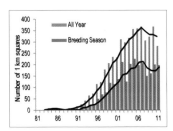

1km squares per year 1981–2011 for Buzzard

Buzzard *Buteo buteo*
Numerous resident

Prior to 1900 the Buzzard was classified as an *occasional casual visitor*. Two birds were recorded at Great Bourton in December 1885 and only four more sightings were recorded before the formation of the BOS in 1952. There were 15 sightings in the next ten years and its status changed to *fairly frequent casual visitor*. By 1972 it had been recorded in 23 parishes and by 1982 records had increased and breeding was suspected, though unconfirmed. It was not until 1992 that breeding was finally confirmed at Ditchley Park and from that point onwards the number of sightings increased year on year, as can be seen from the chart and maps. Far less persecution of the species over the years, as well as more rabbits and carrion being available, are some of the factors which have enabled it to spread eastward across the country.

Rough-legged Buzzard *Buteo lagopus*
Rare casual visitor

Aplin (1889) described the Rough-legged Buzzard as a *rare visitor* and notes that a large female was caught in a trap at Middleton Stoney Park in 1825. The first definite record since then was of a single bird at Charlton which remained from 28 October to 15 November 1962. The only other sighting is of a single bird at Hellidon Tower on 17 April 2009.

Sightings per year for Osprey

Osprey *Pandion haliaetus*
Occasional passage migrant

It was recorded for the first time in the Banbury area on 26 September 1969 at Compton Verney. With natural recolonisation starting in Scotland in 1954, there were 14 pairs in the UK by 1971 and 158 pairs by 2001. Consequently more birds were migrating each year and our records began to increase as well, virtually doubling each decade as shown on the chart. The spring movement is from mid-March until the end of May and the return autumn migration from mid-August until early October. Ospreys have been observed fishing at 12 of our larger waters with Boddington Reservoir having by far the most sightings. There are a few records that occurred in late June and July and could well be of either immature non-breeding birds or of birds which were nesting at Rutland Water. The table shows the monthly distribution of sightings from 1969 to 2011.

Month	Mar	Apr	May	Jun	Jul	Aug	Sep	Oct
Sightings	2	18	7	3	2	8	12	3

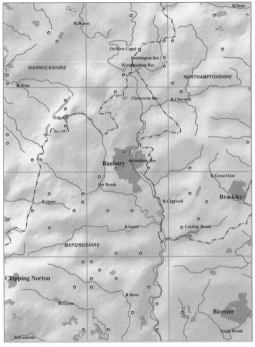

Records in 1982–91 for Buzzard

Records in 1992–2001 for Buzzard

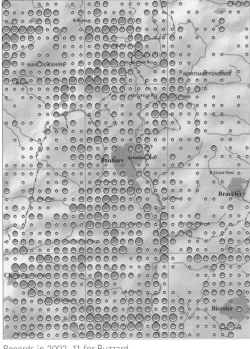

Records in 2002–11 for Buzzard

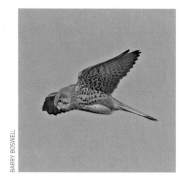

BARRY BOSWELL

Kestrel *Falco tinnunculus*
Fairly numerous resident

The Kestrel is probably the most commonly seen and best known of all the birds of prey, particularly by motorists, as it hovers alongside roadside and motorway verges. Its main food item is the Field Vole; these are taken from uncultivated habitats, mainly around field edges, tracks and roadsides. Aplin (1889) noted that comparatively few individuals remained during the winter. In the 1960s, however, BOS observers did not report this seasonal variation. The WRSS indicates that the Kestrel has not dropped below the 1975–78 starting figure (100) and from 1987 onwards the index increased to reach a maximum of 300 in 2005–08. This may well indicate that during the winter our resident population is now supplemented by an influx of birds from other areas. Over the period of the WRSS the Kestrel has been observed in 33% of squares surveyed. The ABSS of 1986 surveyed 19 blocks of 25 sq. km, each block having one of its corners coincident with a corner of a 10km square. This recorded a minimum of 35 pairs which gives the Kestrel a status of *fairly numerous*. Nationally, during the 1960s and 1970s, numbers were less affected by pesticide contamination than Sparrowhawk or Peregrine but since the mid-1990s the Kestrel population has fluctuated, with some decline but no long-term trend apparent. This fluctuation and decline has a possible link to habitat loss and degradation as farming has intensified to the extent that the Kestrel has been put in the BoCC amber category. Since 2006 the WRSS and SRSS indices have shown a decline in our area, which may be just a minor fluctuation or could indicate a real decrease in numbers. The provisional results of the repeat ABSS held in 2012 indicate that there is no change in status from the 1986 survey.

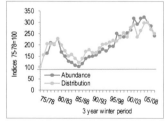

Indices for Kestrel in WRSS

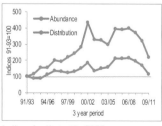

Indices for Kestrel in SRSS

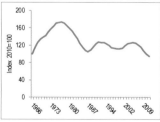

CBC/BBS index for Kestrel

Red-footed Falcon *Falco vespertinus*
Rare casual visitor

A bird was seen on a tree in a set-aside field adjacent to Boddington Reservoir on 30 May 1994. A first-summer male was observed catching and eating insects at Wormleighton Reservoir on 15 May 2003 before flying off northwards. These are the only two records for the BOS.

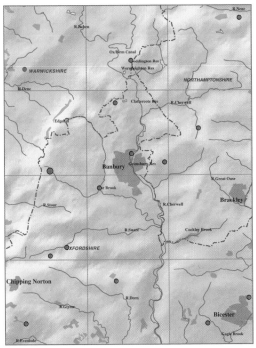

Sightings in 1982–91 for Merlin

Sightings in 1992–2001 for Merlin

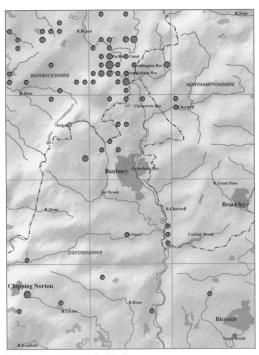

Sightings in 2002–11 for Merlin

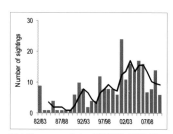

Sightings per winter 1982/83–2010/11
for Merlin

Merlin *Falco columbarius*
Fairly frequent winter visitor

Birds were recorded nine times between 1879 and 1913 and it was classified as a *rare winter visitor*. In the early years of the BOS birds were seen but always just outside the area and the first verified sighting was at Swalcliffe on 12 October 1968. During the period 1972–81 birds were seen in eight out of ten winters and recorded from 14 sites, which changed its status to *occasional winter visitor*. The table shows how the number of sightings has increased in each decade since 1962 such that its status is now that of *fairly frequent winter visitor*. There are only a few observations of perched birds as most records represent Merlin dashing low over arable fields, frequently seen chasing pipits, Skylarks or finch flocks. The maps (page 61) show the distribution of sightings over the last 30 years with the majority of birds found on the open high windswept areas of the BOS. Merlin usually arrive around the end of September/ early October and can be seen throughout the winter, leaving by the end of March.

Winters in decade	1952–1961	1962–1971	1972–1981	1982–1991	1992–2001	2002–2011
Recorded 1km squares	0	1	14	15	34	70

Hobby *Falco subbuteo*
Fairly numerous summer visitor

Davies (1967) commented that the Hobby was a *scarce summer visitor* which nested spasmodically in the area during the nineteenth century. Ruthless persecution in the past may well have been an important factor in reducing its status to that of *passage migrant* until a breeding pair was found nesting in north Oxfordshire in 1961, the first record for 75 years. One or two pairs were then confirmed breeding in the years from 1966 to 1969. Since 1972 sightings have increased continuously each year and its status has now increased to that of *fairly numerous summer visitor*. A study group during the early 1990s of Rob Fuller, Royston Scroggs and three other BOS members carried out an intensive survey and came up with a density of at least four pairs per 100 sq. km. Examination of recent records suggests that the breeding density has increased. Birds usually arrive from mid-April (earliest 4 April 2002) and remain until mid-October (latest 1 November 1995). The first arrivals mainly feed on insects, particularly dragonflies. Later in the season they feed on juvenile hirundines and are consequently frequently seen over villages, open water and Swallow roosts. In the BOS area Hobbies usually like open farmland on high ground and lay eggs in old Crows' nests where the site offers a good all-round view. The maps show the 1km squares in which Hobbies were sighted during the periods 1982–91, 1992–2001 and 2002–11.

BARRY BOSWELL

1km squares per year 1982–2011 for
Hobby

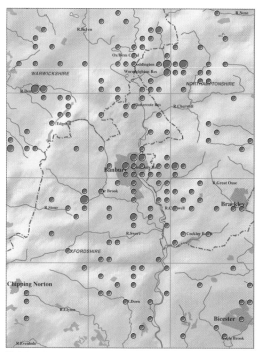

Sightings in 1982–91 for Hobby

Sightings in 1992–2001 for Hobby

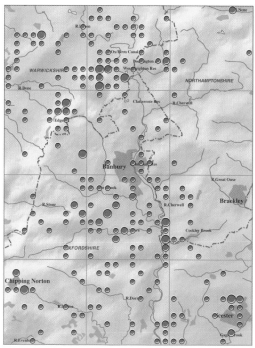

Sightings in 2002–11 for Hobby

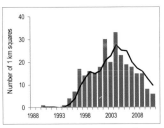

Monthly distribution of sightings
1988–2011 for Peregrine

Peregrine *Falco peregrinus*
Rare resident

The species was regarded as an *occasional visitor* in the early part of the twentieth century. It was recorded at least 23 times between 1890 and 1943 but never during the months of March to August. The first definite records since the formation of the BOS were of single flying birds at Nell Bridge on 12 September 1962 and Charlton on 18 November 1968. There were eight accepted records during 1972–81, mostly from the Cherwell Valley. During 1982–91 there were only two records, one at Grimsbury Reservoir in May 1987 and the other at Whatcote on 31 October 1990. Since 1994, however, the number of sightings has increased considerably, with birds being observed in at least 15 different 1km squares per year. Birds have been recorded in every month of the year and breeding was proved in the north of the area in the first decade of the twenty-first century.

1km squares per year 1988–2011 for Peregrine

Decade	1952–1961	1962–1971	1972–1981	1982–1991	1992–2001	2002–2011
Records	0	2	8	2	61	194

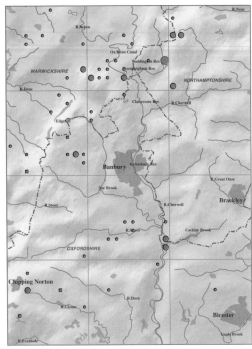

Sightings in 1992–2001 for Peregrine

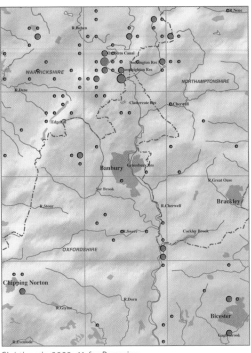

Sightings in 2002–11 for Peregrine

Cranes, Rails and relatives *Gruiformes*

Water Rail *Rallus aquaticus*
Not scarce resident

Water Rail is very shy and secretive so it is often difficult to see or flush it for most of the year. When the weather is severe, however, and waters become frozen, it has to leave its usual habitat and it is then that it is most frequently seen. To prove breeding is extremely difficult and it may well be underrecorded. Up to eight birds were heard calling at Boddington Reservoir during November and December 2004 and up to five birds have been seen at Byfield Pool, Wormleighton Reservoir and Fawsley Park. Adults with two juveniles were seen at Byfield Pool on 9 November 1995 and at Fawsley Park on 26 July 1987. The map and chart illustrate where and when the majority of records have occurred.

Monthly distribution of sightings 1982–2011 for Water Rail

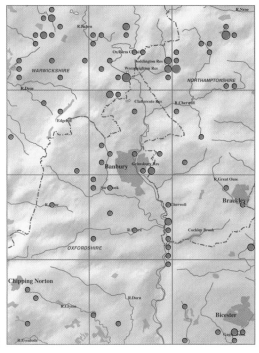

Sites in 1982–2011 for Water Rail

Spotted Crake *Porzana porzana*
Rare passage migrant

The Spotted Crake is a spring and autumn migrant which occurs most commonly in September and October. It was recorded in the Banbury and District area during the autumn period in only ten of the 55 years from 1846 to 1901. The first record for the BOS was of a single bird at Lighthorne on 12 April 1998. The next records occurred at Wormleighton Reservoir on 2 September 1996, from 24 October until 4 November 2003, 4 October 2005 and 17 September 2009. At

Boddington Reservoir single birds were recorded between 10 August and 21 September 1999, with an adult and juvenile seen on 25 August. A male was heard calling there in the flood marsh on 18 May 2002.

Corncrake *Crex crex*
Rare passage migrant
Described as a common and regular summer visitor during the nineteenth century, numbers decreased steadily as agricultural practices changed in the twentieth century. The last confirmed breeding was at Kings Sutton in 1968 and 1969 and then no further records until June 1989 when a male was heard calling at Everdon. At Glyme Farm, Chipping Norton on 29 September 2000, whilst carrying out some late combining, Linden Cornwallis had excellent views of a migrating bird in a crop of Oats.

Moorhen *Gallinula chloropus*
Fairly numerous resident

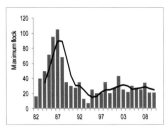

Maximum flock per year 1982–2011 for Moorhen

Birds can be found in all the water habitats throughout the BOS area. The largest congregations (90–100 birds) were recorded at Banbury SF in the winters of 1986 and 1987 and 78 birds were seen at Farnborough Park in November 1987. Since 1995 the maximum number seen together has stabilised at around 20, apart from the sighting of 43 birds at Compton Verney in January 2002 and 34 at Bicester Wetland Reserve in January 2008 (see chart). The decline in numbers from 1988 may well be partially attributed to predation by feral Mink.

Coot *Fulica atra*
Fairly numerous resident

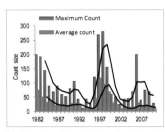

Maximum and average counts per year 1982–2011 for Coot

Coot has been recorded on all the suitable waters of the BOS area, particularly where the water is open, not too deep and where marginal vegetation on which it can breed is available. The species was first studied in 1977 by the ABSS when 163 pairs and at least 230 young were recorded from 55 waters. When the survey was repeated in 2003 the number of breeding pairs had increased by 36.8% to 223. In 1982–83 and 1997–99 flocks of 150+ were recorded at Boddington Reservoir, Fawsley and Middleton Stoney, but the largest number counted on a single water was 280 birds at Boddington Reservoir in February 1998. However, the only three-figure count recorded thereafter was 200 at Boddington Reservoir on 17 September 2006. The chart shows the largest and average flock sizes since 1982.

Crane *Grus grus*
Rare vagrant
The first record was of a single bird shot at Adderbury in March 1913 and the next of one flying over Middleton Cheney on 19

June 1970. In 2003 there were nine birds feeding in a game crop at Glympton from 6 to 14 March. Single birds were recorded at BAD Kineton on 26 July 2004, in the Prescote/Cropredy area from 12 March until 2 April 2007 and at Nell Bridge on 21 May 2008. This last sighting was probably the same bird seen at Steeple Aston on 28 May 2008.

Shorebirds *Charadriiformes*

Lapwing, Curlew, Little Ringed Plover and Woodcock are now the only waders that breed in the area. Most of the others are either passage migrants or winter visitors. The skuas and auks are all vagrants, driven into the BOS area by storms and gales. The terns are passage migrants passing to and from their breeding grounds. All the gulls are common in the area between September and April, with non-breeders present in the period from May to August.

Oystercatcher *Haematopus ostralegus*
Occasional regular visitor

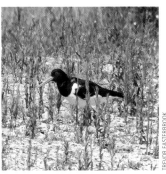

Oystercatchers were recorded at Great Bourton in 1852 and at Croughton in 1864. Since the formation of the BOS in 1952 the species has been recorded in 35 out of the 60 years and in every month of the year. The tables show the monthly distribution and the records in each decade. Birds have been found in a range of habitats and locations with the main sites being Boddington Reservoir, Grimsbury Reservoir, BAD Kineton and the Cherwell Valley with occurrences in eight other areas. The largest group ever recorded in the BOS area was of 24 birds at BAD Kineton on 31 October 1991.

Month	Jan	Feb	Mar	Apr	May	Jun	Jul	Aug	Sep	Oct	Nov	Dec
Records	2	3	10	5	5	5	2	14	3	8	2	4

Decade	1952–1961	1962–1971	1972–1981	1982–1991	1992–2001	2002–2011
Records	5	7	9	12	16	10

Black-winged Stilt *Himantopus himantopus*
Rare vagrant
A bird observed at Boddington Reservoir on 22 and 23 May 1965 is the only sighting in the BOS area.

Avocet *Recurvirostra avosetta*
Rare casual visitor
Four birds observed at Somerton on 23 March 1964 was the first record for the BOS. The other sightings were of single birds at Boddington Reservoir on 9 September 2006 and 15–16 November 2011.

Stone-curlew *Burhinus oedicnemus*

Aplin (1889) wrote that birds were formerly breeding annually on the high sheep-grazed stony ground around Chipping Norton. The last record was in 1871.

Little Ringed Plover *Charadrius dubius*

Fairly frequent passage migrant and rare summer visitor with restricted distribution

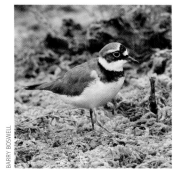

Little Ringed Plover was recorded for the first time in 1966 at three sites in the Banbury area. Since that time records have increased and have occurred in every year. Breeding success has been recorded in 1977, 1980, 1983 and then every year since 1986. The species has nested successfully at five different sites throughout the period with the maximum number of sites used in any one year being three but only one site being used over the last few years. Breeding success has been variable. Sometimes, predation by Crows has been a factor and, just recently, a spare male Little Ringed Plover killed the newly hatched chicks. He then chased off the original male, mated with the female and another clutch was produced. Reservoirs and sewage treatment works, as well as suitable gravel and mineral quarries, account for most of the records. The average arrival date during the 1980s and early 1990s was 10 April but, from 1992 onwards, the average date has been 27 March with the earliest date 23 February 1993. The average departure date falls consistently in the first week of September.

Ringed Plover *Charadrius hiaticula*

Fairly frequent passage migrant

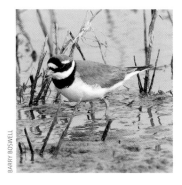

Autumn passage records make up three quarters of all the records received. Boddington Reservoir and Balscote Quarry are the most favoured sites, having 80% of all the sightings with birds recorded once or twice at 12 other sites. There have been twice as many autumn records as spring records as shown on the chart. Periods of records are normally from early March to beginning of June for spring passage and then from mid-July until mid-October for the autumn passage. The earliest record was 24 February 2003 in the Cherwell Valley and the latest record was at Grimsbury Reservoir on

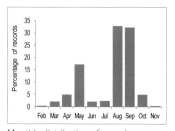

Monthly distribution of records 1982–2011 for Ringed Plover

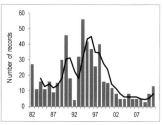

Records per year 1982–2011 for Ringed Plover

15 November 1987. The chart shows that over the last ten years the number of records has decreased dramatically, perhaps reflecting the recent national decline in the breeding population which has led to its presence on the BoCC amber list.

Dotterel *Charadrius morinellus*
Rare passage migrant

By the end of the nineteenth century it had become rare and was only recorded at Bloxham in April 1891, Sibford in both September 1903 and April 1910 and north of Banbury in May 1910. The first sighting in the current BOS area was of two birds at Sibford in August 1980. Two birds were present at Glympton on 5–7 May 1991. Thereafter the only record is a bird sighted with Golden Plover at Balscote Quarry from 24 April until 1 May 2012.

Golden Plover *Pluvialis apricaria*
Frequent winter visitor

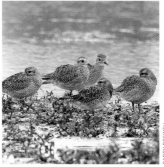

In the nineteenth century Aplin reported that it was a common visitor to the high ground around Chipping Norton and recorded a flock of 500 in March 1883. In the last decade large flocks have also been regularly reported around Chipping Norton. Although there are records from late July through to early May, birds normally arrive in early September and begin to leave from mid-March. Since 1982, birds have been recorded in 466 1km squares which represent 37% of the BOS area. The charts show that overall trends,

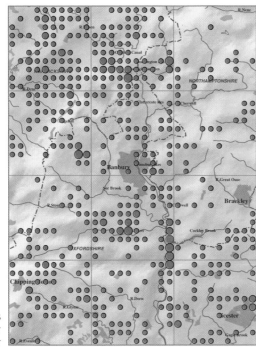

Winter 1km squares
1982–2011 for
Golden Plover

both in number of squares and flock size, have increased. Flocks of 1,000+ birds have been regularly reported from Mid-Cherwell Valley, Barford Airfield, Balscote Quarry, Chesterton and Kingston, Fenny Compton and Over Norton Common near Heythrop. These are shown on the map by the largest dots. The largest recorded flocks were 4,000 birds in the Mid-Cherwell Valley on 19 February 1995, 3,500 there on 2 December 1997 and 2,500 at Barford Airfield on 15 January 1995. On 23 March 2011 several flocks of birds flew northwards over Boddington Reservoir producing a total count of 6,000 birds.

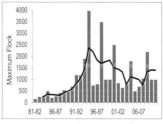

Maximum flock per winter 1981/82–2010/11 for Golden Plover

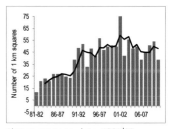

1km squares per winter 1981/82–2010/11 for Golden Plover

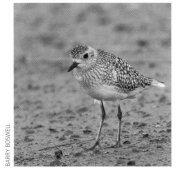

Grey Plover *Pluvialis squatarola*
Very occasional passage migrant/winter visitor
The first record was of a bird shot near Farnborough in 1905. The first sighting since that date was 6 October 1967 at Grimsbury Reservoir. Birds have only been recorded 35 times and in only 12 of the years since 1952. The table shows the monthly distribution of records. All the spring movement records have occurred at Balscote Quarry and BAD Kineton with those for the autumn passage being mainly at Boddington Reservoir plus a few sightings at the other three canal feeder reservoirs. The majority of winter sightings have occurred in the Cherwell Valley with single records from Fenny Compton, Kiddington and Radbourn Lakes. The last sighting was at Wormleighton Reservoir on 3 October 2003.

Month	Apr	May	Sep	Oct	Nov	Dec	Jan	Feb	Mar
Records	1	11	7	4	1	4	4	1	2

Sociable Plover *Vanellus gregarius*
Rare vagrant
A single bird associating with Lapwings was observed in the Mid-Cherwell Valley on 14 September 1980 which is the only record.

Lapwing *Vanellus vanellus*
Fairly numerous resident

Large flocks can usually be found in the Cherwell Valley during the winter period, depending on the weather. In severe winters or periods of freezing weather, birds move out, returning as soon the soil thaws. The largest recorded flocks have been of 5,000 at Balscote Quarry on 8 January 1992, 4,500 in the Mid-Cherwell Valley on 24 November 1984 and 4,000 there on 5 January 2005. Aplin (1889) comments that 'as a breeding species the Peewit is less numerous than former years'. Over the last 20 years concern has been expressed nationally about the number of breeding Lapwings and our records of breeding pairs have also declined considerably over this period. The ABSS of 1980 located 308 pairs at 133 sites and produced a density of 25.7 pairs per 100 sq. km which is at the upper end of the *fairly numerous* category. The repeat survey, in 2006, located only 71 pairs at 34 sites. This produced a density of only 5.9 pairs per 100 sq. km which is now at the lower end of the category and, if the trend continues, it may well fall into the category of *not scarce*. It is not uncommon for first clutches to fail, mainly due to predation by corvids, farming operations or cold, wet springs. Other factors which affect breeding are trends in modern farming practice, particularly the change from spring to winter-sown cereals, as Lapwings prefer to nest on bare ground.

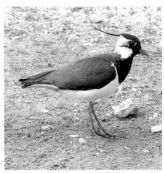

TREVOR EASTERBROOK

Knot *Calidris canutus*
Rare passage migrant

It was recorded for the first time since 1894 at Aynho on 24, 25 and 27 March 1969. Single birds were recorded sporadically in the 1970s and again in the 1990s at Grimsbury Reservoir, Somerton and Balscote Quarry. A flock of 24 was observed at Boddington Reservoir on 23 August 1996. Since 2000 there has been only one sighting, again at Boddington Reservoir, when a single bird was seen on 28 August 2007.

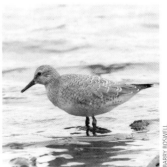

BARRY BOSWELL

Sanderling *Calidris alba*
Rare passage migrant

Sanderling was recorded for the first time in the Banbury area at Grimsbury Reservoir in late May 1966. Since then single birds were seen sporadically in the late 1960s, in the 1970s, the mid-1980s, 1990 and then 1994–97. Three birds were seen together at Nell Bridge on 12 March 1997 and after that date the only records were of single birds at Balscote Quarry on 17 May 2007 and at Wormleighton Reservoir on 22 July 2011.

Semipalmated Sandpiper *Calidris pusilla*
Rare vagrant
A single bird at Boddington Reservoir on 24 September 1999 was
the first record for the BOS.

Little Stint *Calidris minuta*
Occasional passage migrant

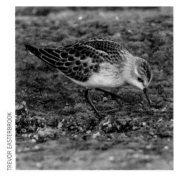

The first records came from Boddington Reservoir on 10 September
1967 and two birds were there on 17 and 20 September 1970. Since
then there have been 93 records but only during the autumn period.
The tables show both the monthly distribution and the number of
records per decade. Boddington Reservoir accounts for 90% of all
sightings and during the period 20–22 August 1996 numbers built
up from 13 birds to a maximum of 19 on 21 August. Three birds were
seen at Wormleighton Reservoir on 20 September 1996 and four at
Grimsbury on 24 September 1996. There were sightings of single
birds at Balscote Quarry on 24 September 2007 and 23 November
2008 and at Wormleighton Reservoir on 20 September 2010.

Month	Aug	Sep	Oct	Nov
Records	13	72	10	1

Decade	1962–1971	1972–1981	1982–1991	1992–2001	2002–2011
Records	3	12	30	43	8

Temminck's Stint *Calidris temminckii*
Rare passage migrant
The first record was of a single bird at Balscote Quarry on 12–14
May 1994 and the only other sighting was again of a single bird
there on 15 May 2004.

Pectoral Sandpiper *Calidris melanotos*
Rare passage migrant
All sightings occurred at Boddington Reservoir. The first record was
of a single bird on 1, 3 and 9 October 1982, two birds were there
from 25 August until 4 September 1994 and the last sighting was
of a single bird on 28–29 September 1996.

Curlew Sandpiper *Calidris ferruginea*
Occasional passage migrant
Single birds were recorded for the first time at Boddington
Reservoir on 10–13 September 1970. Records that have occurred
at Boddington Reservoir are usually of one or two birds though
a maximum of five were there on 27 September 1985. Sightings
usually occur from late August and through September though
there was a single bird observed at Balscote Quarry on 11–13 May

TREVOR EASTERBROOK

Year	1982	1983	1984	1985	1986	1990	1991	1993	1994	1995	1996	1998	1999	2005	2011
Records	8	2	1	1	1	10	2	7	1	6	5	3	1	1	1

1993. The most recent sightings come from Boddington Reservoir on 8–10 September 2005 and 26 September 2011. The table shows the years of occurrence.

Purple Sandpiper *Calidris maritima*
Rare vagrant
A single first-winter bird was observed at Boddington Reservoir on 17 November 1996. This is the first time the species has been recorded in the BOS area.

Dunlin *Calidris alpina*
Frequent regular visitor
The majority of records occur during the autumn with Boddington Reservoir being the preferred site. There are fewer records in the spring but quarries, and in particular Balscote Quarry, are the most favoured. From November to March, birds frequently use the flood water of the Cherwell Valley together with Grimsbury and Boddington Reservoirs. Even though sightings are normally of one or two birds, the most recent large flocks were of 29 birds in the Mid-Cherwell Valley on 9 March 1995 and 26 at Boddington Reservoir on 27 August 1989. The flock of 64 birds, at Nell Bridge on 27 March 1969, remains the largest recorded.

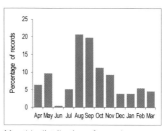

Monthly distribution of records 1982–2011 for Dunlin

Ruff *Philomachus pugnax*
Frequent passage migrant and very occasional winter visitor
The first record was of two Ruff and two Reeve at Boddington Reservoir during the last week of August 1959. During the 1962–71 period 80% of records came from the Cherwell Valley. In the 1972–81 decade the Mid-Cherwell Valley was the favoured area from January to March and Grimsbury Reservoir and Boddington Reservoir at other times. From 1982 to 2011, in the January to mid-March period, six sites were used, with Banbury SF the most popular. During the spring passage, from 21 April to 15 May, there were seven records from three sites but in the autumn migration period, July to October, there were 201 records with 95% occurring at Boddington Reservoir. The three largest flocks were 20 birds at Nell Bridge on 6 March 1977, 19 there on 24 March 1969 and 14 at Boddington Reservoir on 30 September 1990. The table shows the monthly distribution of Ruff during 1982–2011.

Month	Jan	Feb	Mar	Apr	May	Jun	Jul	Aug	Sep	Oct	Nov	Dec
Records	14	1	6	3	4	–	1	81	109	9	2	–

Jack Snipe *Lymnocryptes minimus*
Frequent winter visitor

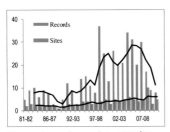

Sites and records per winter 1981/82–
2010/11 for Jack Snipe

In the nineteenth century Aplin considered it to be a *regular winter visitor* but Davies (1967) classified it as a *rather scarce winter visitor.* Brownett (1974) put the species in the *fairly frequent non-breeder* category and this remained its status until the late 1990s when the numbers increased. This may be due to having more suitable habitats in the BOS area such as pools, wet/marshy areas and the Bicester Wetland Reserve. The table shows the monthly distribution of records and the chart shows how both records and sites have changed since 1982. The earliest recorded arrival date is 25 August (in 1990) and latest departure date is 12 May (1985). The largest flock was recorded in 2005 when 24 birds arrived as one flock at Lighthorne Pools on 10 January. There were still ten birds there on 17 February and 11 on 7 March.

Month	Aug	Sep	Oct	Nov	Dec	Jan	Feb	Mar	Apr	May
1km squares	1	3	10	21	17	26	25	19	7	1

Snipe *Gallinago gallinago*
Frequent winter visitor and rare resident with restricted breeding distribution

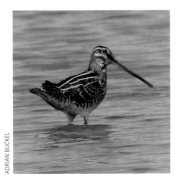

Maximum flock per winter 1981/82–
2010/11 for Snipe

In the late 1800s Snipe was regarded as a *winter visitor* with no evidence of breeding. In 1967 Davies wrote that nests were found at Edgcote in 1956 and birds probably attempted to breed in the Cherwell Valley in 1917, 1922, 1932 and 1959. During 1962 and from 1966 to 1970 a few pairs were proved to be breeding in the Mid-Cherwell Valley, Middle Barton and Horley. In the 1970s and 1980s breeding was confirmed at only one or two sites but displaying was observed at several more locations. There has been no confirmed breeding evidence since then, though there was one record of displaying and drumming in the Mid-Cherwell Valley on 25 May 2008. A flock of 250+ were recorded in the Mid-Cherwell Valley on 30 March 1970. Other large flocks were of 230 birds at Banbury SF on 9 December 1990, 200 at Clifton on 11 December 1982 and 160 at Bicester Wetland Reserve on 8 December 2002. The chart shows the maximum flock per winter since 1982.

Great Snipe *Gallinago media*
There have been no sightings since one bird recorded at Warkworth in 1862.

Woodcock *Scolopax rusticola*
Frequent winter visitor and scarce resident with restricted breeding distribution

Woodcock has a widespread winter distribution and has been recorded in 20% of the 1,200 1km squares of the BOS area as shown on the map. The resident population is augmented in the winter by birds from Northern Europe. The two charts show the number of records per month and number of sites per year. Breeding has been confirmed at Glympton, Ditchley and Whichford. In the past, roding males have been also recorded at Badby, Farthinghoe, Kiddington and Tackley but during the last ten years they have only been recorded at Ditchley, Oakley Wood and Whichford. The species may well be underrecorded in our area because it is crepuscular and difficult to observe, particularly in the breeding season. During roding, displaying males are not defending territory but searching for a receptive female so roding only suggests possible breeding. Nearly all our records are of one or two birds that are flushed from cover. When a shoot takes place on some of our larger estates, greater numbers are reported, for example 16 birds at Kiddington on 4 December 1982, 14 at BAD Kineton on 4 March 1990 and 14 at Ditchley on 7 January 1995. No large numbers have been reported during the 2000s.

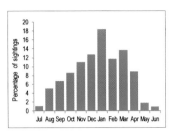

Monthly distribution of records 1982–2011 for Woodcock

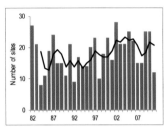

Sites per year 1982–2011 for Woodcock

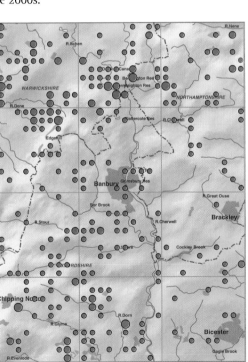

Sites in 1982–2011 for Woodcock

TREVOR EASTERBROOK

Black-tailed Godwit *Limosa limosa*
Fairly frequent passage migrant
The Black-tailed Godwit was first recorded in the Mid-Cherwell Valley on 5 April 1964. Since then there have been 73 records, mainly of one or two birds, with the exceptions including six birds at Boddington Reservoir on 13 September 1997, six in the Mid-Cherwell Valley on 18 October 2002 and nine there on 14 August 2004. There was a flock of 17 birds flying away from Boddington Reservoir on 30 August 1990, 18 flying SE at Lighthorne on 8 August 2001 and 18 flying in the Mid-Cherwell Valley on 13 August 2004. Boddington Reservoir, together with the Mid-Cherwell Valley, accounts for 60% of all the sightings with a few records from Balscote Quarry, Banbury SF, Bicester Wetland Reserve, Enstone, Grimsbury Reservoir, BAD Kineton and Lighthorne. The tables show the monthly and decade distribution of the records.

Month	Jan	Feb	Mar	Apr	May	Jun	Jul	Aug	Sep	Oct	Nov	Dec
Records	1	–	6	2	2	–	2	33	12	6	9	1

Decade	1962–1971	1972–1981	1982–1991	1992–2001	2002–2011
Records	5	7	16	32	14

BARRY BOSWELL

Bar-tailed Godwit *Limosa lapponica*
Occasional passage migrant
The first record since 1893 was of a single bird flying at Bloxham on 23 August 1970. Since then there have been two records of flocks flying in a southerly direction, namely 20 at Helmdon on 16 April 1989 and 24 at Fenny Compton on 1 September 2002. Six birds were seen at Boddington Reservoir on 23 August 1996. One to three birds have occurred at Grimsbury Reservoir in August 1974, Banbury SF in December 1987, Balscote Quarry in May 1994, May and September 1999 and April 2000 and lastly two birds at Boddington Reservoir in April 2011.

Decade	1972–1981	1982–1991	1992–2001	2002–2011
Sightings	3	3	9	3

Whimbrel *Numenius phaeopus*
Very occasional passage migrant
Birds have been recorded in most years since the BOS was formed and from 1990 it has been recorded annually. The spring migration has occurred between mid-April and late May with birds being recorded at Balscote Quarry, Banbury SF, Boddington Reservoir, Croughton Quarry, Mid-Cherwell Valley and Wormleighton Reservoir. Birds frequently call while on migration and also migrate late in the

evening or during the night, as noted by several recorders. The autumn migration falls between mid-July and mid-October. The favoured areas are the three reservoirs of Boddington, Wormleighton and Grimsbury together with the Mid-Cherwell Valley. There have been four records of calling flying birds at Fenny Compton, Hook Norton, Bloxham and Middleton Cheney during late July and mid-August. The largest groups were of ten birds at Boddington Reservoir on 12 August 1997 and seven at Balscote Quarry on 17 April 2009.

Curlew *Numenius arquata*
Fairly frequent casual visitor and not scarce summer visitor with local breeding distribution

The Curlew was classified as an *occasional visitor* in spring, autumn and winter by Aplin (1889). In 1952 breeding during the summer was well established and a pilot study in 1959 indicated a minimum of ten pairs in the Cherwell Valley between Cropredy and Lower Heyford. Curlew was the subject of the ABSS of 1971 when six pairs were found in the Cherwell Valley and a further pair near a tributary of the River Stour, giving a *not scarce* breeding classification. Records during May and June over the following years indicated that the number of pairs had increased and it was maintaining its status. The repeat ABSS of 1997, however, found only five pairs: a lone pair in the Cherwell Valley, possibly due to the very dry spring and summer; the other pairs being in the south Warwickshire part of the BOS area. These figures put the species at the lower end of the *not scarce* category. In subsequent years in the Cherwell Valley a minimum of two to three pairs have been located. From 1984 to 1988 there was a pre-breeding roost at Banbury SF which built up from late February to the end of March. A maximum of 24 birds was recorded there on 18 and 24 March 1985. Since 2005 up to eight birds have flown in to Balscote Quarry each evening throughout

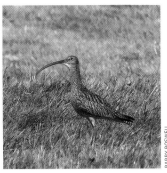

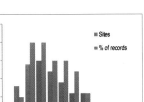

Monthly distribution of sites and records 1982–2011 for Curlew

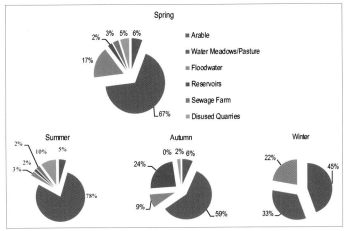

Habitats used by Curlew in different seasons 1982–2011

most of June to bathe and roost. It is not known whether these are non-breeding birds or one bird of each of the local breeding pairs. The breeding population usually departs before autumn though birds have occurred in all months of the year.

Upland Sandpiper *Bartramia longicauda*
There has been no record in the BOS area since 1851.

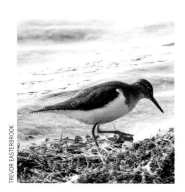

TREVOR EASTERBROOK

Common Sandpiper *Actitis hypoleucos*
Very frequent passage migrant
The species has been recorded in every month of the year but the autumn passage produces almost twice as many records as the spring migration, as shown in the charts. Yet the records would suggest that the spring migration is on a wider front than that in the autumn, with a greater variety of water habitats being used. Birds have been recorded at 65 waters and the reservoirs of Boddington and Grimsbury account for 70% of all records, although any suitable waters in the area such as rivers and pools can attract migrating birds. The largest groups recorded have been of 20+ birds at Grimsbury on 21 August 1970 and 13 at Boddington Reservoir on 3 May 1990. The charts also show that the number of records has decreased in the last ten years.

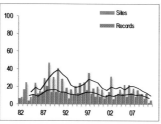

Spring sites and records per year
1982–2011 for Common Sandpiper

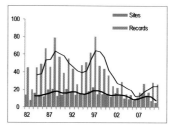

Autumn sites and records per year
1982–2011 for Common Sandpiper

BARRY BOSWELL

Green Sandpiper *Tringa ochropus*
Frequent passage migrant/winter visitor
Birds have been recorded in every month of the year, although in June records tend to be either at the beginning of the month or at the end. Sightings are highest during the peak months of the autumn passage and considerably greater than the spring passage (see charts). Balscote Quarry, Boddington Reservoir and Bicester Wetland Reserve account for two thirds of all the records in the autumn. During the winter most of the sightings are of one or two birds, distributed over a wide range of water habitats from small pools to large lakes, and there are now more birds over-wintering in the area. The largest counts are of 32 birds at Priors Marston on 26 September 1997, 11 birds at Bicester Wetland Reserve on 2 August 2008, 10 there on 2 and 23 July 2007 and 10 birds at North

Aston on 4 August 1968. It can be seen in the winter distribution chart that the number of Green Sandpiper in our area has increased compared to 1982.

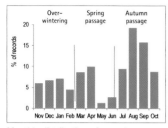

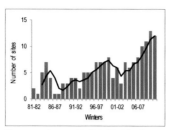

Monthly distribution of records 1982–2011 for Green Sandpiper

Sites per winter 1981/82–2010/11 for Green Sandpiper

Spotted Redshank *Tringa erythropus*
Occasional passage migrant
The first record since 1888 was of two birds at Wormleighton Reservoir on 4 September 1969. The table shows the number of years per decade in which the species was present; there has been no record since 1999. Boddington Reservoir during August and September accounts for 90% of all records, which were usually of just one or two birds. Other single sightings came from the Mid-Cherwell Valley on 21 December 1980, Wormleighton Reservoir on 5 September 1982, Clattercote Reservoir on 28 August 1988 and Balscote Quarry on 28 April 1993. The two largest groups were of five birds at Boddington Reservoir on 4 August 1974 and nine birds at Clifton on 2 February 1984.

Decade	1962–1971	1972–1981	1982–1991	1992–2001	2002–2011
Years	2	8	4	4	0

Greenshank *Tringa nebularia*
Frequent passage migrant and very occasional winter visitor
The charts illustrate the occurrences of Greenshank in the BOS area, with 78% of all records occurring during the autumn migration whereas the spring passage makes up only 12%. Half of all the sightings occur at Boddington Reservoir; Balscote Quarry,

TREVOR EASTERBROOK

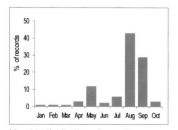

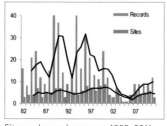

Monthly distribution of records 1982–2011 for Greenshank

Sites and records per year 1982–2011 for Greenshank

Wormleighton Reservoir, Mid-Cherwell Valley and Grimsbury Reservoir have had 20+ sightings since 1982. Birds have also been observed, mainly in the Mid-Cherwell Valley, during the winter months in seven years since 1985. During the period 1982–2009 Greenshank was recorded on 31 waters of the BOS, but usually only one or two birds. The largest numbers recorded were seven at North Aston in 1977 and five at Boddington Reservoir on 15 and 16 August 1984. Our records show that a decline in sightings began in 1997, reaching a low in 2003/04. A recovery in numbers has been seen since 2007, reflecting the national picture.

Lesser Yellowlegs *Tringa flavipes*
Rare vagrant
A single first-winter bird, present at Banbury SF on 2–18 December 1983, remains the only sighting.

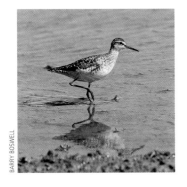

Wood Sandpiper *Tringa glareola*
Very occasional passage migrant
The first record occurred at Chesterton Pools on 18–27 September 1968. Since then the species has occurred 16 times, with 50% of records coming from Boddington Reservoir and single sightings at Banbury SF, Charlton Pool, Lighthorne Pools, North Aston and Wormleighton Reservoir, with the latest sighting at Balscote Quarry on 22–28 April 2010. The table shows the number of sightings in each ten-year period.

Decade	1962–1971	1972–1981	1982–1991	1992–2001	2002–2011
Sightings	1	2	6	5	2

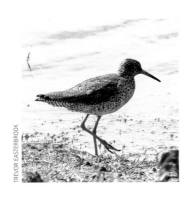

Redshank *Tringa totanus*
Frequent casual visitor
The species was extremely rare in the nineteenth century and the only record was of one shot at Twyford Mill in 1889. Pairs were recorded breeding in the Cherwell Valley and Sor Valley during the first half of the twentieth century. Between 1952 and 1962 a few pairs were breeding in the valleys of the Cherwell, Sor and Swere. Pairs continued to breed until 1971 and, from that point, breeding was attempted at two sites for four years during the 1970s but then ceased, mainly due to change of habitat, pressure from human disturbance and farming activities. In the 1980s breeding was again attempted for a few years at Banbury SF as shown quite clearly on the yearly chart with the increased number of records from 1986 to 1989. Since then there has been no positive evidence that breeding has been attempted in the BOS area. The chart showing the monthly distribution of records illustrates that the spring passage produces many more sightings than the autumn passage. Birds have been recorded at 27 different waters throughout the BOS area: Balscote

Quarry, Boddington Reservoir, Banbury SF, Grimsbury Reservoir and the Mid-Cherwell Valley are the favoured sites. The largest flocks have been 30 birds at Nell Bridge on 21 August 1969, 14 on flood water in the Mid-Cherwell Valley on 14 June 2007 and 14 there on 8 March 2009.

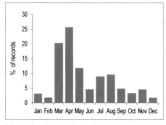

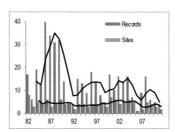

Monthly distribution of records 1982–2011 for Redshank

Sites and records per year 1982–2011 for Redshank

Turnstone *Arenaria interpres*
Very occasional passage migrant

Two birds observed in the late evening of 4 May 1974 at Grimsbury Reservoir was the first record for 100 years. Since that time there have been 28 sightings, with 66% at Boddington Reservoir, 30% at Balscote Quarry and single records from Grimsbury Reservoir, Ardley Fields Quarry and Priors Hardwick. Birds were recorded in 1982–83, 1985, 1989–90, 1992–94, 1996–98, 2000, 2004, 2007 and 2010. The majority of sightings were of one or two birds but there were four birds at Wormleighton Reservoir on 27 August 2010, six at Balscote Quarry on 6 May 1993, and ten at Boddington Reservoir on 16 August 1992 with six also there on 31 July 1994.

TREVOR EASTERBROOK

Month	Apr	May	Jun	Jul	Aug	Sep	Oct
Records	1	4	1	3	13	4	1

Red-necked Phalarope *Phalaropus lobatus*
Rare passage migrant

Single birds were recorded at Boddington Reservoir in September 1957 and on 12 September 1991. These are the only sightings.

Grey Phalarope *Phalaropus fulicarius*
Rare passage migrant

The only records for the BOS area are of single birds at Somerton in November 1960, Boddington Reservoir on 14 October 1974 and one found dead at Kiddington on 4 October 1982.

BARRY BOSWELL

Arctic Skua *Stercorarius parasiticus*
Very occasional vagrant
Single birds were recorded at Grimsbury Reservoir in early May 1978 and at Boddington Reservoir in October 1984 and late April 1989. Dark-phase birds were also observed at Fenny Compton on 11 August 2002 and at Chesterton Pools on 28 August 2010, both finally flying off in a NE direction.

Great Skua *Stercorarius skua*
Rare vagrant
A group of 13 birds appeared at Boddington Reservoir on 19 September 2001 during a strong north wind. A single bird was observed there on 29 September 2007. These are the only records.

Sabine's Gull *Xema sabini*
Rare vagrant
Single birds were recorded at Boddington Reservoir on 21 October 1987 and at Balscote Quarry on 19 September 2006 following autumnal gales.

Kittiwake *Rissa tridactyla*
Very occasional casual visitor
Overland migration does occur but a lot of records are storm driven. Observations have occurred from mid-March to mid-May, then from the last week in July until early October and again from early November to mid-December. There have been 14 sightings of single birds, mainly from Boddington Reservoir, and there were two juvenile birds there on 29 July 1982. A group of two adults and a first-winter bird were observed flying low across the meadows of the Knightcote Valley on 10 November 2007.

TREVOR EASTERBROOK

Black–headed Gull *Chroicocephalus ridibundus*
Very frequent regular visitor
The most common and widespread of all the gull species, it is often associated with pasture and ploughing and frequently seen flying to and from feeding and roosting sites. Birds have been recorded in all months of the year but no breeding has been attempted. Flock sizes have increased over the last 20 years, the average flock size being 300. The largest numbers are recorded at reservoirs or at refuse disposal sites, the largest recorded aggregations being 8,500 birds at Boddington Reservoir on 1 February 1999 and 10 February 2000.

Little Gull *Hydrocoloeus minutus*
Occasional passage migrant
Birds have been recorded during January and February but are mainly seen during the spring passage from mid-March until the end of May and in the autumn passage from mid-July to the end of October. The species has been recorded in 23 of the last 40 years with April and September being the most favoured months. Boddington and Grimsbury Reservoirs account for 90% of the sightings. Normally birds are seen in small groups: the two largest flocks were of 19 and 13 birds on 4 and 6 May 1974 at Grimsbury Reservoir and 12 at Boddington Reservoir on 28 April 1995. These flocks were a mixture of adults, first year and immature birds.

Mediterranean Gull *Larus melanocephalus*
Occasional winter visitor

Birds were first recorded at Alkerton refuse tip on 31 December 1988, feeding with other gulls and since then it has been seen almost annually. During the winter it has been recorded from mid-November through to the end of March. Birds have also been seen in the last week of April and from the end of July to the end of September. Fifty per cent of the records have been at Boddington Reservoir. Other records were from Alkerton, Ardley Fields Quarry, Balscote Quarry and 12 other pasture sites where they were associating with Black-headed Gulls. Records are mainly of single birds, ranging from juvenile, first winter and second winter through to full adult.

Common Gull *Larus canus*
Very frequent regular visitor
It has been recorded in every month of the year but much less frequently between April and September. There is some passage movement but most overwinter. The largest flocks have occurred between January and March with the maximum recorded of 3,500 birds at Priors Hardwick on 28 February 2007, feeding on worms in a very wet pasture field, and 3,000 at Boddington Reservoir on 10 February 2000. The two charts illustrate the maximum flock per year and the maximum flock size per month.

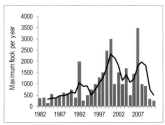

Maximum flock per year 1982–2011 for Common Gull

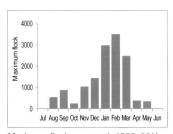

Maximum flock per month 1982–2011 for Common Gull

Ring-billed Gull *Larus delawarensis*
Rare vagrant

Single birds were recorded at Boddington Reservoir on 30 October and 4 November 1993, and on 9 March 2011.

Lesser Black-backed Gull *Larus fuscus*
Very frequent regular visitor

This is the most regular and widespread of the larger gull species. It has been recorded in all months of the year but large flocks occur from late August through to March. Like other gull species, large concentrations are usually found at the reservoirs, at waste disposal sites and occasionally on sheep pasture. The largest recorded flocks were of 2,500 birds at Alkerton refuse tip on 31 December 1998, 2,000 at Ardley Fields Quarry on 22 August 2009 and 1,800 on a pasture field at Great Tew on 2 October 2005.

Herring Gull *Larus argentatus*
Very frequent regular visitor

Birds have been recorded in every month of the year with large flocks occurring from the end of September until mid-March. Herring Gulls are not as widespread as the other large gulls. Alkerton refuse tip has been an important area and has produced 27% of all the records since it began operating in 1986 and up to its closure in 2008. Flocks in excess of 500 were regularly recorded with the largest flocks observed there of 2,500 birds on 3 January 1994 and 2,000 on 31 December 1998. Following Alkerton's closure, and the development of Ardley Fields Quarry as a waste disposal site, it is hoped that flocks will be recorded there instead. The chart shows that there has been a decline in large flocks since 1999, which mirrors the national decline.

Maximum flock per year 1985–2011 for Herring Gull

Yellow-legged Gull *Larus michahellis*
Not scarce casual visitor

Birds were first recorded at Alkerton refuse tip on 8 November 1993. Since then birds have been recorded annually and in every month of the year except June. Usually they can be seen in the company of other gull species, especially Lesser Black-backed Gulls, at reservoirs, disused quarries with water, refuse tips, pasture and arable fields.

Caspian Gull *Larus cachinnans*
Scarce casual visitor

Single birds were recorded at Balscote Quarry on 13 January and 11–13 November 2008 and on 7, 8, and 31 January 2009. One bird was present at Boddington Reservoir on 9 September 2009 and 2 March 2011.

Iceland Gull *Larus glaucoides*
Rare vagrant
A single bird at Alkerton refuse tip on 29 January 1994 remains the only sighting of this species.

Glaucous Gull *Larus hyperboreus*
Very occasional vagrant
Two birds were recorded at Alkerton refuse tip on 10 January 1988 and one or two birds were present from 7 January to 10 February 1992. Other sightings were at Fenny Compton on 24 February 2008 and Ardley Fields Quarry on 24–25 February and 12–13 March 2011.

Great Black-backed Gull *Larus marinus*
Fairly frequent regular visitor
The species has continued to increase over the last 20 years with records in every month although most sightings occur from November to February. Consequently its status has moved from *casual* to *regular visitor*. Distribution has also increased and it has been recorded in 15% of the squares in the BOS area. Alkerton refuse tip was the main site where large congregations were recorded, with a maximum of 62 there on 2 January 2007. Usual sightings, though, are of small groups of up to five birds.

Little Tern *Sternula albifrons*
Rare passage migrant
One was recorded in 1897 and one found dead at Cropredy in 1900; the next sighting was at Grimsbury on 23 May 1966. Since then there have been 15 sightings, mainly of single birds, in only 13 of the next 44 years. Spring sightings have been from the third week in April until the end of May and autumn sightings from late July to mid-September. The latest record was at Boddington on 30 July 2011.

BARRY BOSWELL

Gull-billed Tern *Gelochelidon nilotica*
There have been no records of this species in the BOS area since 1876.

Black Tern *Chlidonias niger*
Occasional passage migrant
In spring, birds can be sighted from early April until early June and the return passage can be from late July though to mid-October. Birds are normally observed at the two main reservoirs of Boddington and Grimsbury but they have also been recorded once or twice on six other waters. The two largest reported flocks were

Decade	Apr	May	Jun	Jul	Aug	Sep	Oct	Total
1952–1961	–	25	–	–	23	16	1	65
1962–1971	13	64	31	–	161	40	3	312
1972–1981	4	91	16	7	92	130	6	346
1982–1991	2	243	–	3	39	42	4	333
1992–2001	13	145	2	6	20	38	1	225
2002–2011	5	4	–	3	1	7	–	24
Total	37	576	49	19	336	273	15	1,305

of 58 birds at Boddington Reservoir on 3 May 1990 and 50 at Grimsbury Reservoir on 12 May 1993. The table shows the number of birds reported per month per decade, and demonstrates that Black Terns were regularly observed each year in good numbers from 1962 through until 2001. As the number of sightings and number of birds since then have plummeted and they have only been recorded in small numbers in five out of the last eight years, its status has changed from *fairly frequent* to *occasional passage migrant.*

Sandwich Tern *Sterna sandvicensis*
Rare passage migrant
There have been 23 sightings since 1968 but only two in the last ten years, of single birds at Boddington Reservoir on 14 September 2004 and at Grimsbury Reservoir on 2 April 2011. The spring passage usually takes place between early April and the end of May and has half the number of sightings of the the autumn passage, which occurs from the end of July until the end of September. The majority of records come from Boddington and Grimsbury Reservoirs but the largest group seen together was of 22 birds at Lighthorne Pools on 8 August 1988.

DEREK WOODARD

Common Tern *Sterna hirundo*
Frequent passage migrant
Birds pass through from early April until early June and again from mid to late June until mid-October. Ninety per cent of all sightings have occurred at the two main reservoirs of Boddington

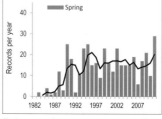

Spring records per year 1982–2011 for Common Tern

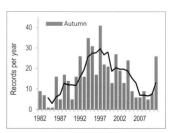

Autumn records per year 1982–2011 for Common Tern

and Grimsbury with the rest at the larger lakes and at quarries with pools. The normal sighting is of 3–8 birds but occasionally large numbers are blown inland. This was the case in 1990 when 62 birds were recorded at Grimsbury Reservoir on 1 May with 36 there on 2 May and also 43 at Boddington Reservoir on 1 May. A flock of 23 was observed at Boddington Reservoir on 7 May 2002 and 22 on 7 October 2010. Over the last 20 years the periods of passage have started earlier and lasted longer, and the charts would suggest that we are now tending to have more spring and fewer autumn passage records, though 2011 saw unusually high numbers in both periods.

Roseate Tern *Sterna dougallii*
There has been no record since 1848.

Arctic Tern *Sterna paradisaea*
Occasional passage migrant

Almost all the sightings have occurred at Boddington Reservoir with a few at Grimsbury Reservoir and two at Wormleighton Reservoir. The spring passage usually begins in early April and continues until early June while the autumn passage may last from the first week in July until mid-October. It can be seen from the charts that the Arctic Tern occurs irregularly compared to the Common Tern. The average flock size is five birds but occasionally large flocks are observed. The four largest have been of 41 birds at Grimsbury Reservoir on 23 April 1990 and, from Boddington Reservoir, 52 on 27 August 2003, 59 on 23 April 2008 and 65 on 26 April 1995.

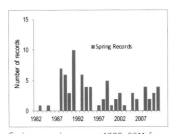

Spring records per year 1982–2011 for Arctic Tern

Autumn records per year 1982–2011 for Arctic Tern

Guillemot *Uria aalge*
This species has not been recorded in the BOS area since 1870.

Razorbill *Alca torda*
There have been no records of this species since 1891.

Little Auk *Alle alle*
Rare vagrant
All records have been of birds that were either exhausted or picked up dead following autumn and winter gales. These were at Drayton in December 1920, Glympton in January 1962, Chipping Norton in 1975, Byfield in November 1979 and Chadshunt in October 1991.

Puffin *Fratercula arctica*
Rare vagrant
A species which gets blown off course during spring/summer gales and is then found either exhausted or dying. The complete record list is: Chipping Norton 1889, Banbury 1893, Epwell 1939, Overthorpe in June 1964 and South Newington on 26 April 1984.

Sandgrouse *Pteroclidiformes*

Pallas's Sandgrouse *Syrrhaptes paradoxus*
Birds were forced into long-distance movements from their breeding grounds on the Asiatic steppes by late-lying snow in several years from 1859 to 1908. The biggest irruption occurred in 1888. O. V. Aplin (1889) commented that, on 5 September in that year, a farmer from Lower Heyford wrote to 'the *Standard*' that he had noticed a flock of 14 birds on his farm since early spring. Aplin also said that in later correspondence with him the farmer stated that they had been present from 12 May until the first week in October but had not bred there. This remains the only record.

Pigeons and Doves *Columbiformes*

Stock Dove *Columba oenas*
Numerous resident
Considered rare in the first half of the nineteenth century, numbers of this species gradually built up only to then decline steeply in the 1950s and early 1960s due to the use of chemical seed dressing. The trend was reversed after the banning of this practice with

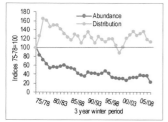

Indices for Stock Dove in WRSS

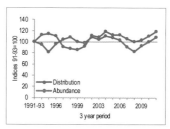

Indices for Stock Dove in SRSS

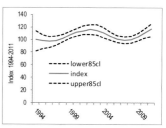

BBS index for Stock Dove

numbers increasing until the late 1970s. Our WRSS indices show that numbers decreased from 1975 until the early 1990s but now appear to have stabilised (see chart). The SRSS also shows that the population has remained constant since 1991. Birds frequent woods and parkland but feed mainly on arable farmland. Forty was the average flock size during the period 1982–2011. Large flocks occur between November and March with the largest recorded being of 700 birds at Fenny Compton on 11 November 2001. Flocks of 300+ have been recorded at Twyford/Kings Sutton in December 1971, Farthinghoe in 1976 and Hellidon in February 1995. The species has been recorded in 57% of the squares surveyed in the WRSS and in 74% in the SRSS.

Woodpigeon *Columba palumbus*
Abundant resident

Aplin (1889) suggested that winter migratory flocks could be as large as 200 birds, whereas currently a flock of 500 is not unusual. The species has increased considerably since Aplin's time even though many birds died during the 1950s and 1960s due to chemical poisoning. The increase may well have occurred because Woodpigeon can survive well in winter, feeding on growing arable crops and autumn-sown cereals. They will breed in many different types of habitat and in most months of the year. Efforts to reduce the population, by shooting in February, seem to have had little effect on numbers. The maximum recorded flock was 5,000 birds at Barford on 18 February 2000 with winter flocks of 3,000+ recorded at BAD Kineton (1987), Nell Bridge (1992), Kirtlington (1997), Fenny Compton (2003) and Wormleighton (2008). In the WRSS Woodpigeon has been recorded in 97% of all squares surveyed and in 98% in the SRSS.

TREVOR EASTERBROOK

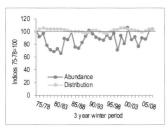

Indices for Woodpigeon in WRSS

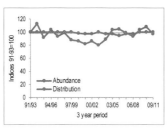

Indices for Woodpigeon in SRSS

Collared Dove *Streptopelia decaocto*
Numerous resident

The species was first recorded at Combrook in 1962 but breeding was not confirmed until 1966 at Souldern. Since then its distribution has been widespread across the BOS area. It is successful as it is prepared to breed where there are human settlements and has a protracted breeding period. When Bibby's, the seed merchants, was in business at Adderbury during the 1970s and 1980s flocks of 100+ were frequently recorded. Other large flocks were 98 at Drayton in 1990, 78 at Tadmarton in 1984, 58 at Kiddington in 2007 and 55 at Shenington in 2004. Birds have been recorded in 40% of the squares surveyed in the WRSS and 68% in the SRSS.

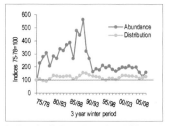

Indices for Collared Dove in WRSS

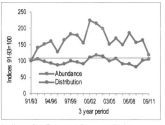

Indices for Collared Dove in SRSS

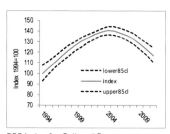

BBS index for Collared Dove

Turtle Dove *Streptopelia turtur*
Rare summer visitor

The earliest recorded arrival date was 27 March 1999 at North Aston and latest departure date was 20 October 1984 at Banbury SF. The main influx of birds usually arrives from mid-April and leaves from mid-September. The maximum recorded concentrations in the BOS area were of 35 birds at Enstone in 1968, 20 at Chesterton (Warks) in

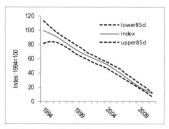

1km squares per year 1990–2011 for
Turtle Dove

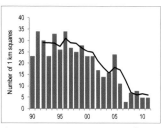

Indices for Turtle Dove in SRSS

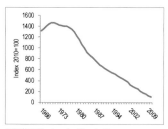

BBS index for Turtle Dove

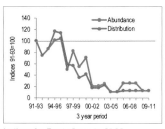

CBC/BBS index for Turtle Dove

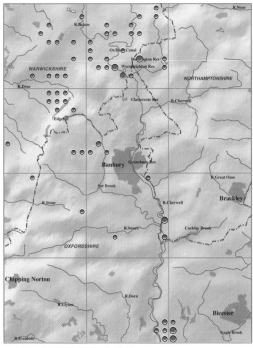

Sightings in 2002–06 for Turtle Dove

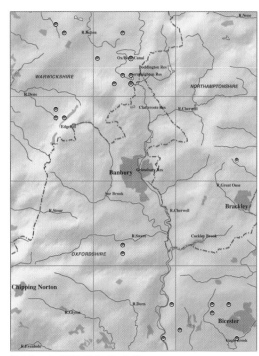

Sightings in 2007–11 for Turtle Dove

1979 and 10 at Radbourn Lakes in 1994. In the nineteenth century the species was considered a *regular summer visitor*, breeding commonly but not very numerously, in woods and plantations and tall hedgerows. In his report, Brownett (1974) rated the Turtle Dove as a *numerous migrant breeder* as did Easterbrook (1984). Concern about the decline in records and numbers was raised in the early 1990s and was noted in the last BOS report (Easterbrook 1994). The chart and maps show the decline in both the number of records and of sites over the last 20 years. Mead (2000) commented that 'The agriculture change, with reduced weed seeding and early planting of crops, has reduced their chances in Britain but the birds are also being shot on migration through France and the Iberian peninsula. There are fewer breeding attempts made by each territorial pair in recent years. Unless proper agri-environment measures are introduced there is little chance of reversing this depressing trend.'

Rufous Turtle Dove *Streptopelia orientalis*
Rare vagrant

A single bird was reported at Chipping Norton on 15 December 2010 but was not definitely identified at that time. In early 2011, however, the bird appeared again a few streets away from the first sighting where it was subsequently seen by many observers and positively identified. It remained, feeding with other birds, in the surrounding gardens until late May 2011. This was only the third record for the UK.

Parrots *Psittaciformes*

Ring-necked Parakeet *Psittacula krameri*
Rare casual visitor/escape
During 1972–81 there were several records of free-flying birds from three different areas but during the next ten years there was only one record. The last sightings were of a juvenile bird feeding on Hawthorn berries at Farnborough on 10 January 2008 and an adult bird at Woodford Halse on 5–6 August 2011. Although the species has become established in parts of London and the South East, our sightings were probably of escaped birds.

Cuckoos *Cuculiformes*

Cuckoo *Cuculus canorus*
Not scarce summer visitor
During the period 1982–2011 the earliest recorded arrival date was 15 March 1988 at Banbury SF with the average date 11 April. Young birds can be seen into late September or early October with the latest recorded date 8 October 1984 at Deddington; the average last date is 10 August. During the last ten years there has been an increasing suspicion that the Cuckoo population has been declining. Their parasitic behaviour does not provide the usual evidence to confirm breeding and the far-ranging calls of the male birds can give the impression there are more Cuckoos than there actually are. During our SRSS it is therefore virtually impossible to ascertain the number of breeding pairs within an observer's 1km square. Recorders are asked to record sightings only. The decrease in sightings during the period 1991–2011 provides circumstantial evidence of this decline and is shown in the chart.

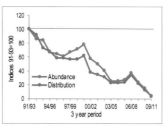

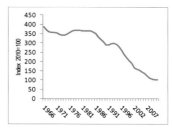

Indices for Cuckoo in SRSS CBC/BBS index for Cuckoo

Owls *Strigiformes*

Barn Owl *Tyto alba*
Not scarce resident

Barn Owls are typically birds of open countryside, rough grassland and of farmland with good mature trees for nest sites though they will also breed in farm buildings and churches. Aplin (1889) concluded that the Barn Owl was holding its own with difficulty in the face of persecution. By 1900, Barn Owls were already beginning to decline nationally, probably being shot as trophies, and because anything with talons and a hook beak was viewed as a threat to Pheasant rearing. Numbers continued to plummet until the 1990s, the population for all of England and Wales having decreased by 69% during the period 1932–85. There are many factors which may have contributed to this more recent decline: new agriculture methods, the use of rodenticides and insecticides which get passed up the food chain to the owls as well as the fact that they hunt along roadside verges and can become road casualties. They also do not survive well in wet and windy weather or prolonged cold and freezing conditions. In recent years, many people in the countryside (landowners, farmers, conservationists and birdwatchers) have invested a great deal of money, time and energy in an attempt to reverse this trend. In our area a former BOS member, Peter Burman, has been very involved with this work over the last 30 years. There was an active release programme in

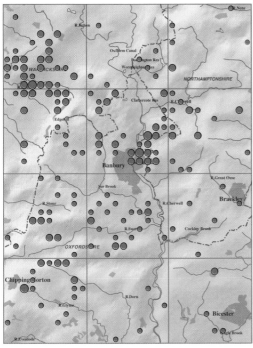

1km squares per year 1982–2011 for Barn Owl

Sightings in 1982–91 for Barn Owl

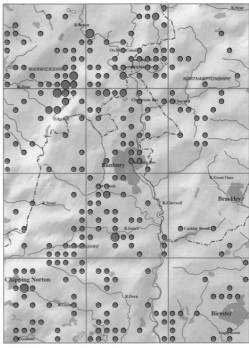

Sightings in 2002–11 for Barn Owl

which he participated that lasted until 2002. He also made and placed a large number of Barn Owl nest boxes throughout the BOS area and neighbouring districts which helped to compensate for the shortage of suitable nest sites, such as the loss of Elm trees and the conversion of many barns into dwellings. For 20 years he also collected Barn Owl pellets from both nesting and roosting sites, and his work on analysing the contents of 61,000 of these pellets was subsequently published in *Bird Study* (Meek *et al.* 2012). It was thought that Barn Owls' preferred food was Field Voles which led them to use habitats where Field Voles were likely to be found (i.e. areas of rough grassland). Analysis of the pellets showed that it is much more probable that prey items are taken simply in accordance with their availability and the predominance of Field Voles, where it occurs, is merely a reflection of that species' general abundance. Barn Owls seem perfectly capable of thriving in arable environments in which Wood Mouse replaces the Field Vole as the main prey species. The research study demonstrated that it was common to find pellets with a healthy live weight equivalent from completely arable areas and also to find pellets containing no Field Voles. Peter Burman's efforts have contributed to the increase of the species in our area and he continues to monitor the population of Barn Owls in the region. The chart and the maps show how Barn Owl numbers and distribution have changed over time. It has benefited from the increase in the number of nest boxes since 1982, although numbers have fallen in the last two years, possibly as a result of cold winters and two poor breeding seasons.

Little Owl *Athene noctua*
Fairly numerous resident

Birds were first introduced successfully in Kent (1874–80) and Northamptonshire (1888–90). By the end of the century there were two feral breeding groups that spread rapidly and by 1908 birds had reached the River Trent in the North and the River Severn in the West. The first recorded bird in the BOS area was at Horley in 1910. The Little Owl generally prefers open agricultural land with mature hedgerow trees. Sightings are more frequent between April and August and birds can often be seen sunning themselves, particularly in late summer. They feed on Earthworms, insects and other invertebrates all year round; Wood Mouse and Field Vole dominate the diet in years when these are abundant. The peaks on the charts may roughly correspond to the abundant years. Our ABSS of 1978 and 1979 produced a density of 20.16 pairs per 100 sq. km and the repeat survey of 2004 and 2005 gave a density of 26.87 pairs per 100 sq. km. The species has therefore maintained its status of *fairly numerous*. However, the chart, which shows the number of recorded 1km squares per year and the three-year moving average, indicates that since 2000 there is a slight downward trend. The CBC/BBS surveys also show a downturn in recent years and that there is probably a long-term decline in numbers.

1km squares per year 1982–2011 for Little Owl

Tawny Owl *Strix aluco*
Fairly numerous resident

Originally a bird of woodland, it can now be found in open agricultural land which has small copses or hedgerows with large mature trees. It also inhabits the town and village environment where there are churchyards, parks and large gardens. It is a difficult bird to monitor as it is nocturnal and research has found that if a calling pair of birds is found it does not necessarily mean they are a breeding pair. The ABSS of 1978 and 1979 revealed a density of 17.74 pairs per 100 sq. km and the repeat survey of 2004 and 2005 gave a density of 23.12 pairs per 100 sq. km. Tony Brownett, survey leader, concluded that the species had maintained its status of *fairly numerous*.

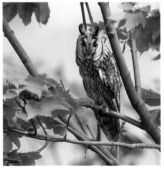

1km squares per year 1982–2011 for Tawny Owl

Long-eared Owl *Asio otus*
Rare resident

Described by Aplin (1889) as a scarce resident which used to breed in woodland localities, it may have also occurred as a winter visitor. The winter of 1975/76 produced a large influx of birds to Oxfordshire, with birds present in the Bicester area from December 1975 to March 1976. These were the first sightings since 1916. The next records were of single birds at Newbottle in May 1977, Edgcote in March 1981 and an injured bird picked up on the minor road between Hook Norton and Milcombe on 31 December 1981. Although breeding sites are very difficult to ascertain, a breeding pair was confirmed at Horley in 1981, the first recorded since 1850. More recent proof of breeding came on 9 May 2004 when three juveniles were located in a coniferous plantation at Radbourn. In 1989 a communal roost holding up to seven birds was found in the Kineton/Chadshunt area. The number of sightings per year (1984–2011) is shown in the chart; these represent 50 records from 21 sites covering 30 1km squares. Fifty per cent of the sightings have occurred during February and March with none in August.

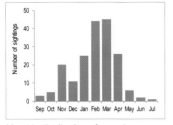

Monthly distribution of records 1984–2011 for Long-eared Owl

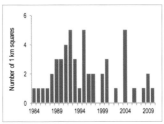

Yearly distribution of records 1984–2011 for Long-eared Owl

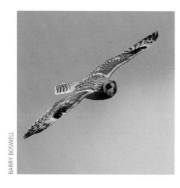

BARRY BOSWELL

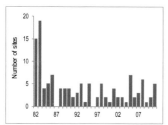

Monthly distribution of records
1982–2011 for Short-eared Owl

Sites per year 1982–2011 for Short-
eared Owl

Short-eared Owl *Asio flammeus*
Fairly frequent winter visitor

In the late nineteenth century the species was regarded as a scarce winter visitor as it was recorded only spasmodically. Aplin (1889) wrote, 'In February 1888, I flushed three together in a rough hassock meadow near Adderbury, and it is sufficiently well known to some people in the county to have the local name "Marsh Owl". It occurred on four occasions during 1920–27 and one bird was seen at Bloxham from June to December in 1945. A single bird was observed at Aynho in December 1969 and in the wet meadows around Grimsbury Reservoir during February and March in 1970. During the decade 1972 to 1981 the species was recorded in six of the ten years. The winter of 1978/79 was exceptional as birds were present throughout at Grimsbury, Poolfields and Banbury SF, where there were five birds on 15 December 1978. On 23 November 2011 a roost of 11 birds was recorded at Priors Hardwick and this built up to at least 16 birds by February 2012. The monthly distribution of records from 1982 to 2011 indicates that Short-eared Owls are most frequently observed during November to February, quartering rough grassland or wet meadows with tussocks. Whilst birds normally arrive in late October and leave by the end of April, the earliest recorded arrival date was 18 September and the latest departure date 13 May. The chart showing the number of recorded 1km squares per year demonstrates that, apart from the winter of 1982/83 where the species was recorded in 18 squares across the BOS area, in most winters

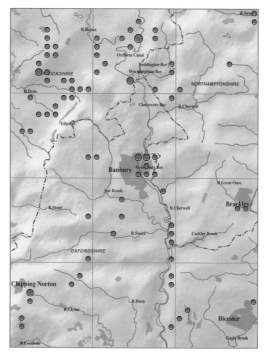

Sightings in
1982–2011 for
Short-eared Owl

birds are observed at up to five sites. The exceptions were the two winters of 1986/87 and 1995/96 when birds were absent.

Nightjars *Caprimulgiformes*

Nightjar *Caprimulgus europaeus*
Rare passage migrant
Nightjars were recorded six times between 1889 and 1960. The only sightings since then have been a male at Bloxham on 23–24 May 1967 and a male at Ditchley Park on 14 May 1995. From the eight sightings, five have occurred in May and three in August. Breeding has never been proved in the BOS area.

Swifts *Apodiformes*

Swift *Apus apus*
Numerous summer visitor
Parties of screaming Swifts are frequently seen and heard flying around our villages and towns during the summer. The majority of Swifts arrive in the last week of April or first week of May and depart from the end of July to mid-August. Passage birds may be seen over reservoirs or along the Cherwell Valley up to the middle of September. The earliest recorded date was 31 March 1982 and latest date 1 November 1994. Large numbers of birds can sometimes be seen over water, their appearance often preceding a thunderstorm. The largest flocks seen were of 1,000+ birds at Banbury on 9 May 1966, 700 birds at Boddington Reservoir on 21 June 1999 and 500 at Farnborough on 5 August 2006. Nationally, the Swift was considered to be an abundant and widespread species breeding in the majority of all towns and villages in the late 1990s. Its status had changed very little over the previous 100 years. Since the start of the BBS in 1994, however, there is evidence of a considerable decline in their population (see chart). As a result, Swift has recently been moved from green to amber on the BoCC list. Changes in climate may have affected wintering areas and migration routes thus contributing to a decline in numbers. Another factor that has certainly had an impact is the loss of traditional nest sites caused by the modernisation and refurbishment of buildings and, at the same time, new buildings do not provide suitable nest-places for Swifts. The BOS has recently linked up with Cherwell District Council to try to safeguard traditional nest sites. Members of the Society and other volunteers in the district are noting buildings used by Swifts for nesting, as well as trying to raise awareness of declining Swift numbers and encouraging homeowners and communities to be more Swift-friendly. A register of Swift nest-sites prepared by

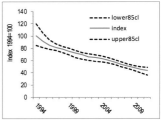

BBS index for Swift

the Thames Valley Environmental Records Centre enables Council planners to request that development work should take account of Swifts' nesting sites during building work. The project has also resulted in nest boxes being put up by some homeowners, boxes being installed in several church towers, and the Council incorporating nest sites in some of its new public buildings.

Kingfishers and relatives *Coraciiformes*

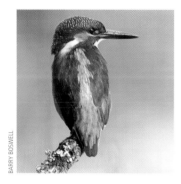

Kingfisher *Alcedo atthis*
Not scarce resident

Kingfishers can frequent any of our reservoirs, lakes, ponds, rivers and small streams. They are particularly vulnerable to winter weather fluctuations: if hard frosty weather persists for long periods and all waters become frozen over this affects the following year's breeding population. The Kingfisher can, however, have three or four broods per year and clutch sizes can be as high as six or seven, which gives them the capacity to restore the population relatively quickly. The first broods of Kingfishers are frequently fed on Bullheads but with subsequent broods they make use of the later abundance of Sticklebacks that move from streams into lakes and reservoirs. The ABSS of 1970 showed a complete recovery from the effects of the severe winter of 1962/63 with 13 pairs found, which placed the Kingfisher in the *not scarce* category. The repeat survey

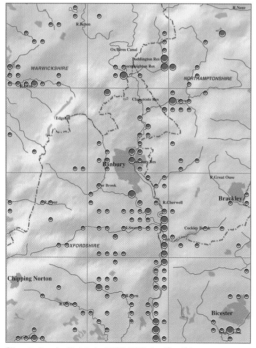

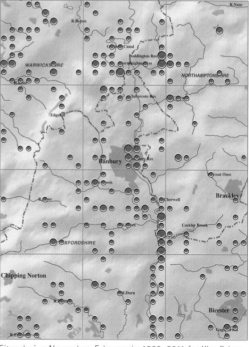

Sites during April–July in 1982–2011 for Kingfisher Sites during November–February in 1982–2011 for Kingfisher

in 1996 found only eight pairs which indicated that the local population had halved compared to 1970. The mean number of pairs per 100 sq. km was 0.67 compared to 1.63 in the first survey which still puts the Kingfisher in the status category of *not scarce* albeit at the lower end. The chart shows the number of recorded 1km squares per year for both the breeding season and throughout the year, indicating the extent of population fluctuation year by year and how numbers were affected by the cold winters of the 1980s, 1990s and 2010/11. The species tends to be distributed more widely during the winter months when it uses smaller streams and backwaters, hence the greater number of records in the November to February period (see maps).

1km squares per year 1982–2011 for Kingfisher

Roller *Coracias garrulus*
The only record was of one shot at Balscote in May 1869.

Hoopoe *Upupa epops*
Very occasional vagrant

Britain is at the NW edge of the Hoopoe's range and those that do occur are thought to be birds that have overshot their intended destination. All records have been of single birds, with 75% of records occurring between mid-April and the end of May. There were nine recorded sightings between 1840 and 1941. The table shows the number of records per decade since 1952. The most recent records were of single birds, at Harbury on 17–18 October 2002, Enstone on 27 April, at Glyme Farm, Chipping Norton from 27 April to 3 May 2003 and at Shenington on 1–6 November 2003.

Decade	1952–1961	1962–1971	1972–1981	1982–1991	1992–2001	2002–2011
Records	3	2	2	5	1	4

Woodpeckers and relatives *Piciformes*

Wryneck *Jynx torquilla*
Rare passage migrant

It was once a regular passage migrant and a scarce summer visitor but became rare by the late nineteenth century. It was observed in the area in 1927 and in 1959, which remained the only records until 1984. All the following records were of single birds during the period from late August until early October: Adderbury in August 1984, Boddington in September 1988, Hook Norton in September 1993, Kineton in October 1993, in September 2002 at Upper Tysoe and Chipping Norton and in September 2004 at Sulgrave.

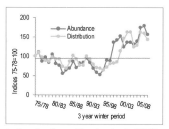

1km squares per year 1982–2011 for
Green Woodpecker

Green Woodpecker *Picus viridis*
Fairly numerous resident with extensive distribution

In the nineteenth century the species was considered a common resident inhabiting woods and parkland and was often seen feeding on open grassland. It can be seen from the WRSS chart that the indices fell below the starting figure of 1975–77 for many years and it was not until the late 1990s that an increase was seen. This is also illustrated by the indices of the SRSS, which although it was not started until 1991, shows the increase in the 2000s. Green Woodpecker population changes are probably related to two factors. First, as it is mainly a ground-feeding species severe weather conditions can make its prey unavailable. The second factor may well be related to modern farming practices. In the 1970s a lot of old permanent pasture was ploughed up for arable crops or had been fertilised and reseeded. This, together with a decline in sheep farming and the deliberate introduction of the myxomatosis virus, affected the amount of well-cropped grass which is necessary for diverse ant populations. During the ABSS of 1976, 17 breeding pairs were located in SP43, the preferred habitat being confirmed as old pasture land with ant hills. The repeat survey of 2002 found 25 breeding pairs which meant that species was at the higher end of the *fairly numerous* category.

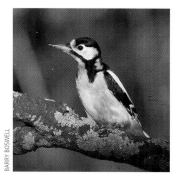

Indices for Green Woodpecker in WRSS

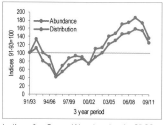

Indices for Green Woodpecker in SRSS

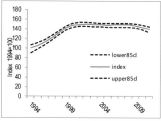

BBS index for Green Woodpecker

Great Spotted Woodpecker *Dendrocopos major*
Numerous resident with extensive distribution

Previous to 1900 Aplin considered that it was scarce and not so numerous as the Lesser Spotted Woodpecker. In 1967, Davies wrote that the Great Spotted Woodpecker was not as widespread as the Green Woodpecker. It also normally inhabited woodland and parkland but was seldom seen in open country. The 1975 ABSS concentrated on finding as many breeding pairs as possible in the 10km square SP43, which produced a maximum of six breeding pairs. Since then, however, the incidence of Dutch elm disease, which killed virtually all local Elm trees, favoured the spotted woodpeckers for several years. In the repeat survey of 2000, 18 pairs were recorded, showing a threefold increase. It was thought that when all the Elm trees had been removed numbers would decline. However, since 1988, the number of recorded 1km squares, both in the breeding season and throughout the year, has increased

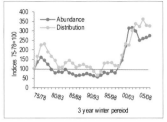

Indices for Great Spotted Woodpecker in WRSS

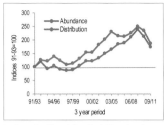

Indices for Great Spotted Woodpecker in SRSS

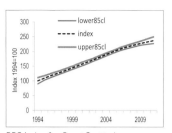

BBS index for Great Spotted Woodpecker

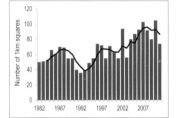

1km squares during the breeding season 1982–2011 for Great Spotted Woodpecker

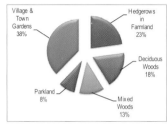

Major habitats 1982–2011 for Great Spotted Woodpecker

noticeably, reaching levels well above the highs of the 1970s. Both the WRSS and the SRSS have shown this increase (see charts). Analysis of the habitat codes from 10,000 records of the species indicates that it has moved into farmland, particularly where there are hedgerows with mature trees, and into built-up areas (see pie chart). Birds are now very commonly reported from many town and village gardens, particularly those that have feeders. Birds are often conspicuous during the winter period when trees are devoid of leaves and also when displaying early in the year. They can often be heard 'drumming' from January onwards and when excavating nest-holes during April, but during the laying and incubation period they become secretive and silent. After hatching, the chicks become very noisy, particularly when an adult lands on the tree with food, so nest sites can often be discovered by listening for the young birds' incessant calling.

Lesser Spotted Woodpecker *Dendrocopos minor*
Scarce resident with widespread distribution

In 1889 Aplin commented that the species was 'resident and is not at all uncommon, but, from its diminutive size, and its habit of frequenting the upper branches of tall forest trees is frequently overlooked.' Davies (1967) suggested that it was rather scarce and local in distribution but that the species was not seriously affected by the extremely cold spell of the winter of 1962/63. The table shows the number of sites per ten-year period since 1952. The ABSS of 1975 was conducted to establish the minimum number of breeding pairs in the 10km square SP43. It yielded two pairs in

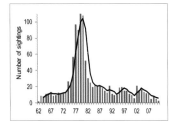

Records per year 1962–2011 for Lesser
Spotted Woodpecker

deciduous woodland and two pairs in garden/parkland habitat, which put it into the *fairly numerous* category. Other nest sites have been observed at Adderbury, Byfield, Great Tew, Horley, North Aston, and Thenford. In 1976 in a private garden at Sibford Gower, a nest site was excavated in a Victoria Plum Tree less than 3m from the ground and only 10m from the kitchen window while other located nests were more than 8m from the ground. The species has declined from its high levels of the late 1970s and early 1980s when Dutch elm disease was most prevalent. Since 1988, the number of breeding records has declined quite noticeably such that the repeat ABSS in 2000 found no pairs in SP43 and across the whole area it is now in the *scarce* category. The chart shows the number of sightings per year from 1962 to 2011 where the bulge from 1974 to 1984 represents the period that Dutch elm disease was at its height. The loss of suitable habitat, such as orchards, may also be contributing to the decline. Like the Great Spotted Woodpecker, they are very quiet during egg laying and incubation. After the chicks are hatched their constant calling, particularly when an adult lands near the nest hole, can be heard from quite a distance.

Decade	1952–1961	1962–1971	1972–1981	1982–1991	1992–2001	2002–2011
Sites	9	41	44	88	67	47

Perching Birds *Passeriformes*

Orioles *Oriolidae*

Golden Oriole *Oriolus oriolus*

There were four records during the late nineteenth century: a bird shot at Chipping Norton in 1862, two adult males shot at Great Tew in 1880, a single bird seen at Bloxham Grove in 1870 and a pair seen at Bourton in 1891. The next records occurred 70 years later: an immature singing male at Rousham in June 1963, one at Wroxton in June 1964 and an adult male singing at Glympton on 30 May 1965. These remain the only records.

Shrikes *Laniidae*

Red-backed Shrike *Lanius collurio*
Rare passage migrant
Before 1900 the species was considered a *scarce summer visitor*
with one or two pairs breeding in most years. The former known
breeding haunts were situated near Banbury, Bloxham, Milcombe,
Bourton, Tadmarton and Wykham but the last breeding record was
in 1957. A female was recorded at Swalcliffe in May 1963. The
next sightings were in 2001 when a single female was observed at
Boddington Reservoir on 5 August and a single juvenile bird there
on 27 August.

Great Grey Shrike *Lanius excubitor*
Rare winter visitor
Birds were recorded ten times between 1844 and 1901 and then not
again until 1951. The table shows the number of sightings in each
of the decades since the start of the BOS. Birds have been recorded
between late October and early April. The latest records were of
single birds in the Radway/Kineton area, at Barnrooden Farm in
January/February 2003 and at Whatcote in January 2008.

BARRY BOSWELL

Decade	1952–1961	1962–1971	1972–1981	1982–1991	1992–2001	2002–2011
Sightings	3	5	4	1	1	3

Corvids *Corvidae*

Magpie *Pica pica*
Numerous resident with widespread distribution
The species showed a dramatic increase up until the late 1980s/
early 1990s and numbers then declined. This may be due to Larsen
traps which are often used on shooting estates and Pheasant-
rearing farms to control predators. Birds are frequently seen in pairs
but larger groups of up to ten birds are not uncommon. The three
largest groups recorded were of 42 birds at Overthorpe in January

TREVOR EASTERBROOK

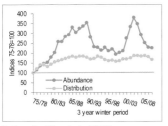

Indices for Magpie in WRSS

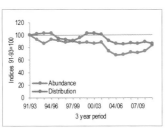

Indices for Magpie in SRSS

DEREK HALES

1989, 36 at Banbury SF in February 1995 and 33 at Wormleighton in March 2004. The WRSS chart shows that the distribution index increased from 1975 until the 1990s and then remained fairly constant whereas the abundance index shows much more variation throughout.

Jay *Garrulus glandarius*
Fairly numerous resident with widespread distribution
The Jay is a species of deciduous woodland and parkland though in the last five years it has been more frequently recorded in village gardens. Though usually seen in ones or twos, the largest numbers seen together were 15 birds at Tadmarton in November 2004 and 13 in Great Tew Park in October 1993. The national picture from CBC and BBS shows that the species increased up to the mid-1980s, then declined until the mid-1990s and since then it has been increasing. Our WRSS and SRSS indices also support these findings (see charts).

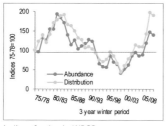

Indices for Jay in WRSS

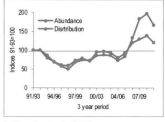

Indices for Jay in SRSS

TREVOR EASTERBROOK

Jackdaw *Corvus monedula*
Abundant resident with widespread distribution
Jackdaw numbers have increased over the last 30 years in the BOS area (see WRSS chart) which is also true nationally. The increase is possibly due to better breeding performance and could also reflect their generalist feeding habits. As many houses have been converted to central heating, chimneys have become redundant and are therefore available as nesting sites for Jackdaws. When roosting, flocks of 200–400 birds are not uncommon but exceptionally large flocks have been recorded. The three largest were 1,500 at BAD Kineton in January 2009, 1,000 at Fenny Compton in November 1996 and 1,000 at Charlbury in July of the same year.

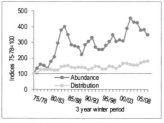

Indices for Jackdaw in WRSS

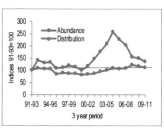

Indices for Jackdaw in SRSS

Rook *Corvus frugilegus*
Abundant resident with extensive distribution

Rook surveys covering the whole of the BOS area took place in 1975, 1991, 1998 and 2006 though this last survey only covered 11 of the 12 10km squares. The first three surveys indicated stability in the Rook population; in 2006, and calculating over an equivalent area, there was a percentage increase of 9% on the 1998 survey. The median size of rookeries was 32 nests in 2006 and the largest rookery consisted of 372 nests in 84 trees at King's Spinney, Rousham compared with 212 nests at Steane in 1998. The number of small rookeries (25 or fewer nests) continued to fall compared with 1975. Most rookeries, well over 80% of all nests, were situated in blocks of woodland, primarily deciduous and mixed woods. The most popular host trees were Ash, Pedunculate Oak and Scots Pine, accounting for over 60% of all recorded nests. Prior to the advent of Dutch elm disease the preferred nesting tree in this part of the country had been the English Elm. The tables summarise part of the data (for further details see *BOS Annual Report 2006*). The two largest flocks recorded were of 1,000 birds at Hook Norton in July 1995 and 900 at Mollington in January 1986.

Survey Year	1975	1991	1998	2006
Total nests	7,711	7,787	8,338	8,627

Survey year	Number of nests per 1km square					Total squares
	1–10	11–25	26–50	51–100	100+	
1975	61	96	74	29	8	268
1991	33	55	64	45	9	206
1998	32	66	63	38	14	215
2006	25	55	63	46	14	203

TREVOR EASTERBROOK

Carrion Crow *Corvus corone*
Abundant resident with extensive distribution

Nationally, population numbers have increased steadily since 1960 and this probably reflects its ability to adapt to various habitats. The numbers killed by gamekeepers show little effect on the size of the Crow population, despite the use of Larsen traps which certainly seems to have curbed Magpie numbers. The evidence can be seen in the BOS area with the increase in the abundance index in both the SRSS and WRSS even if the distribution index remains fairly constant because almost every square surveyed contains at least one pair. Crows are usually seen in small numbers but exceptionally large flocks can occur, particularly at roosts or at refuse tips. The three largest recorded congregations were of 1,000 birds at Ardley Fields Quarry on 13 September 2009, 450 at Alkerton refuse tip in February 1990 and 300 at Kirtlington in January 1986.

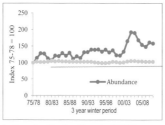

Indices for Carrion Crow in WRSS Indices for Carrion Crow in SRSS

BARRY BOSWELL

Raven *Corvus corax*
Not scarce resident

The species may have been resident in the past as the name 'Raven Hill' occurs near Nether Worton on early maps, probably denoting a former well-known breeding site. The only early records were of two birds seen at Tusmore Park in 1841 and one shot at Astrop Park in 1877. The next occurrence was of a single bird flying SW at Preston Capes on 20 August 1970. It was not until January and February 1998 that birds began to be seen at Radway, Chadlington and Avon Dassett, and from then onwards many more sightings have occurred. It has now been recorded in 330 out of the possible 1,200 1km squares of the BOS area. The first confirmed breeding was in 2001 and there are now 12 positive breeding sites, many in conifers and particularly Scots Pines. The majority of sightings have been of one or two birds but records of 5–15 birds are not uncommon. In the Hellidon/Catesby areas 30–50 birds were recorded during 2009 and 15–30 at Mantles Heath. Its expansion across the area from the west has been relatively quick as shown by the chart and maps.

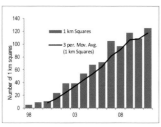

1km squares per year 1998–2011 for Raven

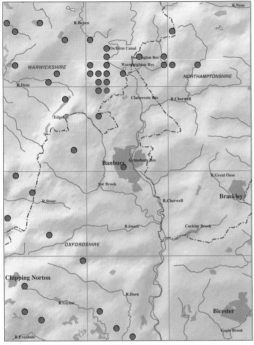

Sightings in 1998–2001 for Raven

Sightings in 2002–05 for Raven

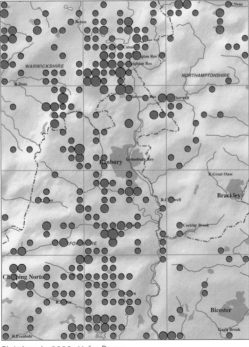

Sightings in 2006–11 for Raven

Kinglets *Regulidae*

Goldcrest *Regulus regulus*
Numerous resident
Goldcrest is mainly associated with coniferous woodland but any area containing conifers, such as churchyards, parks and gardens may well contain birds. They can be easily overlooked because of their very high-pitched call and song that is inaudible to some observers. Cold weather, with prolonged low temperatures, snow and ice or hoarfrosts that last for many days, affects the species badly. There was a national decrease of 60% during the prolonged hard winter of 1986/87 but numbers recovered well in the following breeding seasons. From our WRSS results, the troughs on the related graph show the cold winters and how numbers have decreased in those years. Since the mid-1990s numbers have increased and are well above the 1975/77 figures though the effects of the cold winters of 2009/10 and 2010/11 are also apparent. Birds have been recorded in 32% of all the squares surveyed. Our SRSS, which does not cover as many 1km squares as the WRSS and only began in 1991, suggests that the Goldcrest is becoming more widespread with a slight increase in numbers.

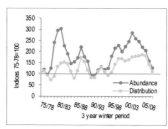

Indices for Goldcrest in WRSS

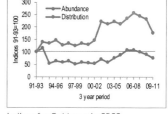

Indices for Goldcrest in SRSS

Firecrest *Regulus ignicapilla*
Rare casual visitor
An adult male was killed near Banbury in December 1881 and the next record was not until September 1971. Single birds were then observed at Badby in April 1979 and two at Avon Dassett in September of the same year. Since then there have been 54 sightings from 15 areas, with breeding recorded at Badby, Whichford and Oakley Woods. The photograph was taken by Anthony Temple in his garden at Hellidon in 2009. The table shows the number of sightings per year since 1983.

Year	1983	1984	1995	1996	1999	2000	2003	2004	2005	2006	2007	2009	2010	2011
Sites	1	1	1	1	2	2	4	3	2	2	1	1	1	1

Tits *Paridae*

Blue Tit *Cyanistes caeruleus*
Abundant resident with extensive distribution

In 1889 Aplin commented that the Blue Tit was the most abundant of all the tits. This is still true today: it is the most widely distributed and is found in a very wide variety of habitats, greater than any other tit. It has occurred in 94% of all the 1km squares that have been surveyed. From the WRSS data it is on average 1.5 times more abundant than the Great Tit and 15 times more abundant than the Coal Tit. SRSS data shows that numbers of Blue Tits have been increasing since 2003, which replicates the trend in the national CBC/BBS findings. Feeding in gardens during the winter and their ability to nest in any suitable hole, such as those found in trees, walls and pipes, as well as making use of conventional nest boxes, may have aided this increase.

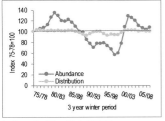

Indices for Blue Tit in WRSS

Indices for Blue Tit in SRSS

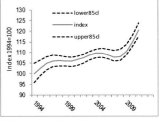

BBS index for Blue Tit

Great Tit *Parus major*
Abundant resident with extensive distribution

Great Tits can be seen in a variety of habitats across the BOS area. It is more commonly found in gardens and deciduous woodland and tends to avoid farmland, particularly where the hedgerows are low and devoid of trees. It has been found in 86% of the squares surveyed in the WRSS. Its persistent calls and distinctive song make the Great Tit easily recognisable and it can be heard on mild days in January. Like the Blue Tit it has exploited the increasing and widespread use of garden bird feeders and nest boxes which may be one explanation for the improvement in numbers shown in both the WRSS and SRSS since 2000. Recent national CBC/BBS results suggest that this increase is continuing across the UK.

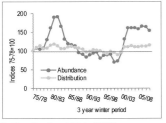

Indices for Great Tit in WRSS

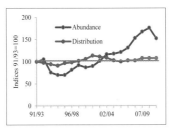

Indices for Great Tit in SRSS

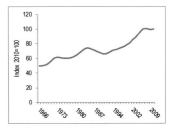

CBC/BBS index for Great Tit

TREVOR EASTERBROOK

Coal Tit *Periparus ater*
Numerous resident with widespread distribution

The Coal Tit is, in general, much more sedentary than Blue, Great and Long-tailed Tits. Sometimes large numbers can be seen in winter flocks; the largest number encountered was 65 birds in two flocks in Oakley Wood on 9 February 1997. It generally prefers coniferous woodland but can be found in deciduous mixed woods and in any small stands of conifers in parks and gardens. Its persistent fine clear 'sitchu' call can be heard from late winter. More widespread than the Marsh Tit, it has been found in 22% of squares in the WRSS. The charts of abundance and distribution in the WRSS show clearly how cold harsh winters affect the Coal Tit population and how quickly numbers can be built back up in the following years.

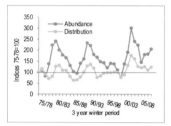

Indices for Coal Tit in WRSS

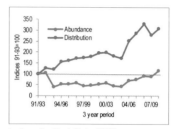

Indices for Coal Tit in SRSS

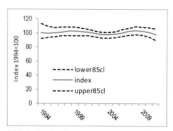

BBS index for Coal Tit

Willow Tit *Poecile montana*
Scarce resident

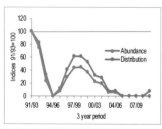

Indices for Willow Tit in WRSS

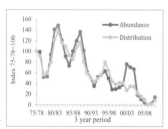

Indices for Willow Tit in SRSS

When Aplin wrote *The Birds of Oxfordshire* in 1889, the Willow Tit was not yet included on the British bird list as a separate species. It was only recognised and accepted well into the twentieth century. The species has a sedentary nature; it prefers scrub and mixed damp woodland with a good shrub layer and some rotting wood but can occasionally be found in thick hedgerows and in gardens. The BOS carried out pioneer surveys in 1964 and 1965 to determine density levels of Willow Tit in the Banbury area, finding 36 breeding pairs in 600 sq. km in 1965 (Brownett 1966). The ABSS of 1982 found 24 pairs in 108 sq. km; in the repeat survey of 2008 there were only five pairs in 82 sq. km. Since then the species has declined further as the charts of WRSS and SRSS illustrate. This now puts Willow Tit into the *scarce* category though there are a few strongholds left in the BOS area, mainly to the north of Banbury. The national picture is that the Willow Tit has been declining since the mid-1970s and is now on the BoCC red list. It is thought that a likely reason for the decline is the deterioration in the quality of woodland. This affects Willow Tits' feeding habitats both as the canopy closes over and the shrub layer is destroyed by browsing deer.

Marsh Tit *Poecile palustris*
Fairly numerous resident with widespread distribution

Marsh Tit is one of the species for which all sightings are required and, since 1982, our record system has also made it mandatory to provide a habitat code for each record. Analysis of these codes reveals habitat differences between Marsh and Willow Tits, as shown on the chart. Marsh Tits are mainly found in deciduous mixed woodland, good thick hedgerows, copses, spinneys, scrub with good shrub layer and in gardens. The ABSS of 1982 found 33 pairs in 108 sq. km and from this information the species was categorised as *numerous*. The repeat survey of 2008 produced only 15 pairs in 82 sq. km. This meant that Marsh Tit has dropped into the *fairly numerous* category. The indices of abundance and distribution in the WRSS and SRSS show fluctuations over time with decreases corresponding with cold winters. The SRSS index of abundance shows a marked decline since 1991. Marsh Tit abundance has declined nationally for many years with the species now being placed on the BoCC red list. The damage to the shrub layer caused by overgrazing by deer or by canopy closure can seriously affect Marsh Tits as they appear to select breeding territories based on the quality of that shrub layer.

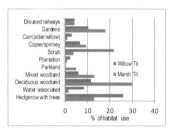

Habitat usage 1982–2011 for Marsh and Willow Tits

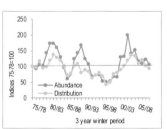

Indices for Marsh Tit in WRSS

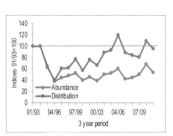

Indices for Marsh Tit in SRSS

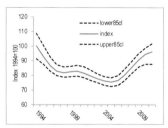

BBS index for Marsh Tit

Babblers and Laughing Thrushes *Timaliidae*

Bearded Tit *Panurus biarmicus*
Rare vagrant

The species is listed in *History of Banbury* (Beesley 1841) and it is more than likely that the species had a much wider national distribution than it does today. The first definite record was of a bird seen in a patch of marshy ground at Bloxham in 1933. The only other sightings were two females present at Fawsley on 12 February 1967 and a female there on 16–19 April 1967, a pair in the reed-bed at Grimsbury on 23–24 October 1971 and a female at Banbury SF on 30 October 1985. A single male bird was recorded at Bicester Wetland Reserve on 14 November and 12 and 17 December 2012.

Birds of the Heart of England

Larks *Alaudidae*

Woodlark *Lullula arborea*
Rare casual visitor
The only definite early records were at Balscote in 1892 and Edgehill in 1898 after which it was not seen again until 1958. The only recent sightings are of a single bird flying at Wormleighton on 16 October 2001, one flying and calling at Fenny Compton on 6 October 2002 and one observed on set-aside at Priors Hardwick on 21 April 2004 before being chased off by Skylarks.

Skylark *Alauda arvensis*
Numerous resident
Until the 1970s all the evidence suggested that the Skylark was an *abundant resident*, its effusive and melodious song heard in almost all fields. From the mid-1970s to mid-1980s there was a severe decline in the population nationally, particularly on farmland (see chart). A possible explanation for this decline is the reduction in their preferred foods (cereal grain, weed seeds and insects) as a result of more efficient methods and widespread use of pesticides. More spring cereals, less intensive and more mixed farming together with a greater diversity of crops would benefit the species. Birds tend to flock together in the winter and can sometimes be found in large flocks in stubble or arable fields. In really severe winters birds move out of our area. The chart shows the largest flock recorded in each winter. In February 1991 a flock of 300 birds was regularly observed at Aynho and near the end of the month the flock gradually increased to an exceptionally large flock of 1,000+ birds. This figure was not included in the chart as it would distort the scale so the average flock at the site was used instead. The WRSS chart shows that since 1975 the distribution index has dropped by 30% and the abundance index has dropped by 65% but over the last few years has not declined as fast. The SRSS index, which started in 1991, has not shown such a dramatic decline in our area, with the distribution index remaining more or less constant and the abundance dropping slightly.

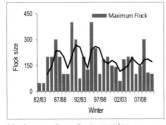

Maximum winter flock 1982/83–2010/11 for Skylark

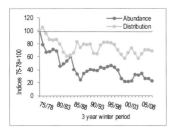

Indices for Skylark in WRSS

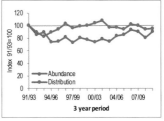

Indices for Skylark in SRSS

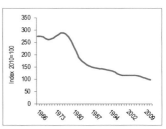

CBC/BBS index for Skylark

BARRY BOSWELL

Swallows and Martins *Hirundinidae*

Sand Martin *Riparia riparia*
Scarce summer visitor and very frequent passage migrant

This small delicate bird arrives in late March and leaves again late September/early October. The earliest arrival date is 15 March 1994 and latest departure date 14 October 1995. The first birds sighted are normally those on passage and are seen over large expanses of water at reservoirs and larger lakes. The later arrivals usually stay and breed. Nesting has occurred spasmodically in the area since 1884 with birds nesting in colonies in sand-pits and sometimes in suitable river banks. In the 1950s and 1960s the constant opening and closing of sand-pits affected the number of breeding pairs. Steeple Aston pit held a colony that existed between 1952 and 1961. There were 50 pairs nesting there in 1958 and only two pairs in 1961. Small colonies were also recorded at North Aston and Tadmarton Heath in the mid-1950s. The main sand-pit at Duns Tew held 80 nests in 1957 and was abandoned in 1958 although 20–30 pairs were found in nearby pits. However, throughout the 1960s birds were using the main pit again, reaching a maximum of 100+ nests by 1968. Nationally, numbers crashed in 1969–70, thought to be due to drought conditions in the Sahel region of West Africa. In *The State of the Nation's Birds* (2000) Chris Mead of the BTO estimated the national population in 1984 to be only 10% of the population of the mid-1960s. Breeding colonies were not recorded in the BOS area from the early 1970s to 1980. A small colony of 30 pairs was established at Fawsley in 1981 and this remained for a few years with a maximum of 30 pairs in 1983. Birds have been recorded at the Duns Tew sand-pits from 1983 until the present day. The colonies there have varied in size from 10 pairs to 30 pairs though in 2011 there were at least 100+ pairs breeding throughout the complex. In 2003, at the BOS Reserve at Balscote Quarry, a tower of sand was constructed in the hope of enticing Sand Martins to nest. Eight years later, in 2011, four pairs began to use the tower as a breeding site. The largest recorded flocks were of 700 birds feeding in rain at Boddington Reservoir on 26 August 1998 and 430 at Lighthorne Quarry on 11 September 2002. On 18 September 2004, 1,350 birds on passage were counted in an hour flying over Farnborough.

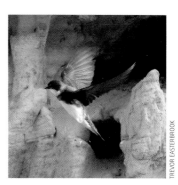

TREVOR EASTERBROOK

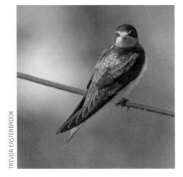

TREVOR EASTERBROOK

Swallow *Hirundo rustica*
Numerous summer visitor

Birds arrive from late March to early April and depart late September/ early October. The earliest arrival date was 5 March in 1997 and 2003 and the latest date was 25 November 1960 when four birds were seen at Kings Sutton. The Swallow population can fluctuate widely from year to year and serious drought conditions in the western Sahel region also affect the numbers returning. Nationally the CBC indices declined between 1980 and 1988 with the Swallow population half that of the 1960s, even if numbers did improve in the following years. However, there are variations across the country with the eastern arable areas showing a decline which is also particularly noticeable in the BOS area. This has been attributed to improved hygiene on farms, loss of livestock farming and grazed grassland, together with arable intensification and modernisation of farm buildings. These factors reduce the number of both suitable nest sites and the insects Swallows feed on. Very large roosts used to occur in reed-beds in August and September during the 1950s and 1960s. The largest recorded roost was of 3,000+ birds on 11–12 September at Wormleighton in 1968. The next highest roost numbers were 600 at Sibford in August 1977 and a pre-roost group of 400 birds at Boddington Reservoir on 28 August 1995. During the 20 years from 1962 to 1981 nearly 3,000 birds were ringed, mainly at the Grimsbury reed-bed roost, with less than 1% subsequently recovered or controlled. Four recoveries in South Africa back up evidence of British Swallows wintering there and controls in both Spain and Malta indicate the broad migration front. Glyn Davies, one of the founder members of the BOS and organiser of the ringing section from 1962 to 1981, was also involved in 1965 with the Malta Ornithological Society training local ornithologists in ringing and fieldwork techniques. While he was on the island of Gozo just off Malta, he ringed a large number of Swallows in the early spring of 1974. In the autumn of the same year he was catching and ringing Swallows at the Grimsbury reed-bed and extracted a ringed Swallow from a mist net. He was amazed to find that he had actually ringed this same bird in Malta in the spring.

House Martin *Delichon urbicum*
Numerous summer visitor

Birds normally arrive a week or so later than Swallows, from mid-April through to the first week of May and leave again at the end of October. The earliest recorded arrival date was 25 March 1995 and latest date 4 December 1981. Birds nest on the outer walls or under eaves of buildings. House Martins can return to previous years' sites but also take advantage of new housing developments. Often this is only temporary as not all householders are tolerant of the mess made by a nesting pair, which means that local populations are very mobile and can fluctuate widely. Tony Brownett has

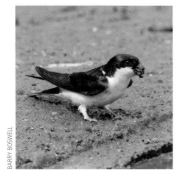

BARRY BOSWELL

studied nests in the village of Bloxham since 1990 and has found that the number of occupied nests can vary from year to year, with a highest count of 42 nests in 2006 down to only ten nests in 2010. House Martins can be double or treble brooded and it is not uncommon to see young being fed in nests in early October. Large flocks of 500–800 House Martins are occasionally reported feeding over the reservoirs of Boddington, Grimsbury and Wormleighton during late August and September. The highest number recorded was 1,000+ birds at Boddington Reservoir on 29 September 1999. Several of these records have occurred during periods of rain, as this may force insects to congregate over the water. Nationally, because of the moderate decline in the CBC results from 1974 to 1999 the species was moved from green to amber on the BoCC list.

Bush Warblers *Cettiidae*

Cetti's Warbler *Cettia cetti*
Rare casual visitor
This skulking warbler of damp scrubby areas, with a loud explosive burst of song, was first recorded at Wormleighton on 29 October 1999 and over-wintered there until 8 March 2000. Another bird was recorded over-wintering at Chesterton Pools from October 2005 until March 2006. Up to two birds were recorded at Wormleighton during the winter of 2006/07. Single birds were also recorded at Northbrook in April 2006 and again in late October 2009 and at Wormleighton, also in October 2009. Passage birds were seen or heard in late September at Byfield Pool and Priors Hardwick in 2008.

Long-tailed Tits *Aegithalidae*

Long-tailed Tit *Aegithalos caudatus*
Fairly numerous resident with extensive distribution
Long-tailed Tits favour deciduous and mixed woodland, particularly those with a well-developed shrub layer, and are often found along the woodland edge. They can also be found in scrub with scattered trees, bushes and hedges on farmland and in parks and gardens. Their loud 'chirrup chirrup' calls can easily be heard well before they arrive. Birds often forage for food in large groups following along the tree line. The three largest recorded flocks were of 52 birds at Milcombe on 21 August 2010, 50 at Oakley Wood on 5 December 1999 and 49 at Ditchley on 28 January 1999. A major factor which can affect the population is severe winters, particularly those with prolonged hard frosts. They do, however, have the ability to quickly replace their numbers over a few breeding

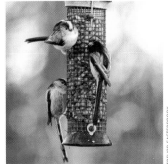

TREVOR EASTERBROOK

seasons. Records show that, over the last few years, birds have learnt to visit garden feeding stations and feed on fat-balls. As a greater number of people are now feeding birds, this may be a reason why birds have better survived more recent cold winters. The results of the WRSS and SRSS show the increase over the last few years, especially in the WRSS where birds have been observed in 37% of all squares surveyed.

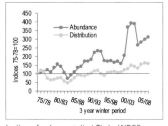

Indices for Long-tailed Tit in WRSS

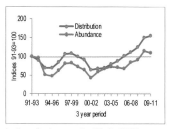

Indices for Long-tailed Tit in SRSS

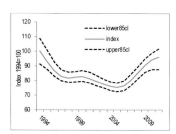

BBS index for Long-tailed Tit

Old World Warblers *Sylviidae*

Yellow-browed Warbler *Phylloscopus inornatus*
Rare vagrant
A single bird was seen and heard in a hedgerow by a feeder stream to Boddington Reservoir on 18 October 1993. The bird was first located by its frequently repeated call and was clearly seen for brief periods. This was the first and only record for the BOS.

Wood Warbler *Phylloscopus sibilatrix*
Fairly frequent passage migrant and rare summer visitor
Aplin, in his diaries (1967), records a pair at Bloxham in 1880 and 1901, two males and a female at Great Tew in 1890 and single birds at Wigginton in 1901 and Epwell in 1902. Birds could be found breeding at Edgehill and Great Tew until the late nineteenth century. For the next 60 years the species was unknown in the Banbury area until two singing males appeared at Edgehill in 1965. Brownett, in the BOS newsletter of July 1966, comments that 'the recent spate of records has come about as a result of a better coverage of the area and the species being overlooked in the past.' The chart shows that there is a yearly variability of occurrences; no birds were recorded within the period 1995–2003. The majority of records have occurred from late April until the end of May with a few in June, July and August. From 1978 to 1981 birds were recorded breeding at Badby Woods.

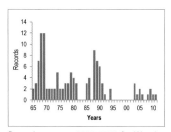

Records per year 1965–2011 for Wood Warbler

Chiffchaff *Phylloscopus collybita*
Numerous summer visitor with a few birds over-wintering

Their favoured habitat is broad-leaved woodland with a good shrub layer though they can also be found in parkland, farmland with copses and tall hedgerows. They prefer more mature trees where they feed mostly in the tree foliage. Aplin (1889) wrote that 'it is a common summer migrant but not nearly so plentiful as the Willow Warbler'. This was still the case until the 1990s but it would now appear that the Chiffchaff is more abundant and Willow Warbler numbers have decreased. Chiffchaff numbers crashed in the late 1960s and early 1970s, in common with other trans-Saharan warblers (Siriwardena *et al.* 1998). After remaining stable for a decade, the population recovered strongly and has continued to increase as is evident from both CBC and BBS national data. The indices of distribution and abundance from our SRSS also indicate this trend (see chart). The largest number counted at one site was at Wormleighton where a fall of 85 birds was recorded on 2 September 2003. Birds arrive from the second week in March and stay until mid-October, average dates being 19 March and 13 October. The first winter record was a bird at Chadlington on 28 December 1980; since then birds have been recorded in nearly every winter. The chart shows the number of recorded sites per winter.

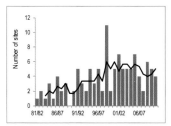

Over-wintering sites per winter 1981/82–2010/11 for Chiffchaff

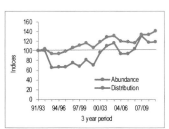

Indices for Chiffchaff in SRSS

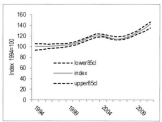

BBS index for Chiffchaff

Iberian Chiffchaff *Phylloscopus ibericus*
Rare summer visitor

A single singing bird was heard at Great Tew on 26 April 2000 by Una Fenton and was later seen, heard and identified by several other members. It was submitted and confirmed by the BBRC.

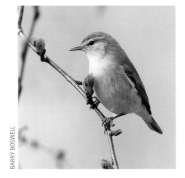

Willow Warbler *Phylloscopus trochilus*
Numerous summer visitor

Birds normally arrive at the end of March/early April with the earliest recorded arrival date being 4 March 1982 and the latest departure date 20 November 1994. Their preferred habitat is woodland edge, scrub and young plantations including conifer. Willow Warblers tend to feed low down in the shrub layer more frequently than the Chiffchaff. Aplin (1889) stated that the Willow Warbler was the most abundant and most widely distributed of all the warblers. This state of affairs continued up until the 1990s but since that time numbers in the BOS area have steadily decreased as is illustrated by the results of the SRSS in the chart.

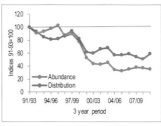

Indices for Willow Warbler in SRSS

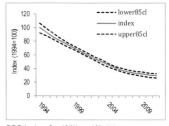

BBS index for Willow Warbler

Blackcap *Sylvia atricapilla*
Numerous summer visitor with a few birds over–wintering

Before the late 1970s Blackcap preferred woodland and copses with a good shrub layer. Since then, numbers nationally have steadily increased and, as they have done so, some birds have been forced into farmland, particularly where there are good hedgerows and shrubby areas. The Blackcap is now one of our most widely distributed warblers. The small numbers over-wintering are mainly continental breeding birds which form one population, the other being summer migrant breeding birds. The latter usually arrive in late March or early April and depart from mid to late October. The charts show the upward trend in Blackcap numbers for both breeding and over-wintering populations.

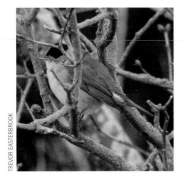

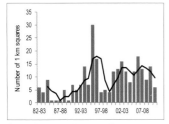

Over-wintering sites per winter 1982/83–2010/11 for Blackcap

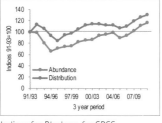

Indices for Blackcap for SRSS

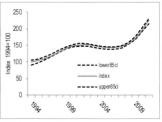

BBS index for Blackcap

Garden Warbler *Sylvia borin*
Numerous summer visitor

Male birds arrive first, from mid-April to early May, followed by females a week or so later. The earliest recorded arrival date is 22 March and the average date 22 April. Birds are often secretive and sing their fast-flowing pleasant warble from within the habitat rather than on prominent perches. They are found along woodland edges, and in woodland with thick undergrowth, new plantations including conifers, copses with tangled bushes, tall scrub and dense overgrown hedgerows. Birds depart from mid-September until early October though a very late bird was observed at Glyme Farm on 8 December 2001. National evidence shows that the population of Garden Warblers declined between 1970 and 1976 with a recovery thereafter, but there now seems to be evidence of a shallow decline (BTO 2011). The only data the BOS has on the Garden Warbler, apart from first and last dates, is that from the SRSS, and the chart shows fluctuations in abundance and distribution since the survey started in 1991; short-term fluctuations are also found in the national CBC/BBS and CES data, both of which also suggest that the population may be in long-term decline.

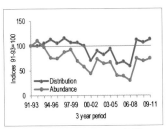

Indices for Garden Warbler in SRSS

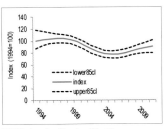

BBS index for Garden Warbler

Barred Warbler *Sylvia nisoria*

The only known record was of a single bird at Bloxham in the autumn of 1888.

Lesser Whitethroat *Sylvia curruca*
Fairly numerous summer visitor

Male birds usually arrive in the last week of April with females following a fortnight or so later; the earliest recorded arrival date was 24 March at Barford. Birds arrive from an easterly direction rather than a southerly one as many other warblers do. Birds depart during September and early October with our latest record being 28 October. Although droughts in the Sahel region do not affect populations of the Lesser Whitethroat because they migrate SE to their winter quarters in north-east Africa, there have been substantial droughts in that area since the mid-1970s. This, together with the variable weather patterns on their migration routes, may explain the fluctuations in their numbers over many years. Birds

begin to sing as soon as they arrive, tend to go quiet by the middle of June and then have a second singing session later in the summer. They usually remain well hidden, singing their rattle-type song, with or without some warbling, from dense cover. Thick hedgerows, used and disused railway edges, dense scrub and woodland edge are their favoured habitats. Our ABSS survey of 1984 and the repeat survey of 2010 showed that birds had a underlying preference for habitats associated with permanent pasture. The initial survey, together with our records, placed the Lesser Whitethroat in the *numerous* category but the survey in 2010 indicated a reduction in status to *fairly numerous*.

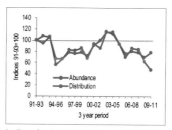

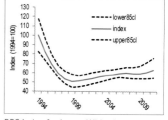

Indices for Lesser Whitethroat in SRSS BBS index for Lesser Whitethroat

Whitethroat *Sylvia communis*
Numerous summer visitor

Males normally arrive in mid-April with the earliest recorded arrival date 9 April, and the females follow about a fortnight later. The Whitethroat is less secretive than other warblers: its scratchy song can frequently be heard and their dancing flight seen along the top of hedgerows throughout the area. It is found in habitats with hedgerows which have tangled vegetation nearby, woodland edge, scrub with bushes and young plantations. Due to severe droughts in the Sahel region in the 1960s, their wintering area was severely damaged and between the breeding seasons of 1968 and 1969 the population decreased by 70%. Nationally, numbers remained low until the mid-1980s but since then they have shown a recovery. The SRSS chart shows how the indices for abundance and distribution have fluctuated in the BOS since 1991 with a marked increase since 2006, similar to the BBS index for SE England.

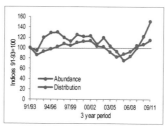

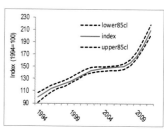

Indices for Whitethroat in SRSS BBS index for Whitethroat

Dartford Warbler *Sylvia undata*

This species may well have been a rare resident on the heathlands that used to exist in the area. The last confirmed record was at Milcombe Gorse in 1891.

Grasshopper Warbler *Locustella naevia*
Scarce summer visitor

Male birds, with their distinctive reeling calls, are usually heard from mid-April onwards, the earliest recorded date being 11 April. Many of the early records are of birds passing through on migration. Young conifer plantations, Bramble, scrub with long grass, disused railway embankments or similar sites are often chosen for breeding and the chart shows the fluctuation in the number of 1km squares during the breeding season from 1982 to 2011. The evident decline is mirrored by the findings of the ABSS surveys where in 1969 there was a breeding density of 7.40 birds per 100 sq. km and in the repeat survey of 1995 this had dropped to 1.08. In the 1970s and 1980s there were many new small conifer plantations across the BOS area but by the 1990s these trees had matured and few new conifers were being planted. This loss of one of the most suitable habitats, together with the national decline, may be part of the reason for the decrease in sightings in our area during the last twenty years. The species is currently on the BoCC red list.

1km squares in the breeding season per year 1982–2011 for Grasshopper Warbler

Icterine Warbler *Hippolais icterina*

No record since 1947.

Aquatic Warbler *Acrocephalus paludicola*
Rare vagrant

The only record was of a single bird at Boddington Reservoir on 16 September 1999.

Sedge Warbler *Acrocephalus schoenobaenus*
Numerous summer visitor

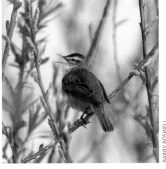

Birds arrive in mid-April and leave again by mid-September. The two earliest records were 28 March 1977 and 4 April 2008; the latest 21 October 2003. Birds have a loud distinctive song with a singing period from April until mid-July. Sedge Warblers are not as particular as the Reed Warbler in their choice of habitat and are therefore more widely distributed, favouring vegetation alongside rivers, canals, lakes and wet areas with bushes and shrubs. More recently birds have been found in hedgerows alongside Oil-seed Rape fields. The largest number of birds recorded was 21 pairs seen in 1975 on a 5km stretch along the River Cherwell during the BTO

Waterways Survey (1975–80). The data shown in the SRSS chart is slightly misleading as the survey only covers a small number of squares each year and it is possible that the selected 1km squares may not contain any suitable habitat for Sedge Warblers. The peaks and troughs of our SRSS chart do, however, correspond largely to the national chart shown. The smoothed CBC/BBS trends also show four troughs in population and these relate to years of poor West African rainfall, with a low point in 1984–85.

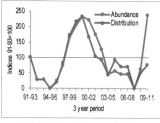

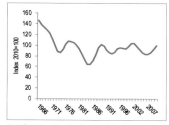

Indices for Sedge Warbler in SRSS CBC/BBS index for Sedge Warbler

Marsh Warbler *Acrocephalus palustris*

In 1886 a pair attempted to breed at Broughton Grange and two males and a female were seen at Great Tew. In 1960 a breeding pair was recorded in the Cherwell Valley. These are the only records for this species.

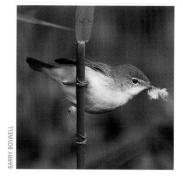

Reed Warbler *Acrocephalus scirpaceus*

Fairly numerous summer visitor

Birds arrive from mid-April to mid-May, the earliest recorded arrival date being 17 April 1995 at Fawsley. Departure is usually from mid-September to early October, the latest record being 14 October 1980 at Grimsbury. Nests are usually constructed in stands of Common Reed although other riparian vegetation has been used. The ringing data from Grimsbury reed-bed during 1970–80 indicated a faithful return to the breeding site by adult birds but little evidence of young birds returning. The number of breeding sites varied from five in 1985 and 1989 to 20 in 2010. In the 1980s it was noted that some sites were used regularly and others only for one or two years. Since the 1990s more ponds and lakes with small pockets of reed-beds have been formed and Reed Warblers appear to take advantage of them quite quickly, hence the increase in the number of breeding sites. The two largest counts of breeding pairs were of 20 pairs at Lower Radbourn in 2002 and 15 pairs at Wormleighton in 2006. The ABSS of 1983 located 80 breeding pairs and the repeat survey of 2009 found 73 pairs, which means that the status remains as *fairly numerous*. In both the ABSS surveys it was noted that brood parasitism by the Cuckoo was very low.

BARRY BOSWELL

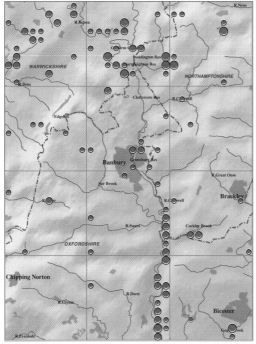

Breeding sites in
1982–2011 for
Reed Warbler

Waxwings *Bombycillidae*

Waxwing *Bombycilla garrulus*
Rare winter visitor

Birds that arrive in Britain are usually from Scandinavia or Arctic Russia. In winter they feed almost exclusively on berries so if the berry crops fail near their breeding grounds they then migrate south and westwards, sometimes in very large numbers. Birds arrive first along the east coasts of Scotland and England moving further and further inland as they exhaust local berry crops. Only when large numbers irrupt do we find birds in the BOS area. When present they are not a shy bird and are frequently seen in parks, gardens and even supermarket car parks, particularly where there are Rowan trees, Cotoneaster or Pyracantha shrubs. The irruptive years nationally were 1965/66, 1970/71, 1995/96, 2004/05, 2008/09 and 2010/11. The table lists the sites and maximum flocks in the BOS area since 1965 and shows that the winter of 2010/11 produced the

Winter	1955/56	1963/64	1965/66	1970/71	1971/72	1975/76	1988/89	1990/91	1995/96	2000/01	2005/06	2008/09	2010/11
Sites	1	1	3	3	1	1	1	1	4	3	3	4	21
Max flock	1	2	2	4	1	1	1	1	9	8	1*	9	60

*40 birds were observed flying NE but never recorded at a site

largest flock ever recorded, of at least 60 birds, largely seen around Bodicote and Banbury. Birds were also seen in smaller numbers at several sites across the area.

Nuthatches *Sittidae*

Nuthatch *Sitta europaea*
Fairly numerous resident
It is a bird which inhabits parkland and mature deciduous woodland with a few pairs known to frequent parks and those country houses with large gardens or parkland. The ABSS in 1966 found 12 pairs in a selected survey area and when repeated in 1992 it also recorded 12 pairs in the original survey area. The total would, however, have been greater but for the destruction of a large mature woodland within the survey area. There has been an increase in the number of records in the last 15 years, a trend also reflected in the WRSS indices since the early 1990s. Birds were present in 13% of the squares surveyed in the WRSS during the period 1992–2011 compared to only 9% in the previous ten years of surveys.

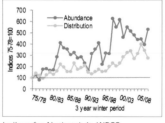

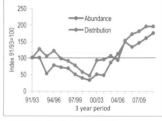

Indices for Nuthatch in WRSS

Indices for Nuthatch in SRSS

Treecreepers *Certhiidae*

Treecreeper *Certhia familiaris*
Fairly numerous resident
Treecreepers are usually quiet and unobtrusive birds of broad-leaved and mixed woodland. Although they sing predominantly from early April through to May, their relatively high-pitched song can be easily missed. Treecreepers have been recorded in only 24% of all the 1km squares covered in the WRSS. The fluctuations in the indices in the chart may be partly the result of sampling errors and also the effect of their secretive nature, making them overlooked and therefore probably underrecorded.

Indices for Treecreeper in WRSS

Wrens *Troglodytidae*

Wren *Troglodytes troglodytes*
Abundant resident with extensive distribution

The Wren is a very sedentary species, borne out by the fact that 700+ were ringed during 1961–81 and none were ever retrapped outside their original location. The distribution index in both the SRSS and WRSS shows that it is fairly likely to be found in every 1km square: in the SRSS Wrens were in 99% of all squares and in 84% of the squares surveyed in the WRSS. The dips in both charts reflect very cold winters which can decrease the population, with a few years of mild winters and good breeding seasons needed to bring the numbers back to previous levels. During cold spells it is not unusual to find several Wrens roosting together. The two largest roosts were of 20 birds at Ledwell, roosting in an artificial House Martin nest on 9 February 1986 and 20 in Bloxham on 5 January 1962.

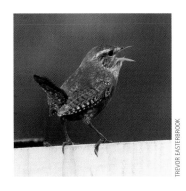

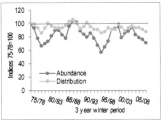

Indices for Wren in WRSS

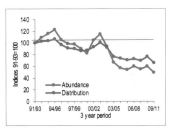

Indices for Wren in SRSS

Starlings *Sturnidae*

Starling *Sturnus vulgaris*
Numerous resident and very frequent winter visitor with extensive distribution

Nationally the abundance of breeding Starlings has decreased since the early 1980s. It is thought that the loss of permanent pasture and an intensification of livestock farming are likely to have had an effect on rural breeding populations. Both our WRSS and SRSS

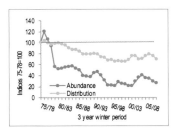

Indices for Starling in WRSS

Indices for Starling in SRSS

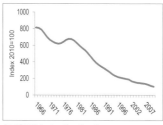

CBC/BBS index for Starling

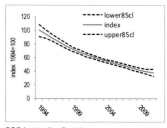

BBS index for Starling

would indicate this to be the situation in the BOS area (see charts) and it is now on the BoCC red list for endangered species. Large-sized winter roosts occur in the area, usually from late September to March, with the largest recorded winter roost flocks being 25,000 birds at Banbury on 4 March 2010, 12,000 there in September 1990, 10,000 at Lighthorne in March 2009 and 10,000 in a small wood at Mollington in January 1996.

Rose-coloured Starling *Pastor roseus*
Rare vagrant
The only record was of a single bird observed with Starlings at Woodford Halse on 14–17 September 1998. This bird was an adult male showing his beautiful pink plumage, unlike the majority of birds that turn up in this country, which are drab juveniles.

Dippers *Cinclidae*

Dipper *Cinclus cinclus*
Rare casual visitor with restricted distribution
The first known breeding attempt was in 1876 near Wormleighton. The other sightings in this period were at Wormleighton Reservoir in 1874, Farnborough and Heythrop in 1886 and Broughton in 1900. The next recorded sightings were not until 1955 with breeding in 1957. During the mid-1960s birds occurred infrequently, usually in the spring, but in 1971 four pairs were confirmed, breeding on streams in north Oxfordshire. In the decade 1972–81 birds were recorded on streams in ten parishes, in 1982–91 only in six parishes and since then only at three sites. The last records occurred in north Oxfordshire during March in 2000 and 2003. Its status is now that of *rare casual visitor*. Of all sightings 90% have occurred during January to May. The chart shows the number of recorded sites since 1971 with the irregularities in occurrence due to the fact the BOS area is on the eastern edge of the Dipper's range.

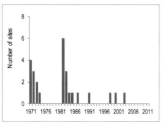

Sites per year 1971–2011 for Dipper

Thrushes, Chats and Flycatchers *Turdidae*

Ring Ouzel *Turdus torquatus*
Very occasional passage migrant

The Ring Ouzel was recorded 12 times between 1876 and 1923 and then not again until April 1953 when a female was seen at Broughton. The next occurrence was when three birds were caught and ringed at Bloxham in October 1966. Birds have occurred erratically, being recorded in only 18 of the next 44 years. The table shows the number of records/sites during spring and autumn in each decade, the majority of sightings being of single birds with a few of two or three birds. The ten years to 2011 have seen twice as many sightings as previous decades. In 2007 there were four records and this corresponded with an influx of records across the Midlands. Birds usually pass through from mid-March until mid-April and return from mid-September until end of October. There is, however, one record of a very late returner feeding on berries at Harbury on 28 November 2007, just before the snow arrived.

Decade	1962–1971	1972–1981	1982–1991	1992–2001	2002–2011
Mar/Apr	3	0	3	3	6
Sep–Nov	2	1	1	3	7
Total	5	1	4	6	13

Blackbird *Turdus merula*
Abundant resident with extensive distribution

The Blackbird is one of the few species that has adapted well to a large variety of habitats, particularly to urban and suburban environments. In the WRSS it has been recorded in 97% of all squares surveyed and in every square in the SRSS. The charts show that the distribution index has remained very constant in both surveys whereas the abundance index showed a large drop during the 1990s. National ringing data has shown that some birds are partial migrants and can move considerable distances across the country. In some winters the resident population is supplemented by an influx of continental birds, reflected in the number of large counts that are recorded. The three largest counts are of 250 birds on

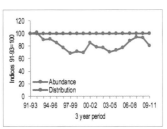

Indices for Blackbird in WRSS Indices for Blackbird in SRSS

a 1km stretch along the Oxford–Birmingham Canal at Wormleighton on 28 October 2001, 145 birds at Fenny Compton on 27 December 2000 and 100+ at Middleton Stoney on 17 January 1965.

Fieldfare *Turdus pilaris*
Very frequent winter visitor with extensive distribution
Birds arrive in early October (earliest date 28 September with an average date of 8 October) and leave from late April/early May (latest date 24 May, average date 27 April). An individual bird was observed at Steeple Aston on 23 July 1976 and had presumably summered locally. Very large flocks are not unusual; the two largest recorded flocks were of 7,000 birds in the Knightcote Valley in November 2004 and 6,000 birds at Fenny Compton in November 2007, feeding on haws. In the WRSS the Fieldfare has been recorded in 72% of the squares surveyed. The chart illustrates how consistent their distribution is each year and how variable their numbers. Factors which affect this fluctuation in abundance may well be the amount of food available (haws, berries etc.) and also the severity of the weather as too harsh a winter will cause large numbers of birds to move south.

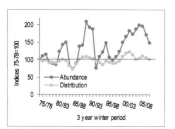

Indices for Fieldfare in WRSS

Song Thrush *Turdus philomelos*
Numerous resident
At the start of the twentieth century the Song Thrush considerably outnumbered the Blackbird. After 1940, the Song Thrush went into decline and this continued up to the 1990s. Cold winters cause many birds to die and their failure to recoup their numbers fully in the following breeding season contributes to their decline. From the late 1970s the observed decline became greater, with a fall of 73% on farmland areas, the precise reasons for which are not known. Possible causes may be related to changes in agricultural methods over the decades, for instance loss of hedgerows where they nest or a shift to autumn-sown crops leading to a loss of spring tillage on which farmland Song Thrushes have previously fed. The use of slug pellets and other pesticides, which have a secondary effect of killing snails, also needs to be considered as their deployment became widespread from the mid-1970s. Slugs and snails are eaten particularly when birds are experiencing difficulty in dry conditions in the summer, when soil invertebrates are hard to find, and again in late winter when the berry crop is finished. The number of young birds surviving their first winter has also declined since 1960. In 1998 an increase was noted in the CBC index and it was hoped that this would be maintained but the species remains on the BoCC red list. Our work on the WRSS and SRSS also falls in line with

these national observations (see charts). Both the distribution and abundance indices on the WRSS show the steep decline from 1975 to the mid-1990s and have then shown a slight upward trend. The SRSS, which did not begin until 1991, shows the decline in abundance until 1997 and from then the indices have increased to be above the 1991–93 starting point. Occasionally there is an influx of continental birds, which have a greyish appearance and usually arrive during late autumn or early winter. Flocks of 30+ birds are not uncommon; the largest number recorded was 100+ birds seen along a 1km stretch of the Oxford–Birmingham Canal at Wormleighton on 28 October 2001.

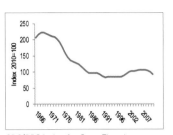

CBC/BBS index for Song Thrush

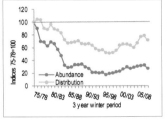

Indices for Song Thrush in WRSS

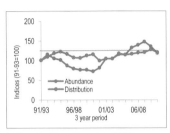

Indices for Song Thrush in SRSS

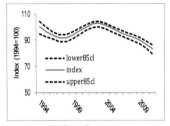

BBS index for Song Thrush

Redwing *Turdus iliacus*
Frequent winter visitor

Birds arrive from late September, with the majority arriving during the first week in October (average date 3 October). The large initial influx of birds feed on Hawthorn berries and, if they clear them, move southwards. This, combined with cold weather movement, may well account for the variability in the abundance index and the relatively low figure of 56% of positive squares in the WRSS. Large flocks are frequently encountered with the four largest recorded being 7,500 at Whichford on 29 December 1971, 3,000 at Fenny Compton in October 2005, 2,500 in the Knightcote Valley in November 2004 and 1,200 at Hook Norton in October 1995. The majority of birds leave by mid-April (average date 11 April); the latest recorded date is 3 May.

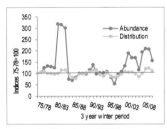

Indices for Redwing in WRSS

Mistle Thrush *Turdus viscivorus*
Fairly numerous resident

Birds are found in woods, gardens and parklands in the breeding season and can often be seen on pasture during the winter months. It is one of the earliest breeders, with eggs sometimes laid as early as February. The Mistle Thrush eats invertebrates, supplemented by berries in autumn and winter. It is not uncommon to find birds noisily defending a fully laden fruiting bush against other birds, particularly Holly or Rowan trees. Cold winters are known to affect populations but even after the severe winter of 1962/63 numbers recovered quite quickly. The CBC index values show that numbers

continued to rise slowly until about 1977 and then began to fall to the extent that the species is currently on the BoCC amber list. The cold winters of the mid-1980s may have contributed to this decline, together with changes in farming practices. The charts for the indices of distribution and abundance in our WRSS also reflect this downward trend. The SRSS, which started in 1991, shows a decline until 1996 and then a return to slightly below the starting level. Medium-sized flocks (10–99 birds) are not uncommon between July and November, and the table shows the largest flock recorded in each ten-year period which also indicates a decline.

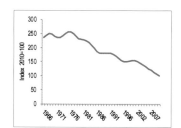

CBC/BBS index for Mistle Thrush

Decade	1962–1971	1972–1981	1982–1991	1992–2001	2002–2011
Max flock	50	75	66	30	25

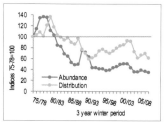

Indices for Mistle Thrush in WRSS

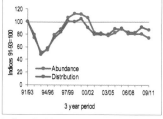

Indices for Mistle Thrush in SRSS

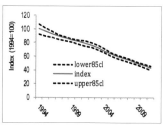

BBS index for Mistle Thrush

Spotted Flycatcher *Muscicapa striata*
Not scarce summer visitor with local distribution

Spotted Flycatcher is one of the last summer migrants to arrive, usually by the end of the first week of May. The earliest arrival date is 17 April 1996 and the median date 7 May. They leave again by mid to end of September with the latest date 4 October 1994. Aplin (1889) states that the species was common and a familiar garden bird in the Victorian period. Birds use a variety of different habitats including deciduous woodland, churchyards, parkland and gardens. Within woodland they prefer woodland edges, glades and clearings where they sing from high in the canopy; in village environments they sing from fences, telegraph poles, roofs and garden trees. They sit in a very upright position and can frequently be seen darting out to catch flies and then returning to the same or a nearby perch.

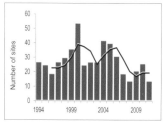

Sites per year 1994–2011 for Spotted Flycatcher

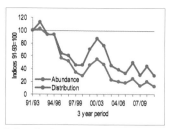

Indices for Spotted Flycatcher in SRSS

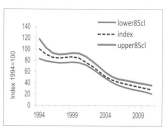

BBS index for Spotted Flycatcher

Nationally the species had begun to decline in the mid-1960s. It was after a few years into our SRSS that a sharp decline was noticed in the BOS area (see chart) and from 1998 members were asked to record all sightings; the subsequent values show that the decline continues. It is a long-distance migrant, spending much of the year in Africa, south of the equator. A possible factor in the fall in numbers could be the deteriorating conditions in their wintering grounds or along their migratory routes over the Sahara and Sahel region. Another factor could be a decrease in the number of flying insects, its major food item, which affects clutch and brood sizes.

Robin *Erithacus rubecula*
Abundant resident with extensive distribution

Another ubiquitous species which has been found in 99% of all squares in the SRSS and 91% in the WRSS (see the distribution indices). Being originally a bird of woodland from which, as the landscape has changed, they moved into farmland with good hedgerows, then parks, churchyards and private gardens. The two charts show that the Robin population has remained fairly stable over the last 35 years. The only serious threat to populations is winter weather but this is mitigated by many more people feeding birds in both urban and rural areas. Robins can be double or treble brooded so can quickly build up numbers. The largest number recorded in a 1km square during a survey was 26 birds in Badby Wood in 2005.

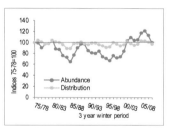

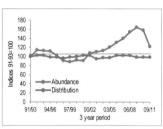

Indices for Robin in WRSS

Indices for Robin in SRSS

Nightingale *Luscinia megarhynchos*
Scarce summer visitor with local distribution

Between 1889 and 1934 O. V. Aplin noted in his diaries (1967) up to six pairs in the good years in the NW area of the BOS, from Deddington to Edgehill and across to Swalcliffe. From 1952 to 1961 birds were recorded at 12 sites in the same area. In the period 1962–71 it was recorded in 29 parishes with the highest number of singing males in any one year being 17 in 1965. Since 1967 Nightingales have been recorded in every year except 1979 and 2001 and, during the ABSS of 1973, 12 singing males were located. A minimum of nine pairs were proved to be breeding, eight in deciduous woods and one in coniferous plantation. In the repeat

Sites per year 1982–2011 for Nightingale

survey of 1998 two singing males were found with only one pair breeding at Bowshot Wood. The favoured habitat in 1998 was mainly deciduous/mixed woodland and pioneer scrub rather than the coppice-with-standards of years gone by. There remain patches of perfectly good Nightingale habitat yet the bird has disappeared from much of the area. Possible causes of decline are national range contraction of the species (the BOS area lying towards the northern edge of the Nightingale's range in Britain), climate change, degeneration of coppice woodland or habitat destruction by humans or deer. Birds arrive in mid-April through to early May and leave unnoticed. The earliest arrival date is 15 April (in 1993 and 1998) but the average date in the period 1982–2011 was 1 May.

Bluethroat *Luscinia svecica*
Rare vagrant
An adult male bird in late moult was observed in the Cherwell Valley on 21 September 1980. This is the only record.

BARRY BOSWELL

Pied Flycatcher *Ficedula hypoleuca*
Rare passage migrant
Early records suggest that pairs may have bred near Horley in 1919 and Compton Wynyates in 1961 and a male was observed defending territory near Sibford in the spring of 1948. Birds have been recorded from mid-April to mid-May and again from mid-August to mid-September as they pass to and from their breeding areas in the western and northern counties. The species has been observed at 30 different sites in our area but the only record during the last ten years was of a single bird at Grimsbury Woodland Reserve on 6 September 2011. This may be due to the fact that we are on the edge of their migration path and as numbers have declined fewer birds pass through our area.

Decade	1962–1971	1972–1981	1982–1991	1992–2001	2002–2011
Records	15	11	15	14	1

Black Redstart *Phoenicurus ochruros*
Occasional passage migrant and very occasional winter visitor

Birds were first noted at Bloxham in March 1916 with the next recorded being a pair at Sibford in November 1932. By 1960 the species was considered to be a *rare visitor*. Since 1982 the number of records has increased (see table) with the species being recorded in 19 out of the last 30 years. Small numbers of birds arrive in the spring passage (March to May) and then move on to breed elsewhere. In the autumn there is another slightly smaller influx of birds, mainly in October, of which the majority move on to their wintering areas around the southern Mediterranean, though very small numbers have been recorded occasionally in November and December. Birds have been recorded at 38 sites across the BOS area with Banbury, Chipping Norton and Fenny Compton being the most favoured.

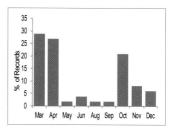

Monthly distribution of records
1982–2011 for Black Redstart

Decade	1952–1961	1962–1971	1972–1981	1982–1991	1992–2001	2002–2011
Records	3	6	6	21	14	16
Sites	3	5	5	13	11	9

Redstart *Phoenicurus phoenicurus*
Occasional passage migrant

In the late nineteenth century the species was considered to be a fairly numerous summer visitor, arriving in mid-April and leaving by the end of September. In 1961 the BOS held a pilot breeding survey which indicated that at least 20 pairs attempted breeding. Birds tended to frequent stream and river valleys, parkland and the gardens of large country houses. In the 1963 ABSS, of the 17 nesting pairs found, most were in trees though a few were nesting in dry-stone walls. Nationally, birds are mainly recorded in the west and north of the country with the BOS situated on the eastern edge of its range. During the late 1980s, records of breeding birds began to decline sharply and by the mid-1990s they had ceased to breed in the area. Records since then have increased but are now only of birds passing through and the trend is downward (see chart). The earliest arrival dates were 1 April at Stoneton Manor in 2001 and Upper Heyford in 2008 and the latest departure date was 22 October 1988 at Kings Sutton.

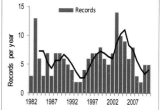

Records per year 1982–2011 for Redstart

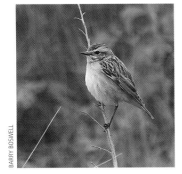

BARRY BOSWELL

Whinchat *Saxicola rubetra*
Occasional passage migrant
In the 1880s the Whinchat was a regular summer visitor and always found on heathlands, particularly Wigginton Heath. In the 1960s it was considered by Davies (1967) to be a *scarce summer visitor breeding locally*, particularly in the Cherwell Valley south of Banbury. Brownett (1974) regarded the species as *not scarce* with an average of four pairs breeding between 1962 and 1971. From 1972 to 1981 the number of records increased but breeding sites declined to only one or two; breeding ceased in the area by 1994. Sightings continued to increase until 1997 but have been declining each year since. Its status is now that of a *passage migrant* and the trend is declining (see chart). The average spring movement is from late March until mid-May and birds pass back through the area from early July until the end of October. One very late bird was recorded at Kiddington on 22 November 1997. Most sightings are of small numbers but occasionally a large group passes through. The largest counts were of 27 birds at Priors Hardwick on 4 September 2003, 13 in the Cherwell Valley on 13 September 1981 and 13 at Upper Heyford in 1961.

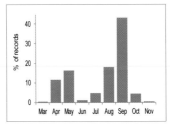

Monthly distribution of records 1975–2011 for Whinchat

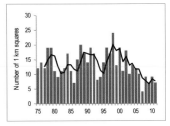

1km squares per year 1975–2011 for Whinchat

Stonechat *Saxicola torquatus*
Frequent winter visitor
At the beginning of the twentieth century a few pairs used to breed each year in the heathland areas around Banbury, with the last proven breeding record at Great Bourton in 1930. By 1960 it was considered to be a *scarce passage migrant*. The great unpredictability of the number of sightings in any one year can be seen in

TREVOR EASTERBROOK

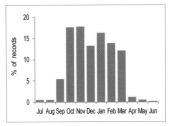

Monthly distribution of records 1982–2012 for Stonechat

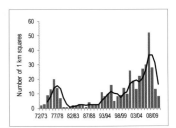

1km squares per winter 1972/73– 2010/11 for Stonechat

the chart, but do appear to be influenced by prevailing weather conditions. The two best periods in the 1970s corresponded to hot summers, which may have resulted in good breeding success and a subsequent movement of more juvenile birds southwards. The severe winters of the 1980s may have adversely affected the number of records in this period. Since 1992 numbers have increased considerably, reaching a maximum in 2007/08, but sightings dropped noticeably during the cold winters of 2009/10 and 2010/11.

Wheatear *Oenanthe oenanthe*
Very frequent passage migrant

Aplin (1889) quotes circumstantial evidence that the species may have attempted to breed at Barford in 1885 and Nether Worton in 1888. There has been no conclusive evidence of breeding since that time. Birds are very frequently seen on ploughed fields, grasslands, disused quarries, reservoir surrounds and in particular on disused airfields. They move through the area on a wide front, usually from mid-March until mid-May. In the spring passage the earliest date was 25 February 1993 at Swalcliffe and the latest, 11 June 2000 at Balscote Quarry. The southward movement can start from as early as 17 July but is more usually from the first week in August until late October. There have been three very late records, namely a bird at Purston on 7 December 1975, a female at Grimsbury Reservoir surrounds on 8 December 1988 and a male there on 31 December 1988. Medium-sized flocks occur occasionally: 20+ birds were recorded at Barford Airfield on 10 May 1992 and 7 September 2008, Grimsbury Reservoir on 20 August 1970 and Kiddington on 8 September 1974. Birds of the Greenland race (*Oenanthe oenanthe leucorhoa*) have occasionally been recorded at Bishop's Itchington, Chipping Norton, Fenny Compton, Napton Halt, Priors Hardwick and Wigginton.

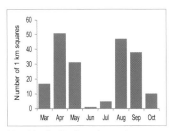

Monthly distribution of records 1985–2012 for Wheatear

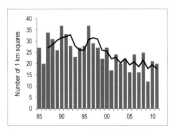

1km squares per year 1985–2011 for Wheatear

Accentors *Prunellidae*

TREVOR EASTERBROOK

Dunnock *Prunella modularis*
Abundant resident

The Dunnock is a common and unobtrusive species that can be found in town and village gardens as well as rural hedgerows and woodland edges. It is a sedentary species that is very widespread across the area and in the WRSS it has been recorded in 96% of all the squares surveyed. Nationally it suffered badly in the severe winters of 1961/62 and 1962/63 but made a rapid recovery by 1965. The results from our WRSS would indicate that numbers fell in the ten years from 1975 to 1984 but have since stabilised at this lower level while the SRSS results show that numbers have remained fairly constant. Mead (2000) suggests that severe treatment of hedgerows in farmland is to blame for local declines. The Dunnock is an early breeder and its pleasant song can be heard on mild days from late winter until the summer. Research evidence suggests that some pairs are monogamous while others exhibit polygyny and polyandry (Davies 1983).

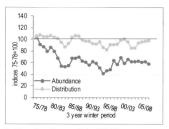

Indices for Dunnock in WRSS

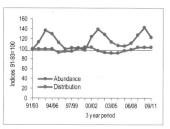

Indices for Dunnock in SRSS

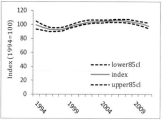

BBS index for Dunnock

Sparrows *Passeridae*

House Sparrow *Passer domesticus*
Fairly numerous resident

It is a bird that is frequently found in association with human settlements in our towns, villages and farms. Aplin (1889) writes, 'Gardeners have plenty of complaint against the Sparrow, and few ornithologists have a good word for it. The rapid increase of the Sparrow must have the effect of checking that of some of our other small birds, and not only indirectly so, for it is not wholly guiltless of attacking and tyrannizing over weaker and more gentle birds; House Martins especially are frequent sufferers, being often ejected from their nests, and this in some places has been carried to such an extent as to seriously affect the numbers of these graceful and most beneficial insect-eaters. The Sparrow is all very well in its place, but it has clearly increased out of all due bounds, and the sooner properly managed Sparrow Clubs are revived in every

parish the better for the farmer, gardener, and bird lover; combined effort alone can thin the Sparrow's numbers, and make way for an increase of other more useful species.' How things have changed! Numbers fell in the 1920s and it is thought this was due to mechanical transport beginning to replace horse-powered vehicles, particularly on farms. Many local surveys across the country during the 1970s and 1980s had begun to signal the decline of the species. The results of our WRSS suggest numbers had declined by 80% in 1996 compared to the 1975 level and since then numbers have levelled off. Birds were found in 61% of the squares surveyed in the WRSS and in 72% in the SRSS with the latter also showing that numbers have fluctuated and fallen below the 1991 starting point. The largest recorded flocks were of 500+ at Purston in 1963, 200 at Boddington in 1987 and 140 at Wormleighton in February 2010. At a garden in Milcombe 139 House Sparrows were ringed during the month of June 2010 and another 133 new birds were ringed there in July of the same year showing there is a healthy population in this village.

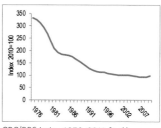

CBC/BBS index 1976–2011 for House Sparrow

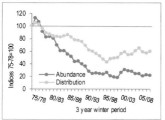

Indices for House Sparrow in WRSS

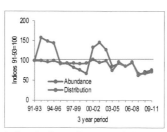

Indices for House Sparrow in SRSS

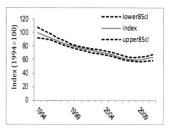

BBS index for House Sparrow

Tree Sparrow *Passer montanus*
Not scarce resident

Tree Sparrows usually inhabit agricultural areas but can occasionally be found in parkland. During the winter they tend to join together in feeding flocks or roost together in dense hedges. They can often be seen feeding in the company of finches and buntings, although Tree Sparrows tend to stay closest to the hedgerow most of the time and dive for cover at the slightest sign of danger. Birds can frequently be heard calling in a thick hedgerow but are very difficult to locate. In the breeding season they often nest in colonies, using tree holes and cavities in walls or buildings. They do not usually compete with House Sparrows for nest sites but will use nest boxes. Royston Scroggs' nest box study (1959–72) at Coneygree Wood found that the number of occupied nest boxes peaked in the late 1960s and then dramatically declined for no apparent reason. Another study at Wytham Woods (some 12 miles outside our area) found similar results for Tree Sparrows in its nest boxes (Seel 1968). The largest flocks recorded in the late 1960s were of 2,000+ birds at Nell Bridge in February 1968 and 1,000+ at Croughton in December 1970 but flocks of this size are no longer being seen. We have three areas

TREVOR EASTERBROOK

where birds are either being regularly fed with large amounts of food over the winter or have game-bird cover crops planted specifically for birds and these sites currently produce the largest flocks: 250 birds at Priors Hardwick in January 2009, 300+ at Walk Farm, Over Norton in October 2010 and 140 at Wormleighton in February 2010. From the late 1970s we began to see the decline of records for Tree Sparrow and the results for the WRSS and SRSS (see charts) show that numbers in our area have fallen dramatically and distribution is now much reduced. In the 1961–72 BOS ten-year report its status was that of *abundant resident* but it has now been reduced to a *not scarce resident*. Nationally, Tree Sparrow numbers have decreased dramatically since the late 1970s and 1980s and, not surprisingly, it is on the BoCC red list.

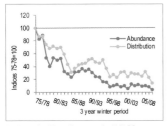

Indices for Tree Sparrow in WRSS

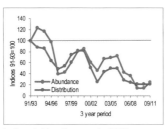

Indices in Tree Sparrow in SRSS

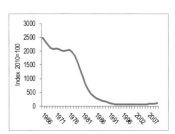

CBC/BBS index for Tree Sparrow

Wagtails and Pipits *Motacillidae*

Yellow Wagtail *Motacilla flava*
Not scarce summer visitor

Birds arrive from late March to mid-April (earliest recorded date 5 March 1979) and leave again from late September to end of October (latest recorded date 8 November 1997). Medium to large-sized flocks can occasionally occur in the spring as passage birds move through the area. Concentrations can build up from July onwards, particularly around the the reservoirs and in the Cherwell Valley. The largest recorded flocks were of 200+ at Boddington Reservoir in August 1967, 160 there in September 1990 and 120 at Glyme Farm, Chipping Norton in August 1996. The ABSS survey in 1990 established 102 breeding pairs in 500 sq. km which compared favourably with the original 1964 survey (84 breeding pairs in 400 sq. km) and indicated that the status remained that of *fairly numerous summer visitor*. The 1964 survey showed that all but one of the 45 reported nesting habitats were in arable crops, 32 of these in wheat. The main difference between the two surveys was that, although the nesting habitat was still in arable, pea and bean crops (not grown locally 25 years ago) were now as popular as wheat. Davies (1967) states that birds were present and breeding in the meadows and valleys of the Cherwell Valley and many books give the impression the species is a bird of flood meadows. This

is not now the situation in the Banbury area where birds have moved away from their traditional lowland meadows to inhabit arable crops including legumes, even on higher ground. From the SRSS (see chart), and since the mid-1990s, our records indicate that Yellow Wagtail is declining and its status has changed from *fairly numerous* to that of *not scarce summer visitor*. Nationally there has been a rapid decline since 1980, so much so that the species is currently on the BoCC red list. Farmland drainage, conversion of pasture to arable, change from spring to winter cereals and the loss of insects associated with cattle have all been cited as possible causes of decline. In 2010, however, there were more records and the maximum flock size had increased compared to previous years. Whether this is an indicator that the species is beginning to make a comeback or just a blip remains to be seen. Birds of the continental race *Motacilla flava flava* have been recorded occasionally, usually in April or September, and one was ringed at Boddington Reservoir in September 1977.

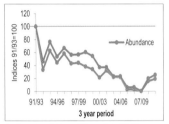

Indices for Yellow Wagtail in SRSS

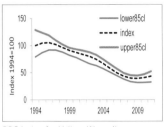

BBS index for Yellow Wagtail

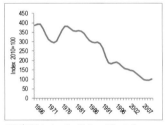

CBC/BBS index for Yellow Wagtail

Grey Wagtail *Motacilla cinerea*
Not scarce resident

In our area, during the nineteenth century, the Grey Wagtail was considered to be a passage migrant and winter visitor. It was very rare in summer with only three breeding attempts known up to 1899. The ABSS of 1961 proved at least 23 breeding pairs giving it a status of *not scarce resident*. All of these were using sites with fast running water near suitable brick or stone work, mill stream lashers or pool outlets. The winter of 1962/63 reduced the population to a single pair on the Sor Brook in 1963 and the status of *not scarce* was not regained until 1971. In 1988 the repeat ABSS found a minimum of 17 breeding pairs and when this is compared to the same area surveyed in 1961, only 13 pairs were located. Changes to the habitat would appear to have rendered unsuitable a number of sites that were occupied in 1961 but not in 1988. Another possible reason for the fall in the number of breeding pairs is that populations are severely affected by cold winters and the mild winters in the late 1960s and 1970s allowed the population to expand. The winters during the 1980s were on average much colder than the previous decades and the interval between really hard winters was too short to allow a full recovery to previous high levels. The

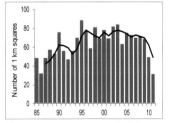

1km squares per year 1985–2011 for Grey Wagtail

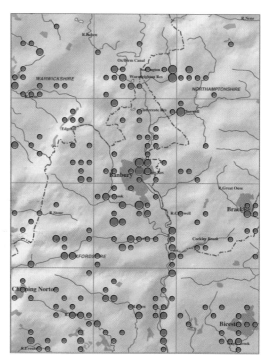

Sites during April–
July in 1982–2011
for Grey Wagtail

winters of 1978/79, 1981/82 and 1984/85 were particularly sharp
and the low values of 1986, 1992, 1997, 2010 and 2011 are due to
the previous hard winter.

Pied Wagtail/White Wagtail
Motacilla alba/Motacilla alba alba
Fairly numerous resident and frequent winter visitor

Davies (1967) wrote that they are 'seen throughout the year, mainly
in the open country and in the grounds and parks of the built-up
areas. The numbers vary, particularly in the autumn and spring,
where there is a movement of passage migrants throughout the
area. Pairs are present and breeding during the summer months, but
it is not a common resident.' The species was surveyed in the ABSS
in 1965 and 1991, establishing that the status was *fairly numerous*
and had remained reasonably constant. In 1965, 32 breeding pairs
were found in 300 sq. km; in 1991, 38 pairs were found in the
same area and 11 more pairs in a further 100 sq. km. Both surveys
found that, for nesting habitat, farm buildings and other sites that
are closely related to man were strongly represented. The WRSS
shows that, for most of the 1980s, the Pied Wagtail fell below the
1975–78 indices but from 1997 rose noticeably, returning to the
starting index in 2009. The SRSS, which started in 1991, shows
that indices of distribution and abundance have not fallen below
the starting index. In the period 1965–81 1,000+ birds were ringed
at the reed-bed at Grimsbury, which was used for roosting. From
July to September local birds gathered there and from October to

December they were joined by passage migrants, with the largest number present on one evening being 500+ in October 1974. Since the 1980s birds have been recorded roosting in reed-beds, on roofs of large industrial buildings and trees in supermarket car parks in several of our larger towns. The largest recorded roosts in this period were 450 birds in Bicester in January 2000 and 400 at Banbury in November 1990 (see chart). One of our members, Ted Flaxman, carried out a study of roosts within the BOS area. He found that once the birds had finished 'jostling for position' there was always a lot of calling and when this dies away there is always a burst of bill-snapping. This is quite audible, continuing after the birds have settled down for the night, and is often the last sound heard from a roost. He conjectured that birds are echo-locating their surroundings before darkness deprives them of vision and seems unlikely to be associated with threat, anger or excitement (*BOS Annual Report 1998*). Birds showing the characteristics of the White Wagtail are recorded occasionally in small numbers, for instance at Balscote Quarry and Grimsbury Reservoir in April 2008.

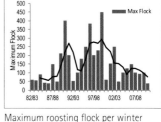

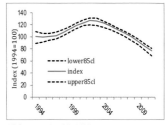

Maximum roosting flock per winter 1982/83–2010/11 for Pied Wagtail

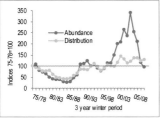

Indices for Pied Wagtail in WRSS

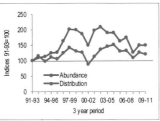

Indices for Pied Wagtail in SRSS

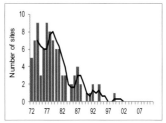

BBS index for Pied Wagtail

Tree Pipit *Anthus trivialis*
Very occasional passage migrant

Davies (1967) stated that the species was a regular but *not common summer visitor*, and Brownett (1974) reported that it was recorded in 56 parishes. The ABSS of 1968 recorded 51 breeding pairs with the preferred habitat of young conifer plantations, and the proximity of mature deciduous trees was also of importance. By 1981 the status had changed to *not scarce summer visitor* with birds recorded at only six sites. Many of the conifer plantations had matured without successive planting, suitable nesting areas had decreased, and in the repeat ABSS of 1994 only one breeding pair was found. The chart shows how the species has declined over the last 30+ years. Since 1994 there has been no definite evidence of breeding and the only sightings that have occurred during June and July were of a singing male at Chadlington on 3 June 1996 and of a passage bird at Fenny Compton on 23 July 1998. All the sightings since 1998 are of birds passing through the BOS area. Since 1994, CBC/BBS national data has shown a further severe decrease, especially in England. The causes of the population decline are unclear but may be linked to changing forest structure (as new

Recorded sites per year 1972–2011 for Tree Pipit

plantations mature) and reduced management of lowland woods (Fuller *et al.* 2005). In 2002 the species was moved from the BoCC green to amber list and, more recently, to red on the strength of its UK population decline (Eaton *et al.* 2009).

Meadow Pipit *Anthus pratensis*
Scarce resident with restricted distribution and a frequent winter visitor with widespread distribution
A few pairs used to breed in the neighbourhood of Tadmarton Heath before 1889 and bred again at Enstone in 1961. Song-flighting birds were recorded at Milton in 1965, Grimsbury in 1969 and Burton Dassett in 1969 and 1970. From 1980 onwards small numbers continued to breed at six sites, including Grimsbury Reservoir, Lighthorne Quarry, Radway and BAD Kineton. Winter birds arrive from September and stay until late April/early May. The heaviest movements were of 1,000+ heading NW at Bloxham in March 1967 and 900+ flying SW at Priors Hardwick in October 2004. The largest recorded flocks were of 200+ birds at Banbury SF in December 1990 and 220 at Fenny Compton on 29 March 2003. The national CBC/BBS trend has been downward since the mid-1970s, accompanied by a range contraction from lowland England (Gibbons *et al.* 1993).

CBC/BBS index for Meadow Pipit

Rock Pipit *Anthus petrosus*
Very occasional winter visitor
Rock Pipit was first recorded at Milcombe in March 1903 and then not again until March 1967 at Nell Bridge. October 1980 at Boddington Reservoir produced the next sighting. Since that time the species has been recorded in 16 out of the last 30 years with 43 sightings from Boddington Reservoir, two from Wormleighton Reservoir, one from Grimsbury Reservoir and one from Fenny Compton. Birds have been recorded during late March to early April and from late September to November with over 80% seen during October.

Water Pipit *Anthus spinoletta*
Very occasional winter visitor
The species was occasionally recorded between 1986 and 2010, usually only of one or two birds. Records have come from Banbury SF, Boddington Reservoir, Grimsbury Reservoir, Wormleighton Reservoir, Lighthorne Quarry and Priors Hardwick. Largest groups were of four birds at Banbury SF in April 1986 and three birds at Wormleighton Reservoir in November 2010. Birds have been recorded from October through to early April.

Finches *Carduelidae*

Chaffinch *Fringilla coelebs*
Abundant resident with widespread distribution

The Chaffinch is one of the most familiar sights and sounds of the countryside. They do not appear to have any specific ecological needs and are well adapted to a wide variety of habitats from suburban gardens to woods and farmland. They breed in gardens, woodlands and hedgerows everywhere. Large flocks usually occur between October and February. It is a most abundant species and local populations can be swollen by a winter influx of continental birds. The largest flock recorded was of 1,500 birds at Hinton-in-the-Hedges and flocks of 400–500 birds are not uncommon. They used to be found on winter stubble fields and then on set-aside, but more recently flocks have been found on unharvested crops such as Linseed or in game-bird cover crops. They appear to be, of the seed-eating birds, least affected by agricultural intensification. The indices of distribution and abundance from the WRSS and SRSS shown in the charts indicate that the Chaffinch population has remained relatively stable. Numbers increased from 1975 to 1990 and are now back to the 1975/77 level.

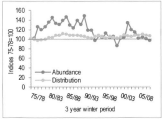

Indices for Chaffinch for WRSS

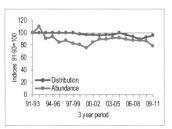

Indices for Chaffinch for SRSS

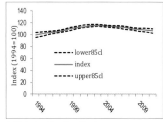

BBS index for Chaffinch

Brambling *Fringilla montifringilla*
Frequent winter visitor with widespread distribution

Birds normally arrive in the BOS area in October and leave by the end of April, though they can occasionally remain into May. England is on the periphery of the Brambling's range so numbers and distribution of birds can vary widely each winter. Birds gather in areas and years where Beech mast or other suitable crops like Linseed are abundant. They feed on the ground and roost communally, usually with Chaffinches and sometimes other finches. Aplin (1967) reported a flock of 100 birds killed at Balscote in 1896 and that in 1909 birds were very numerous with most birds being male. Very large flocks were recorded during the 1960s, namely 2,000+ at Cottisford in December 1965, 1,000+ at Newbottle in March 1969 and 1,800+ at Charlton in March 1969. Since then only flocks in the low hundreds have been recorded: 250+ at Sarsden in January 1981, 120 at Sarsgrove in December 1997, 100+ at Chadlington in

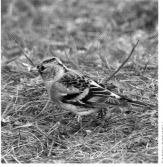

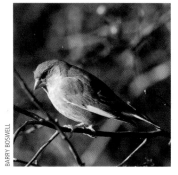

December 1997 and 100+ at Cottisford in January 1995. During the 2000s the largest flocks, of 65 birds, were seen at Tysoe and at Boddington in January 2004.

Greenfinch *Carduelis chloris*
Numerous resident with widespread distribution

In both *The Birds of Oxfordshire* (1889) and his diaries (1967) Aplin regarded the Greenfinch as an *abundant resident* breeding in gardens and woodland edges. Greenfinches are predominately seed-eating birds, found in considerable flocks on arable land from autumn to spring. Nationally, their numbers suffered a setback during the late 1950s and early 1960s due to the use of organochlorines on seed dressing and in pesticides and also the effects of the severe winters of 1962 and 1963. The population recovered quickly, however, over the next few years. In the past, farmland was the most important habitat but now birds occur in areas associated with human habitation, from town and village gardens to farms, and are widely distributed. This change has probably come about as their favoured seeds from wild plants and grain have become less abundant on farmland. Winter feeding sites have also become rarer mainly due to autumn-sown crops which produce less stubble and fewer fallow fields. To fill this gap some birds have exploited the increased acreage of Oil-seed Rape and game-bird crops. They are also now a very common visitor to bird feeders in gardens. The charts indicate how numbers and distribution have varied during the WRSS and SRSS, showing that the population distribution has remained constant but abundance has fluctuated considerably. Both surveys suggest that numbers have been declining over the last five years which may be accounted for by the severe outbreak of *trichomonosis* that began in 2005. The data from the ringing of 1,000+ birds suggests that the majority of Greenfinches are sedentary and not significantly supplemented by continental visitors. Flocks of 500+ occur between September and March, the largest recorded being of 600 birds at Evenly in January 1980, 600 at Lighthorne in January 1993 and 750 at Chesterton in December 2003 feeding in a game-bird crop.

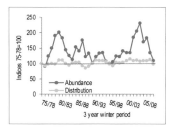

Indices for Greenfinch in WRSS

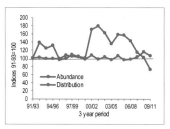

Indices for Greenfinch in SRSS

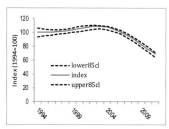

BBS index for Greenfinch

Goldfinch *Carduelis carduelis*
Numerous resident with extensive distribution

The Goldfinch is one of our most colourful and attractive finches and is easily found by its tinkling, twittering musical calls. Birds frequent gardens and parklands in the breeding season, often nesting within the foliage of trees. They feed on Thistles, Ragwort, Groundsel and many other weed seeds in the breeding season, depending on Teasel, Alder and Birch seeds during the autumn and winter. At the end of the nineteenth century Goldfinch numbers were seriously affected by the capture of birds for the cage-bird trade, with numbers beginning to rise again after the restriction on commercial trapping was enacted. In our earlier reports, birds were less common in the winter with many migrating to France or the Iberian peninsula to avoid the cold weather and the shortage of food. Our ringing data of 1965–80, when 200+ birds were ringed, showed that five birds recaught in Spain during the winter were ringed locally during the previous summer. Nationally, numbers of Goldfinch fell sharply from the mid-1970s to the mid-1980s, possibly resulting from a reduction in the availability of weed seeds because of agricultural intensification. Since then there has been a rise in the population which may well be due to increased use of other food sources such as garden bird feeders and game-bird crops. This improvement in numbers has meant that the species has moved category from amber to green on the BoCC list. The charts also show this increase in abundance and distribution in the BOS area in both the WRSS and SRSS. The largest recorded winter flocks are: 200+ in the Cherwell Valley in September 1974, 150+ at Banbury SF in January 1991, 430 birds at Boddington feeding on an unharvested crop in March 2004, 250+ at Priors Marston in September 2007 and 500 birds feeding in Chicory at Glyme Farm, Chipping Norton in September 2011.

TREVOR EASTERBROOK

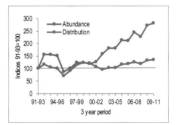

Indices for Goldfinch in WRSS

Indices for Goldfinch in SRSS

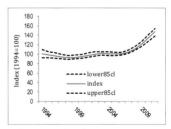

BBS index for Goldfinch

BARRY BOSWELL

Siskin *Carduelis spinus*
Frequent winter visitor and rare resident

The Siskin is the smallest of the finches. Up until the early 1960s its status in the BOS area was that of a *scarce winter visitor* but since the late 1960s birds have been more frequently recorded. It is usually seen in small parties feeding on Alders bordering streams and marshy ground. Siskins began to be reported feeding on bags of peanuts from the late 1970s, when many more people began using bird feeders in their gardens. Birds are now appearing fairly regularly in gardens from late winter to early spring, and this may well be an important factor in helping with over-wintering survival. Over the 40-year period of BTO-led Atlas work, a considerable expansion of their breeding range southwards has been recorded, with breeding populations becoming established in more and more areas (BTO 2011). The first record of breeding in the BOS area was when a female with juveniles was recorded in a large garden at Hook Norton throughout June 2003. Since then breeding may have occurred in 2005, 2006 and 2009, when there were sightings of birds in June and early July in Banbury, Over Norton, Newnham and Whichford. To some extent, the species is an irruptive one as their movements are heavily influenced by food supply, and in winter numbers are occasionally supplemented by large continental influxes as shown on the chart. The largest flocks, of 100+, were recorded at Adderbury in February 1982, Fawsley Park in December 1992 and January 2009, Whichford in January 2000 and Great Tew and Farnborough in January 2006.

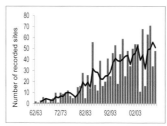

Sites per winter 1962/63–2010/11 for Siskin

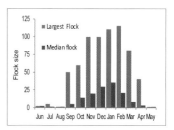

Monthly distribution of flock sizes 1962/63–2010/11 for Siskin

Linnet *Carduelis cannabina*
Numerous resident with extensive distribution

Davies (1967) suggested that the Linnet was a *common resident*, running to *numerous* during the breeding season on Gorse-covered hillsides and waste ground covered with scrub. Nationally, Linnet abundance fell rapidly in the UK between the mid-1970s and mid-1980s; the results from the WRSS are shown in the chart and also follow this trend. Since the late 1980s numbers have fluctuated greatly in the WRSS and are now levelling off at 20% less than 1975/77 figures, whereas in the SRSS both the abundance and distribution indices have decreased since 2000 and are now at 50% of the 1991/93 figures. Possible reasons for the decline may be the grubbing out of scrubby areas and the removal of weeds by the use of modern herbicides, as Linnets are dependent on small seeds for food, particularly weed seeds. Certainly, reduction in hedgerow quality leaves nests more exposed and therefore at greater risk of predation. Following the great increase in the sowing of Oil-seed Rape, some birds have now moved to feeding on its seeds during the breeding season, and the policy of set-aside, which was in existence for a few years from 1993, also helped increase the food availability. Large flocks can occur in the autumn and winter. Two flocks of 1,000+ occurred in 1970, at Hinton-in-the-Hedges in January and Ardley in December. More recently a flock of 1,200 birds was recorded at Fenny Compton in October 2001 on an unharvested grain crop, 700 birds were seen at Wormleighton on a ploughed field in November 2008 and 600+ birds at Little Tew in an unharvested Linseed field in January 2009.

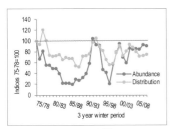

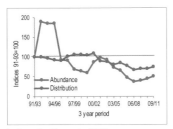

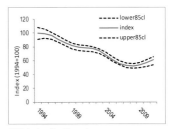

Indices for Linnet in WRSS Indices for Linnet in SRSS BBS index for Linnet

Twite *Carduelis flavirostris*
Rare vagrant

The species was listed in Beesley's *History of Banbury* in 1841. The only confirmed sighting is of two birds on the surround of Boddington Reservoir in December 1981.

TREVOR EASTERBROOK

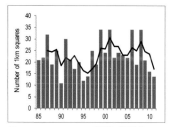

1km squares per year 1985–2011 for
Lesser Redpoll

Lesser Redpoll *Carduelis cabaret*
Frequent winter visitor with widespread distribution and a rare resident

Lesser Redpolls are mainly a bird of Alder, Birch scrub, Hawthorn thicket and young conifer plantation. Nationally, Lesser Redpoll, abundant and widespread in lowland Britain in the 1970s, is now largely absent as a breeding species after a sustained period of severe decline. Having been moved from green to amber on the BoCC list in 2002, the species is now red-listed. In the BOS area the first recorded singing male was heard at Ditchley in June 1968, suggesting possible breeding. In 1972 breeding was finally confirmed at Clevely but this, however, is still our only breeding record. Birds become more widespread in the winter, often to be found feeding with Goldfinches and Siskins in Alders, and have also now been recorded on feeders in gardens. The number of recorded sites per winter has remained fairly constant since 1985. The largest recorded flocks are of 130 birds at BAD Kineton in February 1992, 65 at Chesterton Pools in November 2005, 50 at Farnborough in December 1997 and 50 at Milcombe in January 2008. The majority of sightings were, however, limited to 1–5 birds.

Common Crossbill *Loxia curvirostra*
Scarce resident

Birds periodically erupt westwards and southwards from forests in Europe in search of better feeding conditions after the failure of their staple diet of spruce cone seeds, especially the Norway Spruce. In irruption years, birds tend to move in early summer and begin to arrive in late May or during June. After arrival many stay to breed for a few years before returning back with their offspring to the Continent. Crossbills begin breeding in January, sometimes even earlier, and by the start of April family parties can be seen. Birds are normally found in conifer plantations or large gardens, particularly those with Larch. Aplin (1889) noted that the Crossbill was an occasional visitor of extremely irregular nature. The first record was of a group of five birds near Banbury in 1873; all were shot. Up to 1959 birds were recorded from only 11 sites. The first confirmed breeding pair occurred in 1964 and flocks of 14 and 26 were also recorded during that year. The next sightings in the BOS area were from 1985 with confirmed breeding in 1986, 1987, 1990, 1991, 1997 and 1998. The largest recorded flocks were of 45 birds at BAD Kineton in November 1997, 45 at Alkerton in May 1998, 38 birds at Wroxton in November 1990, 35 at Tackley Wood in July 1997 and 32 at Ledwell in January 1998.

Common Rosefinch *Carpodacus erythrinus*
There has been no record of this species in the BOS area since 1912.

Bullfinch *Pyrrhula pyrrhula*
Fairly numerous resident

In the late nineteenth century Bullfinches were as widespread as they are now but numbers were kept low by the cage-bird trade and persecution by farmers protecting their produce. After the 1880 Wild Birds Protection Act numbers began to increase, particularly from the 1950s to mid-1970s as birds began to exploit more open habitats. Birds are found in deciduous woodland, small clumps of trees, tall dense hedgerows, mature scrub and thickets, and large gardens. Although they will eat the buds of trees and shrubs, adult birds prefer seeds, particularly those of Ash, as well as those of shrubs, and of herbaceous plants including Dock and Bramble. More recently, birds are visiting garden feeders. They are largely sedentary compared to other finches, as confirmed by the ringing data of the 1970s and 1980s with only 12 birds moving a short distance from their original site. Birds have been recorded in 51% of all the WRSS squares surveyed. In the 1961–72 period flocks of up to 30 birds were encountered. Recent large flocks were of 21 birds at Wormleighton in September 2001, feeding on Hawthorn, and 20 at Boddington in August 1992. The UK Bullfinch population entered a long period of decline in the mid-1970s, following a time of relatively stable numbers. Initially very steep, this decline was more evident in farmland than in wooded habitats, but has been shallower since the early 1980s. This is reflected in the chart of the indices of abundance and distribution in the WRSS since 1975. The indices for Bullfinch in the SRSS, started in 1991, show that distribution and abundance slowly declined from 1993 to 2006, though numbers are now back to the 1991 level.

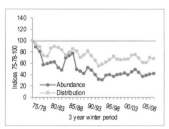

Indices for Bullfinch in WRSS

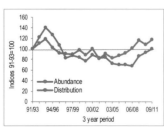

Indices for Bullfinch in SRSS

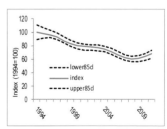

BBS index for Bullfinch

BARRY BOSWELL

Hawfinch *Coccothraustes coccothraustes*
Scarce resident with local distribution

The Hawfinch is a very shy and secretive bird that can easily escape detection. It is attracted to woodland and parkland, particularly those that contain Hornbeam, wild Cherry, Yew and Beech. In the early part of the nineteenth century it was thought to be a winter visitor but Aplin (1889) stated it was a resident that breeds sparingly. Nests were found near Banbury in 1878 and 1889, Bodicote in 1878 and Broughton in 1880. From 1890 to 1912 birds were observed at least ten times but breeding was never proved. The next breeding record was in 1949. A party of Hawfinches was seen near Banbury in October 1959, which was the only record in the period 1952–61. From 1962 to 1971, birds were recorded from 13 sites and a pair was recorded breeding at Rousham in 1968, 1970 and 1971. The last record of breeding was at Sanford St Martin in 1987 when a pair built a nest subsequently destroyed by a predator. Flocks of 10–20 birds have occasionally been seen during the winter at Ditchley, Rousham and Great Tew, with 24 birds feeding in Hornbeam at Middleton Stoney in February 1971 and 23 at Kiddington in January 1997. The table shows the number of sites where birds were seen in each decade since 1952 and the map shows all sites, also from 1952.

Decade	1952– 1961	1962– 1971	1972– 1981	1982– 1991	1992– 2001	2002– 1911
Sites	1	13	18	13	6	6

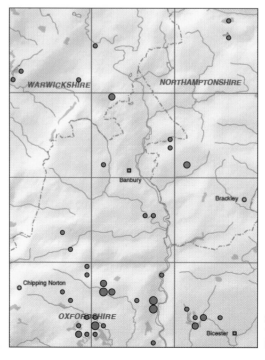

Sightings in 1952–2011 for Hawfinch

Buntings *Emberizidae*

Snow Bunting *Plectrophenax nivalis*
Rare winter visitor

Single birds were shot in Bloxham in December 1878 and Aston-le-Walls in January 1879. The next records did not occur until February 1961 at Middle Tysoe, two first-winter birds were seen at Nell Bridge in April 1966 and an adult male was observed at Moreton Pinkney on February 1967. Only two records of single birds were noted in the 1970s and 1980s, namely at Ardley in January 1975 and North Newington in November 1983. The next appearances were at Chipping Norton in December 1990 and at Great Rollright in November 1995. The most recent records are of single birds at Fenny Compton in November 2004, Chapel Ascote in March 2007 and Wormleighton in November 2009.

Yellowhammer *Emberiza citrinella*
Numerous resident

The Yellowhammer is the most numerous and widespread of all the buntings found in the BOS area. At the end of the nineteenth century it was considered to be an abundant resident, nesting along every hedgerow and gathering in flocks during winter, being most apparent in the upland arable areas. This is not quite the same today as farming practices have changed considerably since the 1900s. Pre-1960 there was a decline in numbers because of the use of organochlorines as a seed dressing. This situation lasted until the mid-1960s and numbers then started to recover by the 1970s.

TREVOR EASTERBROOK

Yellowhammer abundance again began to decline in England in the mid-1980s and has continued on this downward trend ever since. Recent changes in farming methods have again had an effect on numbers with a reduction in winter seed food availability occurring as a result of agricultural intensification. For example, the loss of winter stubbles and a reduction in weed densities are widely believed to have contributed to the population decline. The data from our WRSS reflects the fluctuations that have occurred in Yellowhammer numbers from the mid-1970s until the late 1990s, remaining relatively stable in the BOS area thereafter. The results of our SRSS, held during the breeding seasons since 1991, show that both abundance and distribution have remained constant. Our ringing group ringed 664 birds between 1972 and 1981 and found it was a very sedentary species. The largest recorded winter flocks were 250 birds at Newbottle in March 1967, 300 at Charwellton in February 1982, 350 at Kineton in February 1983 and 350+ at Milcombe in November 2005 on set-aside. Flocks of 100–200 birds have not been uncommon since 2000 when birds have been feeding in game-bird crops, in unharvested crops or on the few stubble fields that are left to overwinter. In the recent hard winters of 2009/10 and 2010/11 birds have been reported coming into village

gardens and feeding underneath bird feeders. The species was listed as green in the BoCC list until 2001 but, because of the recent breeding population decline, has been red-listed since 2002.

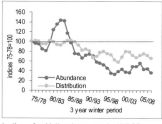
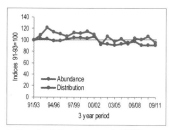

Indices for Yellowhammer in WRSS Indices for Yellowhammer in SRSS

Cirl Bunting *Emberiza cirlus*

The early records include a party of seven near Banbury in January 1877, single birds at Bloxham in December 1878 and at Brailles in 1884, two pairs at South Newington in May 1885 and a male at Bloxham in 1880. The only records in the twentieth century were of birds at Hook Norton in 1918, at three localities in the Sibford district in 1916, an adult male seen near Bodicote in March 1959 and the final sighting at Chesterton in January 1968. The last time the species bred in the area was in 1914.

Little Bunting *Emberiza pusilla*
Rare vagrant

A single bird was present with Reed Buntings in the NW of the BOS area on a farm in south Warwickshire during March 2009.

Reed Bunting *Emberiza schoeniclus*
Fairly numerous resident

Traditionally the Reed Bunting has been found alongside the marginal aquatic vegetation of river valleys and their tributaries and pools. Glyn Davies, in his paper *The Status of Reed Bunting in the Banbury Area* in 1981, indicated a probable increase from the late 1960s to mid-1970s from a minimum of 40 pairs to 80 pairs per 100 sq. km. At this peak of population in 1970, birds moved into drier farmland habitats. By 1976, however, a sharp decline in Reed Bunting numbers began and continued until the mid-1980s, the collapse in the 1970s having coincided with use of herbicides for weed control. Some birds can still be found breeding in lowland arable farmland, in particular in Oil-seed Rape, cereal and set-aside, as maybe this is where most insects are to be found. The WRSS chart indicates that since 2000 both abundance and distribution have increased from the low figures of the mid-1990s. The initial national decline placed Reed Bunting on the BoCC red list but, in 2009, with evidence from the BBS of some recovery in numbers, the species was moved from red to amber. In 1972–81 the BOS

ringing group concentrated on the winter roosts of Reed Bunting at Grimsbury reed-bed, where over 3,000 birds were ringed. It was shown that the resident population is joined by visitors from the north and east of the country including a few from the Continent. The largest number recorded at the roost was 400+, present during October 1974. The most recently recorded largest flocks are of 125 birds at Tysoe in a field of brassicas in November 2004 and 120 at Priors Hardwick in December 2008 on an unharvested wheat crop. Over the last few winters records have been reported of Reed Buntings regularly visiting gardens with bird feeders.

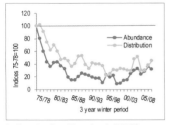

Indices for Reed Bunting in WRSS

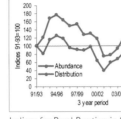

Indices for Reed Bunting in SRSS

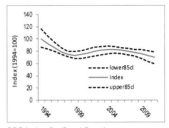

BBS index for Reed Bunting

Corn Bunting *Emberiza calandra*
Not scarce resident

The BOS survey of 1957 showed the Corn Bunting to be well distributed, with local concentrations throughout the area, and 100+ singing males counted in the south. The main habitat for Corn Bunting is open windswept upland arable countryside and the ABSS of 1985 confirmed that the highest density occurred in the south of the BOS area. Although largely sedentary, the species does move out

BARRY BOSWELL

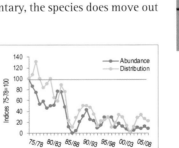

1km squares per year 1993–2011 for Corn Bunting

Indices for Corn Bunting in WRSS

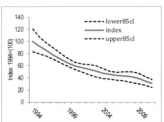

Indices for Corn Bunting in SRSS

BBS index for Corn Bunting

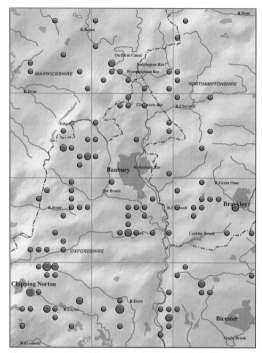

1km squares during May–August in 1997–2001 for Corn Bunting

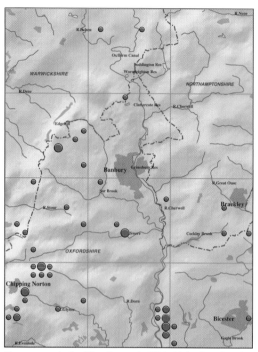

1km squares during May–August in 2002–06 for Corn Bunting

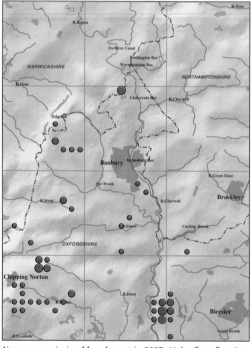

1km squares during May–August in 2007–11 for Corn Bunting

of its breeding territories during the winter into feeding flocks. The largest number of singing males recorded in a relatively small area was 40+ at Hinton Airfield in 1978 and 1979. The largest observed winter flocks were of 350 birds at Lower Heyford in February 1989, 150 at Glyme Farm, Chipping Norton in November and December 2001 and 112 at Barford Airfield in February 1988. Following a national decline starting in the mid-1970s, Corn Bunting is now on the BoCC red list. Our WRSS also shows this sharp reduction between 1975 and the mid-1980s, but since then numbers have declined at a slower rate with birds still breeding in a few areas. The maps show the number of recorded 1km squares during the breeding season May to August in three five-year intervals since 1997.

Other species

Other species recently recorded in the Banbury area, not on the British and/or the BOS list, and whose origin is unknown, probably having escaped from private collections.

Species	Records
Black Swan *Cygnus atratus*	Recorded on four waters in 2002, 2004, 2010, 2011
Bar-headed Goose *Anser indicus*	Regularly seen since 2000, particularly at BAD Kineton
Ross's Goose *Anser rossii*	2004
Emperor Goose *Anser canagicus*	2006, 2007
South African Shelduck *Tadorna cana*	2005
Cinnamon Teal *Anas cyanoptera*	2002
Spot-billed Duck *Anas poecilorhyncha*	2002
White-faced Whistling Duck *Dendrocygna viduata*	2007
Red-tailed Hawk *Buteo jamaicensis*	2005
Saker Falcon *Falco cherrug*	2003
Chukar Partridge *Alectoris chukar*	1988, 1992
Eagle Owl *Bubo bubo*	2002
Black-breasted Thrush *Turdus dissimilis*	2010
Purple Sunbird *Cinnyris asiaticus*	2003
Violet Turaco *Musophaga violacea*	2006
Waxbill *Estrilda Sp.*	2007
Zebra Finch *Taeniopygia guttata*	2004

Conservation in the BOS area

In 1952 the original objectives of the BOS were 'To encourage and coordinate the scientific study of bird life in the Banbury area and to act in the interests of bird protection'. This initial scientific focus meant that little direct conservation was embraced in the Society's first decade. However Glyn Davies, in the first ten-year report (1962), did acknowledge the importance of the Cherwell Valley flood plain in the Clifton–Somerton area and that support from BBONT should be sought to ensure its preservation. He also stressed that damage to habitats would be considerably lessened if planners could be made to realise that it is often possible to make provision for the continued survival of birds within the framework of economic necessity.

Then, when a proposal for large-scale ironstone mining threatened the parklands of north-west Oxfordshire (the Tew area) in 1960, the BOS opposed the application and prepared a report on the likely effects to bird life which was presented to the public inquiry. As a result of the many objections lodged the application was refused. So, even in its infancy, the BOS was showing an interest in conservation matters.

Following the construction of Grimsbury Reservoir in 1967, ten acres at the north-east end of the site were designated as a bird reserve as the result of BOS pressure. The Chairman at the time, Jim Arthur, persuaded the Forestry Commission to plant 12,000 Scots Pines and Alders which enabled a long-term study by BOS of the changes in usage and habitat as the site developed. Also in 1967 the BOS worked with the Northants Wildlife Trust to erect a gate at Boddington Reservoir to prevent walkers from disturbing breeding Great Crested Grebes.

In the early 1970s the final filtration meadows at Banbury SF were designated a nature reserve by BBONT following requests to BOS from the site manager, as a means of policing the area against illegal shooting. The reserve produced many excellent records of birds attracted by the good feeding that the site provided. It was eventually decommissioned in the early 1990s following modernisation of the treatment process.

A nature reserve on the old mineral railway system at Horley was created following the successful blocking of a change-of-use application to develop a motorcycle trail biking area. Again BBONT took out the 25-year lease and management was provided by BOS members. Around the same time BBONT secured the cuttings and embankments at each end of the old railway tunnel at Hook Norton and, again, this was wardened and managed by BOS members.

In 1971 the post of Conservation Officer was created, the first holder being Cliff Christie. This post became increasingly necessary as the discussions taking place with local landowners to oppose the M40 passing through the Cherwell Valley became more intensive. It is generally recognised that this lobbying was instrumental in the re-routing of the motorway, which was constructed in the 1980s, away from the valley between Lower Heyford and Kings Sutton.

During the 1980s a series of meetings between the BOS, Oxford Ornithological Society, English Nature and the RSPB resulted in the establishment of the Oxon Bird Coordinating Committee, the purpose of which was to coordinate conservation projects and constructively oppose possible threats to environmentally sensitive areas. Closer ties were also forged with Cherwell District Council (CDC) who set up twice-yearly countryside forums with the aim of giving a voice to local organisations on countryside issues. As the BOS were the prime movers in local conservation, CDC leisure services and planning departments met regularly with officers of the Society to discuss the county wildlife strategy and the Biodiversity Action Plan implementation at District Council level.

The 1980s were busy times for the conservation side of the BOS, the following being some of the major projects in which it was involved:

- Management of a reserve set up with Northants Naturalist Trust (NNT) at a disused railway line at Farthinghoe.
- Management of a Pocket Park on an old railway system at Woodford Halse, again administered by NNT.
- Opposition to the development of a deep railway cutting at Helmdon at the request of the local community.
- A link road between the Daventry Road and Southam Road was proposed on a line through the woodland reserve at Grimsbury Reservoir. This was successfully opposed by the BOS at an public inquiry, the final approved route passing the waterworks to the south thereby removing any disturbance to the Reserve and reservoir study area.
- The Reserve at Grimsbury became the subject of a 25-year management lease from Thames Water in 1992.

Aerial view of Balscote Quarry before management

BOS-owned reserves

In the 1990s the society began looking to purchase potential nature reserves with monies bequeathed by Glyn Davies.

Balscote Quarry

In 1998, following the cessation of quarrying works, the BOS was able to purchase 6.2ha of the disused site, which now provides a wetland area in the north of Oxfordshire where there was previously no similar habitat. This was the first of the reserves. Part of the reserve is a wetland flash area formed by seasonal rainfall. Unfortunately the water level has been lower over recent years due to the lack of winter rainfall and usually dries out through the summer. There is also a deep pool which retains water all year.

The wet areas attract breeding Little Ringed Plovers, Lapwings, Little Grebes and Mallard, whilst the remainder of the reserve attracts breeding finches and warblers. Waders pass through in spring and autumn with Snipe present in good numbers throughout the winter, as are Golden Plovers and Lapwings. Curlews bathe and roost at the reserve in spring. In 2011 the first Sand Martins were recorded breeding using the artificial tower provided for them ten years earlier.

To date 135 species have been recorded on and over the reserve including Osprey, Red Kite and Peregrine. The site also attracts many butterflies and dragonflies and a survey recorded 60+ species of wasps and bees. There is a substantial variety of flowers and plants including Common Spotted Orchid and a few Pyramidal Orchids.

Balscote Quarry today from the view point

Glyn Davies Wood

The BOS purchased a 3.2ha deciduous wood lying on the Northants/Warwickshire boundary for £36,000 following an auction in October 1999; it was renamed Glyn Davies Wood in memory of the Society's benefactor.

The wood lies on a south-west facing slope 140–155m above sea level on a geology of Jurassic clays. It is shown as existing on the first edition of the Ordnance Survey Map for Daventry published in 1834 and the presence of mature Oak standards, with ground cover of Bluebells, indicates an ancient wood. Though the reserve is relatively small in extent, there is further adjoining woodland to the north-east. Other tree species present include Ash, Sycamore, willow species, Aspen, Silver Birch, Field Maple and Wayfaring Tree, whilst the understorey comprises Hawthorn, Hazel, Blackthorn, Holly and Bramble. Management has concentrated on controlling the amount of Sycamore present as

Aerial view of Glyn Davies Wood

well as maintaining two clearings and a circular pathway around the reserve. A former pond on the southern boundary has been re-excavated and attracts a few common water birds as well as a range of dragonflies.

Breeding birds on the reserve include Sparrowhawk, Tawny Owl, Nuthatch, Great Spotted Woodpecker, Marsh Tit and, most importantly, the

Glyn Davies Wood

rapidly declining Willow Tit. Nest boxes have been erected and are used primarily by Blue Tits. A feeding station is maintained throughout the winter months and the wood additionally supports Woodcock, Siskin and Redpoll. A number of bat boxes have been erected and are regularly used by Brown Long-eared and Common Pipistrelle Bats. Purple Hairstreak butterflies have been observed using one of the Oak standards as a 'master' tree, whilst White-Letter Hairstreaks have been seen egg-laying on Elm regrowth in one of the clearings

Pauline Flick Reserve

Since the closure of many local railway lines during the late 1950s and the early 1960s, a network of wildlife corridors has become established as lengths of these old lines have reverted back to their wild state. The Pauline Flick Reserve, approximately 2ha in area, is one of these and lies in an area of limestone brash farmland close to Great Rollright.

Under ownership of the BOS, the railway line was cleared to create a central ride while leaving the maturing trees and scrub to the north and south boundaries. Over time further scrub has

been periodically removed creating areas with varied age structure.

The site has a good variety of flora and certain areas are kept free of scrub to enable the orchids and other plant species to persist. These more open areas are also favoured by sun-loving reptiles such as Common Lizard and Grass Snake, and the Glow-worm has also been recorded on the site. The Reserve is rich in invertebrates and 300+ species of moth have been recorded, the most notable being the Pale Shining Brown.

In most years the berry-producing scrub attracts a good number of wintering thrushes. During early spring the budding Blackthorn bushes provide good foraging for Bullfinches and at the same time Chiffchaffs and Blackcaps arrive to set up territories for breeding. Other summer migrants pass through the site and seven different species of warbler have been recorded singing. Farmland birds such as Yellowhammer breed in low numbers and the Ivy-covered trees provide breeding locations for a number of species including Goldcrest. Feeding stations are operated during the winter months, regularly visited by Marsh Tit along with other members of the tit family, Yellowhammer, Chaffinch and Brambling.

The disused railway line at the Pauline Flick Reserve

RICHARD HALL

Tadmarton Heath Reserve

The principle behind reserve acquisition was to obtain different habitat types, thus the next purchase was to be farmland, completed in 2005. The site that was earmarked was 7.3ha of rough meadow but, as it was landlocked, it was necessary to purchase a vehicular right of way and construct a culvert at the stream to enable access for farm machinery. The whole site had to be fenced off such that cattle could be allowed on for grazing in autumn, and a further 0.5ha was fenced off and laid down to arable bird crop. The remaining meadow was left to revert to unimproved grassland with stands of Gorse planted on some of the slopes.

The rotational bird crops grown on the arable section have proved very successful in providing plenty of winter feed for Reed Bunting and Dunnock and many species of finch. Ringing on the site has produced some interesting data that normal observation would miss, such as 52 individual Bullfinches and 56 individual Dunnocks.

Management of the meadow has involved the planting of clumps of Gorse, which have had a

Aerial view of Tadmarton Heath Reserve

high percentage success rate and have quickly grown into valuable cover for small birds. The other more challenging management task is that of pulling Ragwort prior to allowing cattle on-site to graze. Meanwhile, a great deal of Hard Rush has invaded the site about which little can be done although it does seem to be stabilising. Already some old meadow plant species are establishing themselves such as Common Spotted Orchid, Common Fleabane and Yellow Rattle. During

Planting Gorse at Tadmarton Heath Reserve

Grimsbury reservoir

Grimsbury Woodland
Nature Reserve

the summer months good numbers of butterflies abound on the grass and mown paths including Marbled White, Common Blue and Small Copper.

The developing Bramble scrub provides nesting sites for numerous Whitethroats whilst Reed Bunting and Skylark occupy the more open areas. Green Woodpecker, Buzzard and Sparrowhawk use the adjacent woodland and boxes erected for Barn Owl and Tawny Owl have both been used. Visiting birds include Short-eared Owl, Wheatear, Stonechat, Hobby and Woodcock. Two winter feeding stations are provided which attract many tits, Nuthatches and Great Spotted Woodpeckers, not to mention Grey Squirrels!

Managed Reserves

Grimsbury Woodland Nature Reserve

As mentioned earlier this was the first BOS involvement with habitat management. The 3.5ha site was planted with Scots Pine and Alder by the Forestry Commission, the idea being to let the woodland develop naturally and record the changes in bird species using it. Initially it resembled very rough wet grassland and was a breeding site for species such as Reed Bunting and Skylark and even Whinchat for one year.

As the trees became established then warblers, especially Willow Warbler, moved in as breeders. Occasional visitors included Barn Owl, Short-eared Owl and, on the stream running through the site, Kingfisher. As the trees really started to grow well, it was decided that some rides and clearings needed to be created to allow light in and create more woodland edge. With the Alders maturing and producing an abundance of fruiting cones, Siskins and Lesser Redpolls became regular winter visitors with, on one occasion, a large flock of Brambling feeding on seeds that had dropped onto the snow beneath the trees. The diversity of species has reduced as the original trees have passed the 45-year mark.

Although the BOS had worked closely with the Thames Water Conservation Section (TWCS) since the plantation was created, there was never a formal agreement between the parties relating to the management of the site. In 1992, however, the BOS was granted a formal licence to manage the reserve on behalf of Thames Water Utilities Ltd. In recent years management of the site has not been as proactive as it had been but, with a new reserve manager now in place, there should be a return to the focus seen in earlier years and, hopefully, a closer involvement with TWCS.

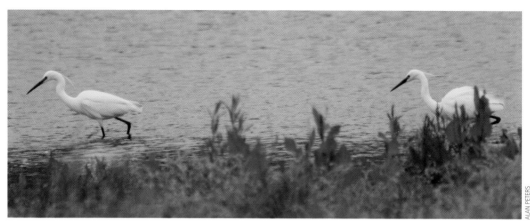

Little Egrets searching for food in the main water area at Bicester Wetland Reserve

Bicester Wetland Reserve

Created in 1999, Bicester Wetland Reserve was the result of an agreement between the BOS and Thames Water. It was developed from an area of meadow, 7ha in size, previously used for the disposal of treated sewage sludge from the nearby sewage treatment works. Channels and scrapes were excavated with supporting bunds and water control mechanisms, wetland plant species were introduced and a reed-bed planted. The aim of the reserve was to provide a suitable habitat to encourage the breeding of a number of wetland-related species, create a safe area for passage waders, and a refuge for wintering waders and wildfowl.

A new hide at Bicester Wetland Reserve

Eight species of warbler have bred on the reserve and Reed Warbler, a target species, first began to use the reserve in 2000; now around six pairs breed each year. Reed Bunting, another target species, is also a regular breeder. Little Grebe, Coot, Moorhen, Mallard, Tufted Duck, Mute Swan, Canada Goose and Kingfisher also breed. Green Sandpipers are found in almost every month of the year and peak in late August to early September, 11 being the highest count on a single day. Common Sandpiper is an annual visitor and records of Little Ringed Plover are increasing. In all, 12 species of wader have been recorded. Teal is the most numerous wintering duck with counts of 200+ and smaller numbers of Shoveler and Wigeon. Wintering Common Snipe average around 30 birds and these are joined by smaller numbers of Jack Snipe. Little Egret is now being seen more frequently and in February 2010 the first Bittern appeared at the reserve.

Reserve maintenance includes rotational cutting of the reed-bed, cutting of the paths, removing invasive trees and other plant species and grazing with cattle from the nearby farm from late summer until early winter.

The Neal Trust Reserve

The Neal Trust Reserve is the newest BOS reserve and comprises most of the land of high conservation value at Oxhouse Farm, Combrook in Warwickshire.

During the 1980s and early 1990s Oxhouse Farm was known for its breeding Nightingales with up to nine singing males some years. Sadly habitat degradation means these have been lost.

Bordered on one side by the River Dene, the reserve is a mosaic of woodland which contains a lot of dead wood, scrub and also more open grassland. Woodland bird species are in the woods throughout the year: Great Spotted and Green Woodpeckers breed and Lesser Spotted are suspected; Nuthatch and Treecreeper abound with all six species of tit present with good numbers of Goldcrest. Warblers are well represented and winter thrushes strip the Hawthorn berries later in the season. Woodcock are regularly seen during the winter.

The Neal Trust Reserve covers approximately 16ha with a further 18ha of sympathetically managed arable land which is owned and managed by the Neal Trust itself. Following the death of Mrs Neal's husband in a farming accident in the early 1960s, the farm was largely abandoned with just a few cattle left grazing a couple of fields. The meadows began to scrub up and, together with thick Blackthorn scrub on the side of the disused railway line which runs along the edge of the reserve, this encouraged some excellent bird, butterfly and invertebrate habitat to evolve. This was at its best in the 1980s at which time it was possible to see 20 species of butterfly in a single afternoon. Large numbers of deer started grazing out the best habitat, though, which has led to its degradation.

The Neal Trust realise that sympathetic management is needed to get the site back to its best and they want to try to ensure the return of the Nightingales as well as encouraging a whole range of habitats and species. There is an SSSI 1.6ha in area which is fantastic for butterflies in July and August and is the only breeding site for Dark Green Fritillary in Warwickshire. During sunny weather it also has good numbers of other grassland butterfly species such as Marbled White. Due to non-management of riverside trees the River Dene contains a lot of submerged timber which, along with its associated invertebrate species, is acknowledged as one of the best sites for this habitat in Britain. As a result, several other bodies such as Natural England and Butterfly Conservation are keen to be involved with the site and provide expertise in their fields of interest.

All seven reserves are managed by BOS members to individual management plans, with assistance from other members in regular work parties. The reserves represent a good diversity of habitats and are valuable environmental assets for the area. Although the BOS is primarily a scientific research organisation, it can be seen to have contributed in no small way to conservation and will continue to do so in the decades to come.

TREVOR EASTERBROOK

The butterfly meadow
at Neal Trust Reserve

Ringing in the BOS

The place of ringing in the BOS

Methods used for the study of birds have changed over the years. Gilbert White (1720–93), often referred to as the 'father of British ornithology', was a field observer and recorder. In Victorian times ornithologists wanted to study birds more closely. Unfortunately this resulted in the killing of many thousands of birds but did enable scientists to form the basis of ornithological classification, i.e. separation into their orders, families, species and subspecies. This process of classification continues today, enhanced by modern techniques such as DNA analysis and has, in some cases, revealed the need for reclassification. In the mid-twentieth century, conservation philosophy

gathered momentum and, from a scientific point of view, there was a need to study plumage variation, moult state and weight change, which was not possible from specimens alone. This led to an emphasis on capturing live birds for examination and also on ringing in order to track movement, life length and so on. If an individual bird can be identified by putting a numbered ring on one of its legs then, once released, much more information can be obtained, particularly if a proportion of ringed birds are retrapped in the same area, caught and released in another location or reported when found dead by the public. The information obtained over a period of time from a large number of ringed birds reveals:

ALAN PETERS

Ringing, measuring and weighing birds in a hide at Bicester Wetland Reserve

- movement and migration patterns
- mortality and longevity rates
- plumage variation in relation to age and location
- moult patterns
- population distribution in an area.

Ringing is a very specialised type of fieldwork which is not suited to everyone. There has to be an extensive training period and high standards are expected. Trainee ringers in the BOS are expected to become good all-round fieldworkers, be willing to take part in routine tasks, be conservation-minded and use common sense in relation to a bird's welfare. They also need the technical skills required for removing birds from mist nets and placing a ring of the correct size on a bird's leg. It is down to the ringing instructor to decide when, and if, a trainee is suitable to become a fully fledged ringer.

Activities 1962–91

In 1962 a few members led by Glyn Davies were already engaged in ringing at the inland bird observatory in the grounds of Tudor Hall Girls' School. With the introduction of the Protection of Birds Act in 1967, however, the ringing or marking of wild birds became restricted to persons authorised by licence from the Natural Environment Research Council. A formal ringing group within the Society was therefore proposed, to encourage other members with similar interests. This was agreed by the committee and the BOS ringing group was duly registered with the BTO. Members were trained and operated under licence such that several members became C ringers and a few went on to hold trainers' A permits. The ringers caught and ringed birds in several different areas throughout the BOS. Throughout the 1970s ringing continued with a lot of effort in particular put into ringing at the Grimsbury reed-bed, catching Swallows, Yellow Wagtails, Pied Wagtails and Reed Buntings at roost between late July and October. Glyn Davies produced two papers using the Grimsbury data; the first, *Pied Wagtail movements in the BOS area* (1974), looked at the results from the ringing of 1,000+ birds and concluded that the build-up

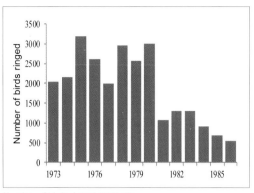

Number of birds ringed 1973–86

from July to September was the gathering of local birds, whilst the October–November surge was probably due to the influx of passage migrants. The majority of Pied Wagtails on the move in the autumn were juvenile birds. The second paper, *The Status of Reed Bunting in the Banbury Area* (1981), was based on 2,000+ birds caught at the roost between 1970 and 1980. Davies concluded that the breeding population probably doubled from 1970 to 1975 but by 1980 had declined back to the 1970 level. The resident population was joined by Reed Buntings from other areas in the winter months and males predominated over females in a ratio of 3:2 in the Banbury roost.

Unfortunately the Grimsbury site was eventually destroyed by the farmer, who allowed cattle and sheep into the reed-bed and made access very difficult. By 1988 only two or three of the ringing group remained active and it became necessary to consider whether the group justified its existence. It was decided to continue but to concentrate on ringing a larger number and a greater variety of birds in order to give new recruits a fair chance of qualifying for their licence. Garden sites were still used for a while but again did not offer enough species or numbers. After the death of Glyn Davies in 1991, ringing activities were wound down except for the ringing of Barn Owl pulli for a Barn Owl Conservation Project. There was no further work by the group until 2006 when a new set of ringers emerged to continue this important part of ornithology.

Sample of recoveries

1974 A Swallow ringed by Glyn Davies in Gozo, Malta on 18 April 1974 was retrapped and taken out of a mist net by him at Grimsbury reed-bed on 22 August 1974.

1976 A Fieldfare ringed at Byfield on 19 January 1975 was found dead in Oslo, Norway on 27 June 1976.
A Lesser Redpoll ringed at Newport Pagnell on 27 June 1976 was caught roosting at Grimsbury on 18 July 1976.
A Kingfisher ringed at Grimsbury on 11 June 1974 was controlled at Dadford, Bucks on 13 November 1976.

1977 A Blackbird ringed at Spurn Point in October 1972 was found dead at Ledwell on 9 January 1977.

1978 A Lesser Redpoll ringed at Grimsbury on 3 January 1974 was found at Balwell Common, Nottinghamshire on 11 October 1978.

1979 A first-year Lapwing ringed at Banbury on 1 May 1978 was found dead at Plondeur-Lauvern, France on 1 January 1979.

1981 A Blackbird ringed at Byfield on 8 December 1980 was found dead at Vest-Vlaunleren, Belgium on 20 March 1981.

1982 A flock of 68 Siskin were caught on 15 March 1982 at Adderbury. Only four in total had been caught during 1962–81.

1983 A Swallow ringed at Stourton, Warwickshire on 17 June 1982 was found dead at Cape Province, South Africa on 8 March 1983.

1984 A Shag ringed in the Farne Islands, Northumberland was found exhausted at Great Tew on 29 January 1984.

Total number of each species ringed from 1962 to 1988

Species	Total	Species	Total
Mute Swan	2	Curlew	2
Mallard	6	Common Sandpiper	7
Sparrowhawk	3	Green Sandpiper	1
Kestrel	56	Black-headed Gull	1
Water Rail	1	Stock Dove	25
Moorhen	8	Woodpigeon	30
Little Ringed Plover	4	Collared Dove	29
Ringed Plover	1	Turtle Dove	2
Lapwing	15	Cuckoo	14
Little Stint	2	Barn Owl	1
Curlew Sandpiper	1	Little Owl	22
Dunlin	2	Tawny Owl	6
Jack Snipe	7	Long-eared Owl	1
Snipe	58	Swift	127

Species	Total
Kingfisher	49
Green Woodpecker	9
Great Spotted Woodpecker	7
Lesser Spotted Woodpecker	4
Magpie	26
Jay	27
Jackdaw	30
Rook	5
Carrion Crow	20
Goldcrest	470
Firecrest	3
Blue Tit	8,883
Great Tit	4,052
Coal Tit	407
Willow Tit	240
Marsh Tit	189
Bearded Tit	1
Skylark	35
Sand Martin	249
Swallow	2,991
House Martin	207
Long-tailed Tit	393
Wood Warbler	8
Chiffchaff	496
Willow Warbler	1,085
Blackcap	404
Garden Warbler	125
Lesser Whitethroat	236
Whitethroat	191
Grasshopper Warbler	13
Sedge Warbler	367
Reed Warbler	570
Nuthatch	68
Treecreeper	218
Wren	774

Species	Total
Starling	1,517
Dipper	3
Ring Ouzel	2
Blackbird	3,578
Fieldfare	64
Song Thrush	1,134
Redwing	177
Mistle Thrush	106
Spotted Flycatcher	282
Robin	1,535
Nightingale	3
Redstart	56
Whinchat	10
Stonechat	1
Wheatear	7
Pied Flycatcher	3
Dunnock	1,705
House Sparrow	872
Tree Sparrow	878
Yellow Wagtail	792
Grey Wagtail	24
Pied Wagtail	1,583
Tree Pipit	1
Meadow Pipit	21
Chaffinch	1,630
Brambling	9
Greenfinch	1,680
Goldfinch	285
Siskin	73
Linnet	592
Lesser Redpoll	81
Bullfinch	1,510
Yellowhammer	690
Reed Bunting	3,318
Corn Bunting	20
Total	47,528

Goldcrest about to be processed

Checking a Kingfisher wing before measuring takes place

Lesser Whitethroat ready for release

Ringing from 2006 to 2011

In March 2005, George Candeline gave a talk to the BOS on the subject of bird ringing. Several committee-meeting discussions regarding the ringing of birds on BOS reserves followed and, at the end of 2006, one member began ringing at the Pauline Flick Reserve under the guidance of a trainer living just outside the BOS study area. Steady progress was made such that, by the end of 2011, the Society had three A permit holders with training endorsements, a C permit holder and a further individual in the process of applying for a C permit along with a small selection of trainee permit holders. The Society therefore currently finds itself well positioned to increase the amount of ringing on its sites and, with several trainers available, it has the potential to attract more individuals into this branch of ornithology.

The first of the new C permits from within the ranks of the BOS was obtained at the end of 2008 and from this point ringing began in earnest on the BOS reserves. Although the new set of ringers have yet to form their own BTO-registered ringing group, activities remain focused, with 5,000+ birds from 50+ species being ringed by the end of 2011. The recommencement of ringing met with a very positive response from the BOS committee: not only has the BOS actively encouraged individuals to gain expertise in this field but it has also given financial support to the North Thames Gull Group to colour-ring large gulls that were using the rubbish tips in the south-east of England, as these sessions are attended by individuals from the Society. In addition, the Society has donated money towards the cost of producing a ringer's manual for use in Malta following recent trips by one of the BOS members to the island (the Society has close links with Malta as a few of the founder members of the BOS helped train members of the Malta Ornithological Society).

Mist netting is the standard method used for catching birds at all the BOS sites. Nest boxes have been located at the Pauline Flick and Tadmarton Heath reserves and are used for both nest recording and the ringing of chicks. In 2010, a CES was set up at the Balscote Quarry reserve; it is hoped that this standardised method of ringing will continue for many years to come with

Catching birds for ringing by mist netting at Bicester Wetland Reserve

perhaps one or two more BOS sites being added to this BTO co-ordinated core activity. Some garden sites are also used for ringing as in the 'retrap adults for survival' (RAS) project, which was established in Milcombe in 2011 and which focuses on the House Sparrow. Here, individual birds are colour-ringed to enable sighting-only recording, reducing the need to retrap adult birds.

Interesting data is already being received concerning both local and more distant bird movements. For example, summer migrant site fidelity over consecutive years has been recorded for Chiffchaff, Willow Warbler, Whitethroat, Lesser Whitethroat and Blackcap. Reed and Sedge Warblers have also shown site fidelity although for these two species the habitat requirements can be more specific so this is perhaps a little less surprising. The bird travelling the furthest out of the BOS study area has been a Goldfinch (L201907), ringed at Milcombe on 29 January 2011, recovered at the Calf of Man on 23 March 2011, 53 days, 323km NW. The bird travelling the furthest coming into the BOS area has been a Lesser Redpoll (L052692), ringed at Ty Rhyg (SW Wales) on 2 August 2010, controlled at Milcombe on 26 February 2011, 208 days, 235km E.

Annual Breeding Season Survey

This survey was begun in the early 1960s and designed to ascertain the status of a group of birds breeding in the BOS area that were neither scarce enough for their status to be easily established from existing records nor numerous enough to be sampled accurately by the BTO CBC. Its aim was to establish the minimum number of breeding pairs of a particular species by means of appropriate sample areas. For example, for Reed Warblers all suitable reed beds were surveyed, whereas for Lapwing the whole of the BOS area was searched.

| Species | First survey (1961–86) | | | | |
	Year	Survey area in sq. km	Pairs located	Density per 100 sq. km	Status**
Grey Wagtail	1961	390	23	5.89	Fairly numerous
Redstart	1963	n/a	17	n/a	Fairly numerous
Yellow Wagtail	1964	400	84	21.00	Fairly numerous
Pied Wagtail	1965	300	32	10.67	Fairly numerous
Nuthatch	1966	116	12	10.34	Fairly numerous
Little Grebe	1967	900	27	3.00	Fairly numerous
Tree Pipit	1968	900	51	5.67	Fairly numerous
Grasshopper Warbler	1969	1,000	74	7.40	Fairly numerous
Kingfisher	1970	800	13	1.63	Not scarce
Curlew	1971	1,200	7	0.58	Not scarce
Nightingale	1973	1,200	9	0.75	Not scarce
Tufted Duck	1974	1,200	11	0.92	Not scarce
Great Spotted Woodpecker	1975	100	6	6.00	Fairly numerous
Lesser Spotted Woodpecker	1975	100	4	4.00	Fairly numerous
Green Woodpecker	1976	100	17	17.00	Fairly numerous
Coot	1977	1,200	163	13.58	Fairly numerous
Little Owl	1978/79	124	25*	20.16*	Fairly numerous
Tawny Owl	1978/79	124	22*	17.74*	Fairly numerous
Lapwing	1980	1,200	308	25.67	Fairly numerous
Sparrowhawk	1981	375	16	4.27	Fairly numerous
Marsh Tit	1982	108	33	30.56	Numerous
Willow Tit	1982	108	24	22.22	Fairly numerous
Reed Warbler	1983	n/a	80	n/a	Fairly numerous
Lesser Whitethroat	1984	93	31	33.33	Numerous
Corn Bunting	1985	100	54	54.00	Numerous
Kestrel	1986	475	35	7.37	Fairly numerous

* As the survey was held over two years the number of pairs and density were adjusted and aggregated
** See page 28 (method 1) for definition of status terms

After an initial survey in 1961 looking at the Grey Wagtail, methods were refined and a short list of 30 species drawn up. Over time some of the species originally selected became so scarce that they no longer matched the criteria or conversely were too numerous for the survey to be necessary. These were removed from the list and other species were included as they were now recognised as matching the ABSS criteria. It was intended that the focus would be on one species each year but, in a few cases, it was more practical to study a pair of related species together, e.g. Greater and Lesser Spotted Woodpecker, Marsh and Willow Tit and Little and Tawny Owl were surveyed together for two years because it was difficult to establish the number of breeding pairs.

A pilot survey, involving a small number of active fieldworkers, is carried out in the year prior to each full survey. This helps to establish the best system of sampling and to provide guidelines for carrying out the survey. Methods used in the surveys have ranged from coverage of the whole area, transects across the area, blocks of 1km squares or just surveying a single 10km

	Second survey (1988–2012)				
Species	Year	Survey area in sq. km	Pairs located	Density per 100 sq. km	Status**
Grey Wagtail	1988	1,200	17	1.42	Not scarce
Redstart	1989	1,200	0	n/a	No longer breeds
Yellow Wagtail	1990	500	102	20.40	Fairly numerous
Pied Wagtail	1991	400	49	12.25	Fairly numerous
Nuthatch	1992	232	19	8.19	Fairly numerous
Little Grebe	1993	1,100	43	3.91	Fairly numerous
Tree Pipit	1994	1,200	1	0.08	Rare
Grasshopper Warbler	1995	1,200	13	1.08	Not scarce
Kingfisher	1996	1,200	8	0.67	Not scarce
Curlew	1997	1,200	5	0.42	Not scarce
Nightingale	1998	1,200	1	0.08	Rare
Tufted Duck	1999	1,200	20	1.67	Not scarce
Great Spotted Woodpecker	2000	100	18	18.00	Fairly numerous
Lesser Spotted Woodpecker	2000	100	0	n/a	Scarce
Green Woodpecker	2002	100	25	25.00	Fairly numerous
Coot	2003	1,200	223	18.58	Fairly numerous
Little Owl	2004/05	80	21.5*	26.87*	Fairly numerous
Tawny Owl	2004/05	80	25*	23.12*	Fairly numerous
Lapwing	2006	1,200	71	5.92	Fairly numerous
Sparrowhawk	2007	225	9	4.00	Fairly numerous
Marsh Tit	2008	82	15	18.29	Fairly numerous
Willow Tit	2008	82	5	6.10	Fairly numerous
Reed Warbler	2009	n/a	73	n/a	Fairly numerous
Lesser Whitethroat	2010	58	6	10.34	Fairly numerous
Corn Bunting	2011	1,200	18	1.50	Not scarce
Kestrel	2012	1,200	n/a	n/a	Fairly numerous

■ Species moved to lower category ■ Species moved to lower end of the status ■ Species moved to higher end of the status

square, the particular method depending on the species. For comparison purposes, it was intended that when each species was re-surveyed, the first survey method would be repeated. Extra areas were added for some species where appropriate but this was not always possible. In total 26 species were surveyed by 1986 and by 2012 the same species had been surveyed for a second time.

Over the 50 years of the ABSS several birds have changed status. The status of the species given in the second table refers to its status in the year of the second survey and is not necessarily the status of the species as of 2011. Grey Wagtail, Nightingale, Lesser Spotted Woodpecker, Marsh Tit, Lesser Whitethroat and Corn Bunting all moved into a lower status category compared to the first survey. Redstart and Tree Pipit no longer breed in the area. Lapwing, Kingfisher and Willow Tit have not changed status but their breeding density the second time they were surveyed was very near the lower end of the category and if the trend continues they could move into a lower category. On the positive side Green Woodpecker and Great Spotted Woodpecker have improved their breeding density.

For more detail on the surveys for each individual species see *A compendium of fieldwork carried out by the BOS 1952–2012* (Brownett) which is currently being written, with publication expected in 2014.

Random Square Survey methods

Winter Survey

From its inception, the aim of the BOS has been to determine the status and distribution of birds within the 1,200 1km squares of its study area and to provide a better understanding of their conservation needs. The WRSS was initiated to obtain detailed information regarding the winter distribution and abundance of all birds within the BOS area and was begun in 1975.

Field method

The aim of the survey is to monitor, systematically and over time, the distribution and numbers of wintering birds in the BOS area. The surveys are carried out on the last weekends in November and the following February with different 1km squares selected each time. Each winter about 50 1km squares are surveyed, depending upon the availability of observers. To ensure a spread of coverage across the BOS area annually, at least two 1km squares are chosen randomly from each 10km square. Once surveyed, the squares are not selected again, to ensure full coverage of the area over time.

The results of the BOS Domesday surveys 1980s, 1990s and 2000s enabled the amount of habitat in winter random square surveys to be calculated. The table shows the results of two winter surveys in each decade. It shows that there is a significant correspondence between the habitat in a winter survey and the area as a whole. It is therefore reasonable to assume that all surveys will produce similar results.

Each member taking part in the WRSS spends a minimum of two hours between 09.00hrs and 12.00hrs within their assigned square, counting every individual of each species they locate. While this does not yield an absolute count of birds over the entire 1km square, with care to avoid double counting it does give a figure for minimum numbers. The two-hour period has, in general, been found to be adequate although some features, such as a village or a river bisecting the area, may necessitate more time to secure full coverage. The time limit ensures that each square is treated in a similar fashion.

	Percentage of habitat				Average length (km) per 1km square	
	Farmland	Built–up	Woodland	Standing water	Streams and rivers	Hedge
Total BOS area habitat in the 1980s	90.50	5.17	3.93	0.21	0.93	6.58
Winter 1983/84 random squares	85.41	5.33	5.27	0.22	0.91	7.82
Winter 1987/88 random squares	85.17	4.25	5.09	0.15	0.64	6.84
Total BOS area habitat in the 1990s	86.30	5.94	5.96	0.25	0.93	5.82
Winter 1994/95 random squares	87.13	4.50	3.58	0.14	0.74	5.96
Winter 1998/99 random squares	80.22	2.80	6.33	0.12	0.85	6.06
Total BOS area habitat in the 2000s	83.40	6.60	7.74	0.31	0.93	5.07
Winter 2004/05 random squares	73.67	7.69	10.56	0.10	0.59	4.16
Winter 2008/09 random squares	79.60	4.51	8.31	0.08	0.67	5.08

Comparison of habitat within selected winter survey squares to that of the whole complete study area.

Analytical methods

In an attempt to eliminate errors due to the use of relatively small samples, the results of the November and February surveys are added together to provide a winter total. Each winter, a measure of distribution (D) for each species is calculated as the percentage of surveyed squares in which a species occurs; a measure of abundance (A) for each species is calculated as the mean number of birds encountered per square surveyed.

Both of these measures were calculated for 48 common species each winter from 1975/76 to 2010/11. To emphasise long-term trends in the data, a three-year moving average was calculated for each of these measures. The data was scaled so that the first three-year average (winter periods 1975/76 to 1977/78) had an index value of 100.

Results

It took about 26 years for all the possible 1km squares in the area to be surveyed; 74 squares are largely inaccessible because the land is owned by the Ministry of Defence. Since then the process has started again and some 500 squares have already been resurveyed. The cumulative total from all surveys for the number of different species seen has reached 106, including 55 species which are not seen regularly, such as Whooper Swan, Great White Egret, Merlin, Short-eared Owl, Long-eared Owl and Crossbill.

The average number of species seen in each winter survey is 65.8 (standard deviation = 3.9). Maximum and minimum totals of species seen in any one survey are 76 and 58 respectively. The average number of observers taking part is 26 (17 to 33). Fourteen of these observers have taken part in over 90% of the surveys, thus helping to reduce observer-related error.

The three-year moving averages for both distribution and abundance indices were calculated and plotted for 48 species recorded in all winters. Some interesting trends for certain species were found which, in the main, both confirm the beliefs of local birdwatchers and agree with national trends. The Systematic Species List (see page 27) includes most of the charts which show these trends. The changes in

indices of abundance of the WRSS for the period 1975–96 were significantly correlated with changes in CBC indices for the period 1969–94 (r_s = 0.668, n = 37, P < 0.001). The strong correlations observed between BOS and national data for both distribution and abundance of birds give considerable credence to the assertion that our winter survey is a valid method for determining the status of many species.

Summer Survey

By 1991 it had become apparent that we did not have any real data about the breeding status of many of our more common resident species or summer visitors. Until that time the BOS had only collected data on arrival and departure dates and on large flocks. Following the success of the WRSS it was decided to carry out an SRSS. This survey differs slightly from the Winter Survey in that three or more visits are made to the same 1km square over a four-month period.

Field method

Observers are given a randomly chosen, 1km square and asked to make a minimum of three visits lasting two to three hours, preferably in late April/early May, late May/early June and late June/early July. Ideally these should be spaced out, i.e. two to three weeks between visits. Extra visits can also be carried out at different times of the day or during late March/early April in order to discover owls or early nesters.

Participants are given a recording form and asked to record the species seen at each visit. At the end of the season, they make a judgement about whether or not a species is breeding in the square and give an estimate of the number of breeding pairs. To help them in this decision they are encouraged to use one or more of the following criteria:

- singing male
- pair in suitable habitat
- carrying nest material
- nest seen/found
- nest with eggs
- nest with young
- fledged young

Analytical method

The method used is the same as in the WRSS to produce measures of distribution and abundance and these measures have been calculated for the common residents and summer visitors each year since 1991. To produce long-term trends, a three-year moving average is calculated for each of these measures, and the data is then scaled so that the first three-year average for the SRSS (1991 to 1993) is given the index of 100.

Results

A total of 289 squares have been surveyed since 1991 in which a cumulative total of 90 species has been recorded breeding. The average number of species seen in each survey is 67.8 (standard deviation = 4.8). Maximum and minimum totals of species seen in any one survey are 75 and 59 respectively. The average number of observers taking part is 14 (9 to 32). Twelve of these observers have taken part in over 90% of the surveys, thus helping to reduce observer-related error.

The trends of abundance and distribution for most of the common residents and summer visitors are shown within the Systematic Species List. It can be clearly seen that these charts exhibit very similar trends to those of the BBS graphs. In 2001 only a few squares could be surveyed due to the foot-and-mouth outbreak so data has been adjusted to take account of this abnormality.

Conclusion

In this book my aim has been to illustrate how the BOS has progressed through the last 60 years, as it has strived to obtain a better understanding of the status, abundance and distribution of the species in our area. I have attempted to make the best use of all the records the Society holds, including 250,000 computerised records. For each species I have given the relevant information and used charts and maps for particular species to show trends in both abundance and distribution.

The BOS has participated in all relevant national surveys since 1952 but its particular strength has been the devising of continuing surveys to investigate aspects of the local bird population and identify changes in species status and in habitat over time. As we have carried out the same winter survey for over 35 years, this may well be the longest continuous survey of its kind of winter birds, anywhere in the country. Although our data, like much birdwatching data, is only an estimate of how many birds there really are and can only represent minimum numbers, our results for the majority of species concur with the trends found nationally by the BTO.

We cannot be definitive about what has caused the continuing decline of some of our species. Changes in farming practice since World War II have led to an increase in mechanisation and more use of fertilisers and pesticides. Many farms in our area are now no longer mixed and many have changed to totally arable farming. Spring sowing seems to be very much a thing of the past and this, together with habitat destruction of rough areas and the removal of hedges, is not likely to help wildlife – and farmland birds in particular – to thrive (Stoate *et al.* 2001).

It is important that the BOS continues to collect records in order to monitor the future status of species, for it has the capacity to continue with and expand its fieldwork and conservation projects for many years to come. It also has an invaluable resource in its database to enable ongoing advice to be provided for planning decisions, both on a small scale and also for very large projects like the proposed high speed rail line which may well cut across our area. This book can form a benchmark for further work as well as give new members a better understanding of how the Society has developed over the last 60 years.

Birdwatching has changed dramatically since the early days of the BOS when most observers were limited to the distance one could travel by bicycle and anyone carrying binoculars was regarded with suspicion! Improved methods of travel and communication have ensured that large numbers of records can be collected with comparative ease and computers deal efficiently with a huge database. Day-to-day observations combined with the results of our long-running surveys has enabled the Society to reveal long-term trends in both the distribution and abundance of our resident species as well as the variety of summer and winter visitors. All this shows just how much can be achieved by a small number of committed and enthusiastic amateurs. Overall, by continuing to follow the principles established in 1952 and maintaining consistent (albeit increasingly refined) survey methods, the BOS will go on providing a unique picture of birds and their habitats in this small area of the heart of England.

Appendix 1

Species league table in WRSS and SRSS

For comparison purposes a species is ranked by the percentage of squares in which it was present in the surveys over the period 1991–2011. The number of squares surveyed was 986 in the WRSS and 289 in the SRSS.

WRSS Species	% of squares surveyed	SRSS Species	% of squares surveyed
Blackbird	97	Blackbird	100
Carrion Crow	97	Woodpigeon	99
Woodpigeon	97	Wren	99
Chaffinch	94	Chaffinch	98
Blue Tit	94	Blue Tit	98
Robin	92	Robin	98
Great Tit	86	Dunnock	94
Dunnock	85	Great Tit	94
Wren	83	Yellowhammer	94
Magpie	81	Carrion Crow	92
Fieldfare	75	Skylark	88
Jackdaw	73	Magpie	88
Starling	69	Pheasant	85
Rook	67	Greenfinch	84
Greenfinch	64	Song Thrush	84
Yellowhammer	61	Blackcap	77
Pheasant	57	Stock Dove	75
Skylark	57	Starling	75
Redwing	57	Whitethroat	75
Black-headed Gull	56	Swallow	73
Stock Dove	54	House Sparrow	72
Song Thrush	54	Chiffchaff	71
Pied Wagtail	48	Jackdaw	71
House Sparrow	48	Goldfinch	70
Long-tailed Tit	47	Collared Dove	69
Bullfinch	46	Linnet	62
Goldfinch	43	Bullfinch	60
Collared Dove	41	Great Spotted Woodpecker	56
Kestrel	40	Pied Wagtail	54
Mistle Thrush	36	Green Woodpecker	53
Goldcrest	35	Long-Tailed Tit	53
Buzzard	35	Willow Warbler	51
Great Spotted Woodpecker	33	Mistle Thrush	50
Mallard	32	Moorhen	49
Green Woodpecker	31	Mallard	44
Moorhen	26	Buzzard	43

Appendix 2

Selected BOS Domesday Survey findings

A field-by-field survey known as the BOS Domesday Survey was carried out during the 1980s, 1990s and 2000s. The data from these surveys provided an accurate measure of the proportion of the various habitats within each of the 1,200 1km squares. From this, the total percentage of each habitat type in the BOS as a whole was calculated for each ten-year period. The last two surveys were carried out single-handedly by a long-standing member, Una Fenton, to whom the Society is extremely grateful.

10km square	Arable	Grassland	Woodland	Parkland	Built-up	Standing water	Other	Contour 0–60	Contour 60–90	Contour 90–120	Contour 120–150	Contour 150–180	Contour 180–210
SP32	62.1	19.3	7.7	4.3	5.2	0.2	1.2	0.0	1.7	8.7	20.1	33.8	27.6
SP33	49.2	38.9	1.4	1.7	2.0	0.1	6.6	0.0	0.4	9.8	28.6	36.6	19.7
SP34	50.3	36.0	3.8	2.1	3.8	0.1	3.8	0.0	14.7	31.0	16.0	21.3	15.0
SP35	45.4	32.5	4.4	1.6	4.9	0.5	10.7	0.0	32.1	53.8	13.3	0.6	0.1
SP42	56.3	25.6	7.7	5.3	4.6	0.2	0.3	14.9	38.1	39.1	7.4	0.2	0.0
SP43	47.6	35.8	2.3	2.5	9.6	0.2	2.0	0.0	18.3	52.4	26.4	2.9	0.0
SP44	47.3	29.4	2.2	3.9	14.2	0.5	2.6	0.0	1.8	41.4	41.2	14.5	1.1
SP45	53.8	38.4	1.8	2.0	3.3	0.5	0.2	0.0	3.4	48.6	34.0	8.4	2.2
SP52	52.0	21.5	7.0	4.2	11.9	0.2	3.3	0.0	32.6	51.8	15.0	0.0	0.0
SP53	58.0	23.3	5.9	4.3	7.1	0.3	1.2	0.0	2.2	38.6	55.9	3.1	0.0
SP54	50.3	40.0	3.0	2.6	3.7	0.2	0.2	0.0	1.8	18.9	49.0	29.2	0.0
SP55	47.1	39.7	4.5	3.1	4.4	0.4	0.9	0.0	7.4	38.9	45.7	7.6	0.4

Percentage of land use and distribution of land in contour heights per 10km square, during the 2003–08 Domesday Survey (where grassland is defined as permanent pasture plus ley)

Survey period	Arable	Pasture	Ley	Set-aside	Total
1980s	55.1	31.0	4.4	0.0	90.5
1990s	52.0	24.8	7.5	1.9	86.3
2000s	51.6	23.4	8.2	0.2	83.4

Percentages of farmland usage in the BOS area during the three BOS Domesday Surveys

Survey period	Deciduous	Conifer	Mixed	Parkland	Plantation	Scrub	Total
1980s	n/a	n/a	n/a	n/a	n/a	n/a	3.9
1990s	1.9	0.4	1.4	1.3	0.5	0.4	5.9
2000s	2.4	0.3	1.7	1.6	0.9	0.8	7.7

Percentage of woodland types in the BOS area during the three Domesday Surveys

Schematic views of the major different habitats of the BOS area, based on the 2003–08 Domesday Survey

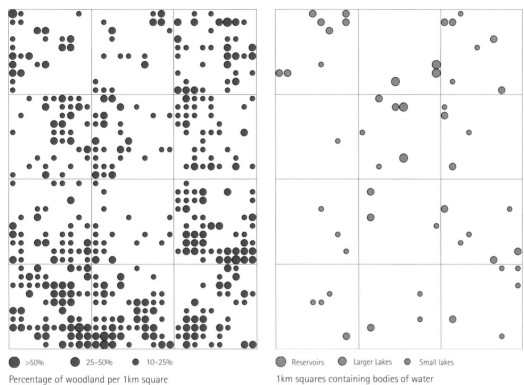

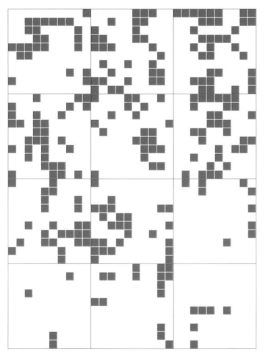

● >50% ● 25–50% ● 10–25%

Percentage of woodland per 1km square

● Reservoirs ● Larger Lakes ● Small lakes

1km squares containing bodies of water

1km squares which contain 50% or more of pasture

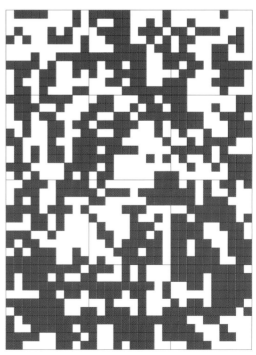

1km squares which contain 50% or more of arable

10km square	Hedges and walls	Stream	River	Canal	Motorway	A roads	B and minor roads	Active railway	Disused railway
SP32	483.4	62	6	0	0	25.2	96.6	2.8	2.3
SP33	537.7	80	0	0	0	8	118	0	9
SP34	572.6	104	0	0	0	16	100.7	0	2
SP35	518.5	83	9	0	14	16	95.8	8	5
SP42	456.2	78	19	14	0	14	86.8	11	0
SP43	464.8	67	29	11	10	26	72	11.2	14
SP44	422.1	81	16	12	11.7	40.2	76	10	11
SP45	593.1	93	4	17	1.2	12	85.3	11	6
SP52	377.3	87	0	0	11	44	87	10	0
SP53	390.8	66	2	0	5.2	22	79	3	8
SP54	577.8	69	5	0	0	6.9	84.4	0	35
SP55	490.7	93	8	0	0	12	101.3	0	21.8

Length in kilometres of hedgerows, roads, watercourses and railways in all 10km squares during the 2003–08 Domesday Survey

10km square	1980s survey	1990s survey	2000s survey	% change from 1980s–1990s	% change from 1990s–2000s	% change from 1980s–2000s
SP32	466	378	416	-18.8	9.8	-10.8
SP33	736	577	531	-21.6	-8.0	-27.9
SP34	817	743	533	-9.1	-28.2	-34.8
SP35	618	534	534	-13.7	0.0	-13.7
SP42	512	425	443	-17.0	4.3	-13.4
SP43	659	498	465	-24.5	-6.6	-29.5
SP44	782	548	421	-29.9	-23.1	-46.1
SP45	717	592	592	-17.4	0.0	-17.4
Sp52	510	402	374	-21.3	-6.9	-26.7
SP53	584	439	389	-24.8	-11.4	-33.3
SP54	818	655	578	-19.9	-11.8	-29.4
SP55	679	644	491	-5.1	-23.8	-27.7
Total	**7,898**	**6,435**	**5,767**	**-18.5**	**-10.4**	**-27.0**

Hedgerow length in kilometres in all 10km squares, in each of the three BOS Domesday Surveys

Grid square SP33 from the BOS Domesday Maps showing habitat types in a typical 10km square. The map was coloured using the data from a field-by-field survey during the 2003–08 Domesday Survey.

Arable

Pasture

Ley

Woodland

Built-up

Water

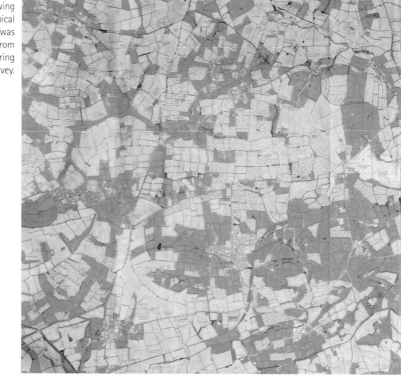

Appendix 3

Weather summary 1952–2011

This data was obtained from the Meteorological Office from their Oxford station, the nearest to the BOS area, to provide a context for comments in the text. The monthly data has been summarised to produce a series of tables and charts which can also act as benchmark, as birds are very much influenced by the weather. Climate change may be an important factor affecting their distribution, abundance and even presence in the Banbury area in the future. The range expansion of egrets, and in particular the Little Egret, as well as the range contraction of Nightingale, may well be classic examples of such change.

Winter rainfall, November to February

Driest winters	
Winter	Rainfall (mm)
1963/1964	121.4
1972/1973	139.4
1974/1975	169.5
1952/1953	175.9
2004/2005	180.4
Average	287.7

Wettest winters	
Winter	Rainfall (mm)
1959/1960	485.1
2001/2002	469.2
1999/2000	416.5
1994/1995	413.5
1957/1958	388.3
Average	434.5

Spring rainfall, March to June

	Rainfall (mm)
Maximum	237.5
Minimum	69.4
Average	152.6
Standard deviation	41.5

Annual rainfall

By using the average annual rainfall of 198.9mm and standard deviation (SD) of 49.8 one can distribute the years in each decade as follows:

Decade	Very wet (more than average + 2SD)	Wet (average + 1SD to 2SD)	Normal (average ± 1SD)	Dry (average – 1SD to 2SD)	Very dry (less than average – 2SD)
1952–1961		1	7	2	
1962–1971		1	8	1	
1972–1981	2		7		1
1982–1991		2	7		1
1992–2001		1	7	2	
2002–2011	1	1	6	1	1

Rainfall data measured and collected by Una Fenton since 1960 at Shipton-under-Wychwood, which lies just outside the BOS area:

January–March rainfall 1960–2011

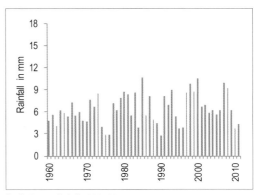

April–June rainfall 1960–2011

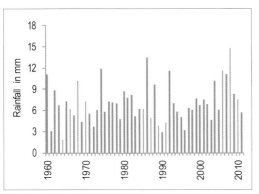

July–September rainfall 1960–2011

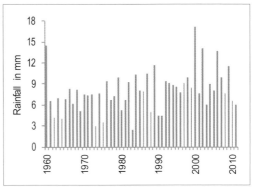

October–December rainfall 1960–2011

Maximum temperature record each year

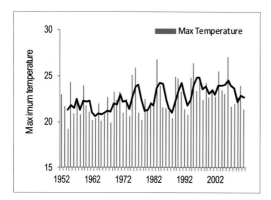

	Recorded temperature (°C)	Year
Highest maximum	27.1	2006
Lowest maximum	19.2	1954
Average	22.6	
Standard deviation	1.81	

Number of hours of sunshine per year

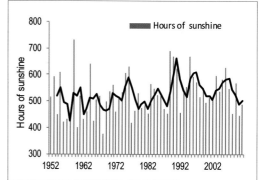

	Number of hours of sunshine	Year
Maximum	732.2	1959
Minimum	375.1	1968
Average	525.14	
Standard deviation	77.1	

Number of days of air frost per winter

Mildest winters	
Winter period	Number of days of air frost
1989/90	7
1960/61	10
1988/89	10
1974/75	11
1991/72	14
1993/94	14

Hardest winters	
Winter period	Number of days of air frost
1962/63	75
1978/79	55
1984/85	55
1995/96	48
2009/10	44
2010/11	43

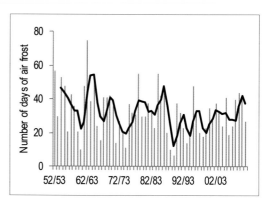

Decade	Very mild	Mild	Normal	Hard	Very hard
1952–1961	1	2	2	5	
1962–1971	2	1	2	4	1
1972–1981	1	1	7	1	
1982–1991	2	2	3	3	
1992–2001	2	4	3	1	
2002–2011		3	4	3	

Appendix 4

Scientific names of non-bird species mentioned in the text

Animal species

American Mink *Neovison vison*
Badger *Meles meles*
Brown Long-eared Bat *Plecotus auritus*
Common Blue *Polyommatus icarus*
Common Lizard *Zootoca vivipara*
Common Pipistrelle *Pipistrellus pipistrellus*
Dark Green Fritillary *Argynnis aglaja*
Earthworm *Lumbricus rubellus*
Field Vole *Microtus agrestis*
Glow-worm *Lamypris noctilua*
Grass Snake *Natrix natrix*
Grey Squirrel *Sciurus carolinensis*
Marbled White *Melanargia galathea*
Pale Shining Brown Moth *Polia bombycina*
Purple Hairstreak *Neozephyrus quercus*
Small Copper *Lycaena phlaeas*
White-letter Hairstreak *Satyrium w-album*
Wood Mouse *Apodemus sylvaticus*

Fish species

Bullhead *Cottus gobio*
Stickleback *Gasterosteus aculeatus*

Plant species

Alder *Alnus glutinosa*
Ash *Fraxinus excelsior*
Aspen *Populus tremula*
Bean *Vicia sp.*
Beech *Fagus sylvatica*
Birch *Betula pendula*
Blackthorn *Prunus spinosa*
Bluebell *Hyacinthoides non-scripta*
Bramble *Rubus fruticosus*
Cherry *Prunus avium*
Chicory *Chichorium intybus*
Cotoneaster *Cotoneaster sp.*
Common Reed *Phragmites australis*
Common Spotted Orchid *Dactylorhiza fuchsii*
Cowslip *Primula veris*

Dock *Rumex sp.*
Elm *Ulmus procera*
Field Maple *Acer campestre*
Gorse *Ulex europaeus*
Groundsel *Senecio vulgaris*
Hard Rush *Juncus inflexus*
Hawthorn *Crataegus monogyna*
Hazel *Corylus avellana*
Holly *Ilex aquifolium*
Hornbeam *Carpinus betulus*
Ivy *Hedera helix*
Larch *Larix decidua*
Linseed *Linum usitatissimum*
Norway Spruce *Picea abies*
Oak *Quercus sp.*
Oats *Avena sativa*
Oil-seed Rape *Brassica napus oleifera*
Pea *Pisum sativum*
Peanut *Arachis hypogaea*
Pedunculate Oak *Quercus robur*
Potato *Solanum tuberosum*
Pyracantha *Pyracantha sp.*
Pyramidal Orchid *Anacamptis pyramidalis*
Ragwort *Senecio sp.*
Rowan *Sorbus aucuparia*
Scots Pine *Pinus Sylvestris*
Silver Birch *Betula pendula*
Sunflower *Helianthus sp.*
Sycamore *Acer pseudoplatanus*
Teasel *Dipsacus fullonum*
Thistle *Cirsium sp.*
Victoria Plum Tree *Prunus domestica 'Victoria'*
Wayfaring Tree *Viburnum lantana*
Wheat *Triticum sp.*
Willow *Salix sp.*
Yellow Rattle *Rhinanthus minor*
Yew *Taxus baccata*

Virus species

Dutch elm disease *Ophiostoma novo-ulmi*
Foot-and-mouth disease *Aphtae epizooticae*

Appendix 5

List of occurrences of species

	Pre–1952	1952–61	1962–71	1972–81	1982–91	1992–2001	2002–11
Mute Swan	x	x	x	x	x	x	x
Bewick's Swan	x	x	x	x	x	x	x
Whooper Swan	x	x	x	x	x	x	x
Bean Goose	x						
Pink-footed Goose		x		x	x	x	x
White-fronted Goose	x	x	x	x	x	x	x
Greylag Goose					x	x	x
Snow Goose					x	x	x
Canada Goose	x	x	x	x	x	x	x
Barnacle Goose				x	x	x	x
Brent Goose	x				x	x	
Egyptian Goose	x					x	x
Ruddy Shelduck			x		x		x
Shelduck	x	x	x	x	x	x	x
Mandarin Duck					x	x	x
Wigeon	x	x	x	x	x	x	x
Gadwall	x	x	x	x	x	x	x
Teal	x	x	x	x	x	x	x
Green-winged Teal							x
Mallard	x	x	x	x	x	x	x
Pintail	x	x	x	x	x	x	x
Garganey	x	x	x	x	x	x	x
Shoveler	x	x	x	x	x	x	x
Red-crested Pochard	x	x	x	x	x	x	x
Pochard	x	x	x	x	x	x	x
Ferruginous Duck	x	x	x	x	x	x	x
Tufted Duck	x	x	x	x	x	x	x
Scaup	x	x	x	x	x	x	x
Lesser Scaup							x
Eider						x	
Long-tailed Duck			x				
Common Scoter	x	x	x	x	x	x	x
Goldeneye	x	x	x	x	x	x	x
Smew		x		x	x	x	

	Pre–1952	1952–61	1962–71	1972–81	1982–91	1992–2001	2002–11
Red-breasted Merganser	x			x	x	x	x
Goosander	x	x	x	x	x	x	x
Ruddy Duck				x	x	x	x
Black Grouse	x						
Red-legged Partridge	x	x	x	x	x	x	x
Grey Partridge	x	x	x	x	x	x	x
Quail	x	x	x	x	x	x	x
Pheasant	x	x	x	x	x	x	x
Red-throated Diver	x			x	x	x	
Black-throated Diver	x				x		x
Great Northern Diver	x		x				
Fulmar	x			x			
Manx Shearwater	x			x	x	x	
Storm Petrel	x						
Leach's Petrel	x	x		x	x		
Gannet	x	x			x		
Cormorant	x	x	x	x	x	x	x
Shag	x		x	x	x	x	
Bittern	x		x	x	x		x
Little Bittern	x						
Night Heron	x						
Little Egret						x	x
Great White Egret							x
Grey Heron	x	x	x	x	x	x	x
Purple Heron	x		x	x	x	x	
White Stork							x
Spoonbill					x		x
Little Grebe	x	x	x	x	x	x	x
Great Crested Grebe	x	x	x	x	x	x	x
Red-necked Grebe			x	x		x	
Slavonian Grebe	x		x		x		
Black-necked Grebe	x		x	x	x	x	x
Honey-buzzard	x					x	x
Red Kite	x			x	x	x	x
Marsh Harrier						x	x
Hen Harrier	x			x	x	x	x
Montagu's Harrier				x			x
Goshawk					x	x	x
Sparrowhawk	x	x	x	x	x	x	x
Buzzard	x		x	x	x	x	x

	Pre-1952	1952–61	1962–71	1972–81	1982–91	1992–2001	2002–11
Rough-legged Buzzard	x		x				
Osprey			x	x	x	x	x
Kestrel	x	x	x	x	x	x	x
Red-footed Falcon						x	x
Merlin	x		x	x	x	x	x
Hobby	x	x	x	x	x	x	x
Peregrine	x		x	x	x	x	x
Water Rail	x	x	x	x	x	x	x
Spotted Crake	x					x	x
Corncrake	x	x	x		x	x	
Moorhen	x	x	x	x	x	x	x
Coot	x	x	x	x	x	x	x
Crane	x		x				x
Oystercatcher	x	x	x	x	x	x	x
Black-winged Stilt			x				
Avocet			x				x
Stone-curlew	x						
Little Ringed Plover			x	x	x	x	x
Ringed Plover	x	x	x	x	x	x	x
Dotterel	x			x	x		
Golden Plover	x	x	x	x	x	x	x
Grey Plover	x		x	x	x	x	x
Sociable Plover				x			
Lapwing	x	x	x	x	x	x	x
Knot	x	x	x	x	x	x	x
Sanderling			x	x	x	x	x
Semipalmated Sandpiper						x	
Little Stint			x	x	x	x	x
Temminck's Stint						x	x
Pectoral Sandpiper					x	x	
Curlew Sandpiper			x	x	x	x	x
Purple Sandpiper						x	
Dunlin	x	x	x	x	x	x	x
Ruff		x	x	x	x	x	x
Jack Snipe	x	x	x	x	x	x	x
Snipe	x	x	x	x	x	x	x
Great Snipe	x						
Woodcock	x	x	x	x	x	x	x
Black-tailed Godwit			x	x	x	x	x
Bar-tailed Godwit	x		x	x	x	x	x

	Pre-1952	1952–61	1962–71	1972–81	1982–91	1992–2001	2002–11
Whimbrel		x	x	x	x	x	x
Curlew	x	x	x	x	x	x	x
Upland Sandpiper	x						
Common Sandpiper	x	x	x	x	x	x	x
Green Sandpiper	x	x	x	x	x	x	x
Spotted Redshank	x	x	x	x	x	x	x
Greenshank	x	x	x	x	x	x	x
Lesser Yellowlegs					x		
Wood Sandpiper			x	x	x	x	x
Redshank	x	x	x	x	x	x	x
Turnstone				x	x	x	x
Red-necked Phalarope		x			x		
Grey Phalarope		x		x	x		
Arctic Skua				x	x		x
Great Skua						x	x
Sabine's Gull					x		x
Kittiwake					x	x	x
Black-headed Gull	x	x	x	x	x	x	x
Little Gull				x	x	x	x
Mediterranean Gull					x	x	x
Common Gull	x	x	x	x	x	x	x
Ring-billed Gull						x	x
Lesser Black-backed Gull	x	x	x	x	x	x	x
Herring Gull	x	x	x	x	x	x	x
Yellow-legged Gull						x	x
Caspian Gull							x
Iceland Gull						x	
Glaucous Gull					x	x	x
Great Black-backed Gull	x		x	x	x	x	x
Little Tern	x		x	x	x	x	x
Gull-billed Tern	x						
Black Tern	x	x	x	x	x	x	x
Sandwich Tern			x	x	x	x	x
Common Tern	x	x	x	x	x	x	x
Roseate Tern	x						
Arctic Tern	x	x	x	x	x	x	x
Guillemot	x						
Razorbill	x						
Little Auk	x		x	x		x	
Puffin	x		x		x		

	Pre-1952	1952–61	1962–71	1972–81	1982–91	1992–2001	2002–11
Pallas's Sandgrouse	x						
Stock Dove	x	x	x	x	x	x	x
Woodpigeon	x	x	x	x	x	x	x
Collared Dove	x	x	x	x	x	x	x
Turtle Dove	x	x	x	x	x	x	x
Rufous Turtle Dove							x
Ring-necked Parakeet				x			x
Cuckoo	x	x	x	x	x	x	x
Barn Owl	x	x	x	x	x	x	x
Little Owl	x	x	x	x	x	x	x
Tawny Owl	x	x	x	x	x	x	x
Long-eared Owl	x	x	x	x	x	x	x
Short-eared Owl	x	x	x	x	x	x	x
Nightjar	x	x	x			x	
Swift	x	x	x	x	x	x	x
Kingfisher	x	x	x	x	x	x	x
Roller	x						
Hoopoe		x	x	x	x	x	x
Wryneck	x	x			x	x	x
Green Woodpecker	x	x			x	x	x
Great Spotted Woodpecker	x	x	x	x	x	x	x
Lesser Spotted Woodpecker	x	x	x	x	x	x	x
Golden Oriole	x		x				
Red-backed Shrike	x		x			x	
Great Grey Shrike	x	x	x	x	x	x	x
Magpie	x	x	x	x	x	x	x
Jay	x	x	x	x	x	x	x
Jackdaw	x	x	x	x	x	x	x
Rook	x	x	x	x	x	x	x
Carrion Crow	x	x	x	x	x	x	x
Raven	x		x			x	x
Goldcrest	x	x	x	x	x	x	x
Firecrest	x	x	x	x	x	x	x
Blue Tit	x	x	x	x	x	x	x
Great Tit	x	x	x	x	x	x	x
Coal Tit	x	x	x	x	x	x	x
Willow Tit		x	x	x	x	x	x
Marsh Tit	x	x	x	x	x	x	x
Bearded Tit	x		x	x	x		
Woodlark	x						x

	Pre-1952	1952–61	1962–71	1972–81	1982–91	1992–2001	2002–11
Skylark	X	X	X	X	X	X	X
Sand Martin	X	X	X	X	X	X	X
Swallow	X	X	X	X	X	X	X
House Martin	X	X	X	X	X	X	X
Cetti's Warbler						X	X
Long-tailed Tit	X	X	X	X	X	X	X
Yellow-browed Warbler						X	
Wood Warbler	X	X	X	X	X	X	X
Chiffchaff	X	X	X	X	X	X	X
Iberian Chiffchaff						X	
Willow Warbler	X	X	X	X	X	X	X
Blackcap	X	X	X	X	X	X	X
Garden Warbler	X	X	X	X	X	X	X
Barred Warbler	X						
Lesser Whitethroat	X	X	X	X	X	X	X
Whitethroat	X	X	X	X	X	X	X
Dartford Warbler	X						
Grasshopper Warbler	X	X	X	X	X	X	X
Icterine Warbler	X						
Aquatic Warbler						X	
Sedge Warbler	X	X	X	X	X	X	X
Marsh Warbler	X	X					
Reed Warbler	X	X	X	X	X	X	X
Waxwing		X	X	X	X	X	X
Nuthatch	X	X	X	X	X	X	X
Treecreeper	X	X	X	X	X	X	X
Wren	X	X	X	X	X	X	X
Starling	X	X	X	X	X	X	X
Rose-coloured Starling						X	
Dipper	X	X	X	X	X	X	X
Ring Ouzel	X	X	X	X	X	X	X
Blackbird	X	X	X	X	X	X	X
Fieldfare	X	X	X	X	X	X	X
Song Thrush	X	X	X	X	X	X	X
Redwing	X	X	X	X	X	X	X
Mistle Thrush	X	X	X	X	X	X	X
Spotted Flycatcher	X	X	X	X	X	X	X
Robin	X	X	X	X	X	X	X
Nightingale	X	X	X	X	X	X	X
Bluethroat				X			

	Pre-1952	1952–61	1962–71	1972–81	1982–91	1992–2001	2002–11
Pied Flycatcher	x	x	x	x	x	x	x
Black Redstart	x	x	x	x	x	x	x
Redstart	x	x	x	x	x	x	x
Whinchat	x	x	x	x	x	x	x
Stonechat	x	x	x	x	x	x	x
Wheatear	x	x	x	x	x	x	x
Dunnock	x	x	x	x	x	x	x
House Sparrow	x	x	x	x	x	x	x
Tree Sparrow	x	x	x	x	x	x	x
Yellow Wagtail	x	x	x	x	x	x	x
Grey Wagtail	x	x	x	x	x	x	x
Pied Wagtail	x	x	x	x	x	x	x
Tree Pipit	x	x	x	x	x	x	x
Meadow Pipit	x	x	x	x	x	x	x
Rock Pipit	x		x	x	x	x	x
Water Pipit					x	x	x
Chaffinch	x	x	x	x	x	x	x
Brambling	x	x	x	x	x	x	x
Greenfinch	x	x	x	x	x	x	x
Goldfinch	x	x	x	x	x	x	x
Siskin	x	x	x	x	x	x	x
Linnet	x	x	x	x	x	x	x
Twite	x			x			
Lesser Redpoll	x	x	x	x	x	x	x
Common Crossbill	x	x	x	x	x	x	x
Common Rosefinch	x	x					
Bullfinch	x	x	x	x	x	x	x
Hawfinch	x	x	x	x	x	x	x
Snow Bunting	x	x	x	x	x	x	x
Yellowhammer	x	x	x	x	x	x	x
Cirl Bunting	x	x	x				
Little Bunting							x
Reed Bunting	x	x	x	x	x	x	x
Corn Bunting	x	x	x	x	x	x	x

Acknowledgements

I would like to thank sincerely all the committee members I have worked with since 1974 and, most importantly, those members of the Society who have regularly submitted monthly records and unstintingly carried out fieldwork and surveys; there are 20 to 30 members who have been regularly doing this for well over 25 years. I would also thank our local RSPB office and the BTO for their support and, in particular, Rob Fuller for his help, encouragement and for writing the foreword. Finally I must thank, and apologise to, my wife Margaret, my sons Matthew and Robbie, my daughter Lucy and my friends who have all had to endure my enthusiasm for and time commitment to birdwatching and bird statistics for well over 35 years.

I would like to thank and express my gratitude to the following people in particular for the help they have given to producing this book.

First, to those who contributed articles and/or read sections of the book and offered constructive criticism or corrected my errors:

Adrian Bletchly
Sandra Bletchly
Anthony Brownett (ABSS)
Frances Buckel
Lindon Cornwallis
Phil Douthwaite (Neal Trust Reserve)
Roger Evans (Balscote Quarry Reserve)
Una Fenton (rainfall data)
Doreen Knight (information about the Society
 1957–70)
Mike Lewis (Glyn Davies Reserve)
Chris Mason
Tony Nash (Conservation and Tadmarton Heath
 Reserve)
Alan Peters (Bicester Wetland Reserve)
Reg Tipping
Andrew Turner (Pauline Flick Reserve and
 Ringing 2006–11)

Secondly, I am extremely grateful to Barry Boswell for his excellent cover photograph and allowing us to use a large selection of his photographs in this book; Anthony Temple for his photograph of the Firecrest and Richard Woodward for his picture of Swifts at a nest site.

All other photographs were taken by myself and the following members of the Society:

Adrian Buckel
Frances Buckel
Una Fenton
Derek Hales
Richard Hall
Tony Nash
Alan Peters
Derek Woodard

Thirdly, to those who have helped produce drafts of this book, Sally Abbey for reading and correcting draft proofs and James P. Easterbrook of Complete Graphics of Tavistock for printing the various draft versions.

The Society would like to thank the following BTO staff: David Noble, Principal Ecologist for Monitoring, and Kate Risely, BBS National organiser, for their help in providing and allowing us to use the CBC/BBS charts and BBS index charts.

We also need to thank Anthony Cond, commissioning editor for Liverpool University Press, for his support throughout the project and, most particularly, Chris Reed and Amanda Thompson of BBR for doing what they do so extraordinarily well. Their expert advice and meticulous eye for detail, both during the writing of the manuscript and in the design and production of the book, has been invaluable. The book has benefited greatly from all of their work.

Bibliography

References

Aplin, O. V. 1889. *The Birds of Oxfordshire.* Oxford University Press.

——. 1967. *Diaries of O. V. Aplin 1930–39.* Ed. G. Davies. Banbury Ornithological Society.

Beesley, A. 1841. *History of Banbury.* London.

BOS Annual Reports 1974–2011. Banbury Ornithological Society.

Brownett, A. 1966. *BOS Field Report No. 1.* Banbury Ornithological Society.

——. 1974. *Study of Birds in the South Midlands.* Banbury Ornithological Society.

——. In press. *A compendium of fieldwork carried out by the BOS 1952–2011.* Banbury Ornithological Society (expected 2014).

BTO. 2011. *Bird Trends.* BTO, Tring.

Davies, G. 1967. *The Birds of the Banbury Area.* Banbury Ornithological Society.

——. 1974. *Pied Wagtail movements in the BOS area.* Banbury Ornithological Society.

——. 1981. *The Status of Reed Bunting in the Banbury Area.* Banbury Ornithological Society.

Davies, N. B. 1983. Polyandry, cloaca poaching and sperm competition in Dunnocks. *Nature* 302: 334–36.

Easterbrook, T. G. 1984. *The Birds of the Banbury Area.* Banbury Ornithological Society.

——. 1994. *The new Birds of the Banbury Area.* Banbury Ornithological Society.

Eaton, M. A., Brown, A. F., Noble, D. G., Musgrove, A. J., Hearn, R., Aebischer, N. J., Gibbons, D. W., Evans, A. and Gregory, R. D. 2009. Birds of Conservation Concern 3: the population status of birds in the United Kingdom, Channel Islands and the Isle of Man. *British Birds* 102: 296–341.

Fuller, R. J., Noble, D. G., Smith, K. W. and Vanhinsbergh, D. 2005. Recent declines in populations of woodland birds in Britain: a review of possible causes. *British Birds* 98: 116–43.

Gibbons, D. W., Reid, J. B. and Chapman, R. A. (eds). 1993. *The New Atlas of Breeding Birds in Britain and Ireland: 1988–1991.* T & A. D. Poyser, London.

Mason, J. 1964. The parish government of Tadmarton in the 18th and 19th centuries. *Cake and Cockhorse* 2: 127–30.

Mead, C. 2000. *The State of the Nation's Birds.* Whittet Books, Stowmarket.

Meek, W. R., Burman, P. J., Sparks, T. H., Nowakowski, M. and Burman, N. J. 2012. The use of Barn Owl (*Tyto alba*) pellets to assess population change in small mammals. *Bird Study* 59(2): 166–74.

Morton, J. 1712. *The Natural History of Northamptonshire.* London.

Seel, D. C. 1968. Breeding seasons of the House and Tree Sparrow Passer species at Oxford. *Ibis* 110: 129–44.

Siriwardena, G. M., Baillie, S. R., Buckland, S. T., Fewster, R. M., Marchant, J. H. and Wilson, J. D. 1998. Trends in abundance of farmland birds: a quantitative comparison of smoothed Common Bird Census indices. *Journal of Applied Ecology* 35: 24–43.

Stoate, C., Boatman, N. D., Borralho, E. J., Rio Carvalho, C., de Snoo, G. R. and Eden, P. 2001. Ecological impacts of arable intensification in Europe. *Journal of Environmental Management* 63: 337–65.

Tompkins, D. M., Draycott, R. A. H. and Hudson, P. J. 2000. Field evidence for apparent competition mediated via the shared parasites of two gamebird species. *Ecology Letters* 3: 10–14.

Further reading

Aplin F. C., Aplin, B. D'O. and Aplin, O. V. 1882. *A list of the Birds of the Banbury District.* Banburyshire Natural History Society, Banbury.

Avery, M., Gibbons, D. W., Porter, R., Tew, T., Tucker, G. and Williams, G. 1995. Revising the British Red Data List for birds: the biological basis of UK conservation priorities. *Ibis* 137: S232–40.

Barr, C., Bunce, R., Cummins, R. P., French, D. D. and Howard, D. C. 1992. Hedgerow Change in Great Britain. *Annual Report of the Institute of Terrestrial Ecology* 1991/92: 21–24.

Brown, A. and Grice, P. 2005. *Birds in England.* T & A. D. Poyser, London.

Campbell, L. H., Avery, M. I., Donald, P. J., Evans, A. D., Green, R. E. and Wilson, J. D. 1997. A review of the indirect effects of pesticides on birds. *JNCC Report No. 22.*

Cramp, S. and Perrins, C. M. (eds). 1977–94. *The birds of the Western Palearctic,* vols I-IX. Oxford University Press.

Davies, G. and Nash, A. 1968. *A Bird Study for Inland Observers.* Banbury Ornithological Society.

Donald, P. F. and Evans, A. D. 1994. Habitat selection by Corn Buntings *Miliaria calandra* in winter. *Bird Study* 41 (3): 199–210.

Easterbrook, T. G. 1999 Population trends of wintering birds around Banbury Oxfordshire 1975–96. *Bird Study* 46: 16–24.

Evans, A. D. 1996. The importance of mixed farming for seed-eating birds in the UK. In: Pain, D. and Pienkowski, M. W. (eds). *Farming and Birds in Europe. The Common Agricultural Policy and Its Implications for Bird Conservation,* pp. 331–57. Academic Press, London.

Evans, A. D., Cutoys, J., Kew, J., Lea, A. and Rayment, M. 1997. Set-aside: Conservation by accident … and design? *RSPB Conservation Review 11.*

Fuller R. J., Baker, J. K., Morgan, R. A., Scroggs, R. W. H. and Wright, M. 1985. Breeding populations of the Hobby *Falco subbuteo* on farmland in the southern Midlands. *Ibis* 127: 510–16.

Fuller, R. J., Gregory, R. D., Gibbons, D. W., Marchant, J. H., Wilson, J. D., Baillie, S. R. and Carter, N. 2002. Population declines and range contractions among farmland birds in Britain. *Conservation Biology* 9: 1425–42.

Gibbons, D. W., Avery, M., Baillie, S. R., Gregory, R., Kirby, J., Porter, R., Tucker, G. and Williams, G. 1996. Bird Species of Conservation Concern in the United Kingdom, Channel Islands and the Isle of Man: revising the Red Data List. *RSPB Conservation Review* 10: 7–18.

Glue, D. 1994. On the slippery slope. *BTO News* 194: 1.

Lack, P. 1986. *The Atlas of Wintering Birds in Britain and Ireland.* T & A.D. Poyser, London.

Marchant, J. D. H., Hudson, R., Carter, S. P. and Whittington, P. 1990. *Population Trends in British Breeding Birds.* BTO/NCC, Tring.

Main, I., Pearce, D. and Hutton, T. 2009. *Birds of the Cotswolds.* Liverpool University Press.

Powell, P. 2005. *The Geology of Oxfordshire.* Dovecote Press, Wimborne.

Sharrock, J. T. R. 1976. *The Atlas of Breeding Birds in Britain and Ireland.* T & A. D. Poyser, London.

Index of species

Page numbers in bold type refer to the relevant species account, and the scientific names refer only to these accounts.